The Other Almanac

For city and country and everywhere in between

CALCULATED FOR THE YEAR

2025

FOR THE MERIDIAN OF NEW YORK, NY

40.7128° N, 74.0060° W

Volume 3

Knowledge Acknowledgment

The Other Almanac would like to call out and acknowledge conventional American almanacs' history of theft of the knowledge, research, and philosophies developed and refined by the people of many distinct Native nations. Much of the information contained in these almanacs would not exist without Native peoples' ongoing collaboration with the ecosystems, flora, and fauna of this land over thousands of years.

Often in land acknowledgements gratitude for stewardship and knowledge is given. As a settler on stolen land, I question the appropriateness of giving thanks for land and knowledge forcibly taken and misused, rather than given with trust. *The Other Almanac* aspires to navigate complexities with care and to embody solidarity with colonized and oppressed peoples everywhere, from New York to Palestine, between and beyond.

I am grateful that most of humanity's years on earth were lived before European colonialism and the invention of capitalism. I am thankful that this planet and everything it supports has been stewarded and respected for much longer than it has been wounded and depleted.

If you are reading this publication in the so-called United States of America, you are standing, sitting, or lying down on stolen land, violently transformed by systematic strategies of erasure, including genocide, ecocide, and intentional transmission of disease.

The Other Almanac strives to be a platform for the work of many people(s), including artists and writers of Indigenous descent from around the world. While I take pride in this third publication, I know we can continue to do better. As future editions are published, we look forward to expanding the depth of our commitment to sharing the work of people who themselves—or whose ancestors—were displaced or wounded through colonization.

The Other Almanac contributes funds monthly to the Indigenous Environmental Network. All non-Native readers are encouraged to find out which nation's land they are currently occupying and to pay a monthly land tax to organizations in their area.

Whose land are you on?

native-land.ca

Below is a list of a few organizations to look into.

indigenousrising.org

ienearth.org

mannahattafund.org

therednation.org

nativefoodalliance.org

sogoreate-landtrust.org

About Almanacs

The Other Almanac is a contemporary reimagining in the tradition of the much-beloved farmers' almanacs. There have been many different American almanacs throughout the last couple hundred years, with the Old Farmer's Almanac being the most widely known, as well as the longest continuously printed publication in the United States.

If *The Other Almanac* is your introduction to the incredible history of almanacs here in the US and the world, then welcome to a very deep new study. You are now taking part in one of the oldest cultural and scientific traditions of humanity.

The first printed almanac was created in Europe in 1457, but almanacs have existed across the globe for much longer, since the discipline of astronomy came into being. They were carved into stones, painted on animal hides, and formed into manuscripts. The oldest surviving almanac was found in Babylonia and lists each day of the year with corresponding favorable and unfavorable activities.

Yearly updated almanacs are still being printed in many countries around the world. *The Other Almanac* is calculated and written for New York City (hopefully expanding geographically in coming years). Unlike other farmer's almanacs in the US, which have historically catered to rural white land-owners, *The Other Almanac* attempts to be a bridge between the rural and urban divide here in the USA. This edition is another attempt at an almanac that talks about climate change, takes stances on cultural and political issues, and includes contributions from professors, farmworkers, scientists, medicine makers, incarcerated poets, activists, astrologers, urban gardeners, midwives, and others. This project is a huge undertaking and I look forward to seeing it grow and change as it continues throughout the years.

Thank you to everyone who helped bring this publication into existence. Many eyes, hands, machines, and minds went into creating this object and I hope you enjoy reading it as much as we enjoyed making it.

—Ana Ratner

Contents

DATA

New York Native Seeds...12
Plant Flowering Times in New York.....................................14
Tree Data Across Various U.S. Cities...................................38
Bodies Found In European Bogs...40
Fires Across America..42
Antarctic Ice Sheet's Ice Loss...44
Top Baby Names in the US..28
Climate Data 2025..46

OBITUARIES

Fauna Extinction Obituaries...32
Flora Extinction Obituaries...34
Tech Extinction Obituaries—Sally Dewind........................36

CALENDARS

Moon Calendar ..48
Full Year Calendar...50
January Calendar...52
February Calendar..60
March Calendar...72
April Calendar..86
May Calendar..100
June Calenda...110
July Calendar..122
August Calendar..130
September Calendar...140
October Calendar..154
November Calendar ..164
December Calendar..172

MOON NAMES

Moon Names..52, 60, 72, 86, 100, 110, 122, 130, 140, 154, 164, 172

MONTHLY COLUMNS

Seasonal Birding—Indigo Goodson-Fields..55, 74, 112, 143
Phenology Calendar—Kay Kasparhauser.....54, 63, 75, 88, 103, 112, 125, 132, 143, 156, 167, 174
Astrology—Morgan Lett................................54, 62, 75, 89, 103, 112, 124, 133, 143, 156, 167, 175
Herbal Tips—Adriana Ayales..................55, 63, 75, 89, 103, 113, 125, 132, 142, 156, 166, 174

RECIPES

Wilder Sauerkraut—Pascal Baudar...56
Nettle Soup—Pascal Baudar..76
Elderflower Sparkling Wine—Pascal Baudar...114
Salted Herbs—Pascal Baudar...144

WRITING

Meet a Farmer: Yemi Amu/Oko Farms—Shannon Lai...18
Meet a Gardener: Merry—Ana Ratner...20
NYC Origins: The Vanishing Cup That Won't Stop Being Famous—Anne Kadet......24
NYC Feud: Tony's Pier v. Johnny's Reef—Meredith Celeste Lawder.............................26
A Eulogy for Flaco—Sally Dewind..30
A Prayer For Burial & Rebirth—Sonya Renee Taylor...58
Phantom Mapping—Spencer Tilger..66
Unseen—Or Zubalsky...78
Future Memory Work—Nora N. Khan...92
An Eco-Somatic Resilience Practice With Dandelion—Cy X...96
To Know Yourself, Consider Your Doppelgänger—Naomi Klein...................................104
Baby, Bird Indigo—Indigo Goodson-Fields...116
The Intoxicating Garden—Michael Pollan..126
The New Green Revolution—Winona LaDuke..134
An Introduction To The Bill Pickett Invitational Rodeo—Sam Russek.......................146
Unending Metamorphosis—Willa Köerner..158
Venom Is A Protein—Yasaman Sheri...168
Live From Gaza—Vivien Sansour..176

ART

Monthly Flash Tattoo —Who Tattoo54, 62, 74, 88, 102, 113, 124, 132, 142, 157, 167, 175
A Eulogy For Flaco—Tony Caridea...30
I Need To Be In Your Arms—Jeffrey Gibson...59
These Are Dense Countries And Empty Cities—Sky Hopinka...................................62
Spilhaus Xix 67—Tauba Auerbach...70
Img_4678 Crop, 2015-05-29 07:10:33 ,Video Still, 2019-07-2 10:55:48—Qais Assali.....84
Made In India, Found In Egypt—Baseera Khan..90
Scab Harvest—Jia Sung...108
Untitled—Day Brière...118
Put Yourself In The Picture—Roberto Lugo...120
É Tão Triste Cair—Paula Querido..127
I See Red: Snowman—Jaune Quick-To-See Smith...138
Where Moonlight Meets The Ground.—Debarati Sarkar..162
Venenum—Hirad Sab..170
Al-Atlal (The Ruins)—Jordan Nassar..180

RESOURCES

Community Gardens of New York ...182
Community Fridges..185
Mutual Aid Groups of New York..186
Apothecaries/Botanicas/Wellness Centers from The Database of Black Healers and
Herbalists - compiled by Jade Forrest Marks..187

IMAGE INDEX

Image Index..188

CONTRIBUTOR BIOS

Contributor Bios...189

HIBISCUS MOSCHEUTOS,
SWAMP ROSE MALLOW

AQUILEGIA CANADENSIS,
RED COLUMBINE

CHELONE GLABRA,
WHITE TURTLEHEAD

IMPATIENS PALLIDA,
YELLOW JEWELWEED

PHYSOCARPUS OPULIFOLIUS,
NINEBARK

PYCNANTHEMUM MUTICUM,
MOUNTAIN MINT

SENNA HEBECARPA,
WILD SENNA

LILIUM CANADENSE,
CANADA LILY

CEANOTHUS AMERICANUS,
NEW JERSEY TEA

THUJA OCCIDENTALIS,
ARBORVITAE

SMILAX HERBACEA,
SMOOTH CARRIONFLOWER

AUREOLARIA PEDICULARIA,
**THE FERNLEAF YELLOW
FALSE FOXGLOVE**

NEW YORK
NATIVE SEEDS

14

in New York State

WISTERIA

WILD COLUMBINE

WILD BERGAMOT

TULIPS

ROSE

PURPLE CONEFLOWER

PEACHES

NEW ENGLAND ASTER

MAGNOLIA FLOWERS

LILACS

HELLEBORE

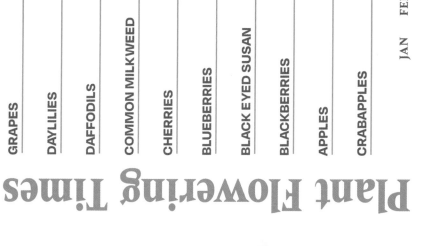

NYC Spring Phenology Checklist

Crocuses blooming

Days getting longer

People sitting on stoops

Canada geese flying in formation

Air conditioned subway cars

Sweaters tied around peoples shoulders and hips

Thirst traps being posted on instagram

People playing pick up basketball games

People holding hands

The Mister Softee truck song playing

Belly buttons everywhere

Warblers migrating through parks

Store signs that say "suns out buns out"

Strangers talking to each other

Running into people you don't want to see on the street

People turning their heads to check out eachother's butts

Petrichor

People sneezing and rubbing their eyes

The sound of horny cooing pigeons

Music coming out of car windows

Kids eating Italian Ices

Meet a Farmer: Yemi Amu/Oko Farms

WITH SHANNON LAI

Oko Farms as a space and operation is a cornerstone of urban agriculture in NYC, spanning over 10 years now from its first iteration on a plot in Bushwick to its new location in Williamsburg. Can you share a bit about its mission and how it's developed over that time?

Oko Farms' mission is to promote aquaponics as an ecological farming method that mitigates the impact of climate change, increasing food security for urban residents while demystifying aquaponics through awareness and education. When we started in 2013, I knew there was a great need for aquaponics projects that were centered around education and awareness, accessibility, and ecology, so I would say our mission hasn't changed but merely deepened. Then, as today, many of the other aquaponics projects in the city were not accessible to the public, or were focused on entering the "Ag-tech" scene and securing venture capital funding—totally opposite from us! Since then, our mission has only gained urgency, with increased shifts in the climate and the social and economic repercussions of COVID-19. The pandemic exacerbated food insecurity in low income communities worldwide and caused a higher number of deaths in BIPOC communities already facing health challenges due to limited access to nutritious food choices. I see there being a greater need than ever for people in urban environments to grow food for themselves sustainably and on a budget.

As a society, we've become more and more detached to the natural environment— this includes our connection to our food sources, natural resources, and plant knowledge. What are your thoughts on ways to empower reconnection to nature? Can you speak a bit about Oko's Clothing Restoration Project in this context and how its mission directly addresses this growing disconnect?

For thousands of years, our lives were inextricably linked to nature through agriculture, which was essential not just for food but also medicine, shelter, clothing, art, and community. I would even argue that spirituality came from this reliance on nature for survival, since many religious and spiritual teachings draw on agriculture for their lessons, as seen in the Bible's Parable of the Sower. While industrialization broke this bond, urban agriculture has paved the way for reconnection. By cultivating food in urban settings, we expand our knowledge of plants and develop respect for insects and other animals crucial for healthy ecosystems. The Oko Farms' Clothing Restoration Project takes this a step further by reviving our ancestral ties to nature through clothing and textiles. This initiative focuses on preserving natural dye and fiber material traditions from West Africa and Southeast Asia, showcasing eco-friendly and culturally significant alternatives to the wasteful and culturally alienated clothing industry. Through this project, we cultivate natural dye and fiber crops, process them into pigments and textiles, and research their historical uses in medicine, spirituality, culture, and more.

Knowledge share and accessibility is a major tool to raise awareness. They hold power to reconnect people to their innate relationship with ecology and ancestry. Can you elaborate on how the Clothing Restoration Project uses knowledge share as a tool to facilitate reconnection to nature and ancestry?

The Clothing Restoration project provided us with the chance to visit West Africa (Togo and Benin) and Southeast Asia (Vietnam and Indonesia) to learn from experts in natural dyeing and textiles. These experienced individuals generously imparted their knowledge to us, equipping us with the necessary tools for hands-on learning and knowledge exchange. Through a series of blog posts, we share insights gained from our travels and research. On the farm, we organize workshops on natural dyeing using

plants like indigo and marigold, involve participants in the processing of heirloom cotton grown here, and collaborate with organizations that conduct clothing repair workshops.

Can you define what urban agriculture means to you and what your hopes and dreams for the future of urban agriculture are for the next 10 years?

As someone of Yoruba descent, I believe in the principles of orí and kádàrá, which both relate to a person's destiny or spiritual purpose. Having spent all my life in both Lagos and New York City, my passion for cities stems from my lived experiences in these locations. On a personal level, my combined love for cities and passion for nature makes urban agriculture feel like a spiritual calling. I believe it should be a calling for all of us in order to secure a sustainable future for humanity, especially considering that most of the world's population is expected to reside in cities in the coming decades. Urban agriculture will play a vital role in our survival as we strive to address climate change, minimize our environmental impact, and enhance the quality of life for urban dwellers. My dream is to have urban agriculture woven into various aspects of city infrastructure such as schools, hospitals, parking lots, rooftops, places of worship, residential spaces, and more. These urban farms should be easily replicable, deeply rooted in community engagement, and promote environmental consciousness.

For people who are wanting to be involved with Oko Farms or in urban agriculture, what are the most effective and supportive ways?

There are many ways to support Oko Farms, including attending our various aquaponics education and clothing workshops, wellness events, culinary workshops, and our market stand. We also accept monetary and in-kind donations. All of these greatly contribute to our mission of increasing food security for NYC's most vulnerable residents while ensuring fair wages for our staff. For more information on monetary and in-kind donations please email Jess Carroll (jess@okofarms.org).

Meet a Gardener: Merry

WITH ANA RATNER

I met Merry when she was taking pottery classes at the studio where I work. She was busy making ceramic beads, bangles, and flower trays when she first told me that she gardens on the High Line.

When did you start working on the High Line?

One day in 2008, I saw a friend walking on 14th Street (near 9th Avenue) with her head bent looking at the ground. So I asked her what she was doing. This was before the High Line opened, but they would have these events to promote it. She'd worked with an artist at a school on making chalk shoes. The kids would then wear these shoes to make lines on the sidewalk that led to the High Line. She was walking along the path to see the results. I had visited part of the High Line during an Open House event and was happy to find out that I could volunteer as well. One day in 2008, I saw a friend walking on 14th Street (near 9th Avenue) with her head bent looking at the ground. So I asked her what she was doing. This was before the High Line opened, but they would have these events to promote it. She'd worked with an artist at a school on making chalk shoes. The kids would then wear these shoes to make lines on the sidewalk that led to the High Line. She was walking along the path to see the results. I had visited part of the High Line during an Open House event and was happy to find out that I could volunteer as well.

As part of the volunteer program, they asked, "do you want to be a greeter on the High Line?" Whatever that meant, but I did say okay. We spoke to visitors and gave out literature. During those days it was even hotter on the Line than now. Just imagine, everything's still little, and there is basically no shade. So I would put my hair up on my head, like the cartoon character Pebbles—I had this crazy Pebbles 'do and I'm a sweaty mess.

It is very interesting that this abandoned bit of land was transformed into an extraordinary park.

We used to go in high school, before it was anything. We'd climb up a fire escape ladder and then you'd have to walk over the roofs of all these abandoned buildings. There were wooden planks with nails sticking out and broken glass everywhere. Once someone I was with did the whole thing barefoot. Then you'd get to the tracks and it was beautiful. As a kid growing up in NYC, finding a place that felt like yours was so important.

Yeah, I had heard that kids went up on the Line when it was abandoned. You have a unique memory of this very hazardous yet beautiful terrain that was filled with holes, rusty nails, and also asbestos—though as a kid, I am sure you didn't even think about the dangers. When we built the High Line, we literally stripped everything. We had to go back down to the cement foundation because of the asbestos.

How did you get into gardening there?	When the High Line opened in June 2009, I was a greeter. Then in March they said the gardeners needed people to help with cutback. So I said, "sure, okay."
	We literally cut back all the plants, more than 100,000 plants. I liked working with the plants so I asked if I could volunteer as a gardener and they said "No, we don't need any help." Then when May comes around, they are seriously seeking help, so I partnered with a full-time gardener. We worked together for years before she went to another garden.
	When the High Line first opened, we had no irrigation. So we hand watered. You would spend 80% of your time just watering. I would help in the morning, and then I'd go to work.
Where were you working?	Midtown. I was going to the office. I work in advertising as a copywriter and editor. My hours then were 10 am to 6 pm so I could go to the High Line early, at 7:30 am.
Do you have a favorite plant on the High Line?	We have these beautiful grasses. There is one grass that I really love called big bluestem. It is such a beautiful grass. I always wondered, why is it called big bluestem? Then last year, finally, I literally saw the blue on the stem. It's rare for any plant to be blue, and it's really blue. I also love this grass because it gets these tiny yellow flowers and it's native.
Did you garden before working there? Was it something you grew up around?	We used to always grow things when I was a kid. We had a backyard where we always had a garden. My mother grew up in Brooklyn, I think she grew things. I know she had a fig tree. I remember she brought home Brussels sprouts still on the stalk so we could see how they grew. We ate everything fresh, we didn't eat canned food.
Would you help out?	Yeah, definitely. Even as a kid I'd like to dig in the earth. I never minded getting muddy.
When you said fig tree I wondered if you were Italian. I associate fig trees with my mom because her family is Italian from Brooklyn and they always had fig trees. Where was your family from?	My mother was born and raised in Bensonhurst. Her mother grew up in Harlem, and her father was from Lithuania or Latvia. My father grew up in Queens, and his parents were born and raised on the Lower East Side. My heritage is Jewish.

Did you garden after you moved out and before you started working on the High Line?	No, my dream is to have a garden of my own, but I do work every week in a grand garden located in New York City. On the High Line, we don't grow food per se, but we have things like sorrel, elderberries, and shad berries.
When we met you told me about weeding out some of the abundant plants and what you sometimes do with them.	Some plants really thrive in certain locations on the High Line, and sometimes they're too abundant so we need to pull them. It's a really cool kind of editing.

When I garden an edible plant, I may taste it. If we cut down a sumac tree I bring the berries home and make tea. We cut down an elderberry once and I made vinegar from the berries. I haven't tasted it yet though. If we pull out a plant with its roots, then I might take it and replant it. |
Where do you replant it?	I'll go to the West Side Highway and find a barren area on the divider. I'll bring a little spade and just plant it. It might not live, but at least it's not going to compost.
What have you planted on the highway?	I can't really remember, but they're always unique. One time I took a clerodendrum and I put it in a park in the West Village with a label on it that said it was a clerodendrum from the High Line. I thought, oh my God, how beautiful to have this tree for everybody! But then someone stole it.
Do you ever go back by the highway and see what took?	No, I haven't. Sometimes I can't even really remember where I put plants. It's nice to put plants in spots where people walk every day. Even if only one of them grows you've made their walk a little nicer.
You've been volunteering as a gardener on the High Line for 14 years now, what has kept you working there for so long?	When I'm there I get to start my day smelling the earth, surrounded by vegetation and wild creatures. People will walk by filled with joy to be up there and thank me for helping to maintain the gardens. Depending on where I'm working it's also so quiet and removed from the urban landscape. Sometimes all I hear are the birds and the rustling of the plants.

I get to see things that I've planted either blossoming or dying depending on the conditions and seasons. It's always fun to see the bulbs we planted in the fall flowering in the spring. I know that I actually planted that flower and it is alive and glorious for all to enjoy. |

NYC Origins: The Vanishing Cup That Won't Stop Being Famous

ANNE KADET

Can a paper cup be famous? Only in New York!

A while back, a reader's comment on one of my many stories about NYC and coffee got me thinking about one of those vanishing icons of New York City life—the Greek paper cup.

"Loved this piece! Made me miss the days of toasted, buttered cart bagels and coffee in the blue Greek cup. Good memories," wrote Amy.

I knew just what she was talking about. "Now you can buy a ceramic version of those blue Greek cups in hipster gift shops," I replied, "but you never see the paper version out in the wild. Sad!"

When Amy said she had no idea they'd discontinued the paper cups, it got me wondering. Had they?

"You know what?" I wrote. "I'm going to do a story looking into whether anyone is still making the paper version, and who is buying them."

Reader, I got my answer. But first, a little history— because it's a fun story!

The saga started in 1963 with a fellow named Leslie Buck, a marketing exec for the Connecticut-based Sherri Cup Company. Back then, the only NYC businesses selling coffee-to-go were diners and pushcarts run by Greek immigrants.

Mr. Buck figured a cup design appealing to these business owners would be a big seller, so he took a standard 10-oz paper cup and slapped a bunch of random Greek signifiers on it: the blue-and-white colors of the nation's flag, a Grecian key border and a weird little drawing of a Greek urn. Most famously, the cup carried the motto, "WΣ ARΣ HAPPY TO SΣRVΣ YOU" with the Greek letter "Σ" replacing the Latin "E."

Greek diner and cart owners went nuts for the design. Over the next few decades, Sherri sold millions of these cups to coffee vendors all over NYC. The cup graced the cover of the Manhattan phone book and is on display at MoMA, which sells a ceramic version in its gift shop.

When I moved to NYC in the '90s, coffee was still served in these cups in many bodegas, bagel shops and diners—Greek or not. According to Wikipedia, sales reached their peak with 500 million sold in 1994. (Can this be possible? That's 68 cups per NYC resident!)

But now, for the life of me, I can't recall the last time I saw a coffee to-go served in one of these cups. Are they totally extinct?

It took ten seconds to Google the answer. A small business based in Ithaca, New York, aptly named "NY Coffee Cup," offers the cup in cartons of 100 for $44 or 1000 for $279. "We sell a lot of these cups," co-owner Michael Turback said when I got him on the phone. "And we send them all over!"

Turback, the "Cup King of NYC," is perhaps better known for his long career as an Ithaca restaurateur. He and his brother, who own NY Coffee Cup, got started by buying the paper cups directly from the Sherri Cup Company to sell on their own website.

Soon, however, the Sherri Cup Company was bought by the much larger Solo Cup Company, which was in turn bought by Dart Container in 2012. By then, sales of the famous Greek cup had fallen sharply thanks to all the Dunkins, Starbucks and indy cafés crowding the NYC coffee landscape with their own cup designs. Dart stopped making the cups twelve years ago. "These huge companies decided, 'This is just some regional pain-in-the-neck,'" said Turback.

When the cup was discontinued, the Turback brothers decided to have it produced for their own business. Today, the cup design is still owned by Dart Container, and NY Coffee Cup has the exclusive license to manufacture and sell it. (You can, of course, buy cheap knockoffs on Amazon.) Turback is not sure exactly how many cups he sells a year, but it's a lot! They're made in Chicago, he said, and he has a truckload of 50,000-70,000 cups delivered to his warehouse 4-5 times a year. "You do the math," he said.

So who's buying the cup? Oddly, they get very few orders these days from NYC coffee shops. "If I had my own café, I would totally be using these cups," I told him.

"Well, but you won't," said Mr. Turback. "I'll tell you why you won't. Because we pay a premium to get these things custom-made. And what we pay to get them

made, and what we pay to transport them, makes them sell for probably close to twice what you can buy a typical paper cup for."

"The other reason is, this is a ten-ounce cup," he added. "People drink coffee in bigger cups now." True! A small coffee at Starbucks, for example, is twelve ounces—too big if you ask me. Ten ounces is exactly the right size!

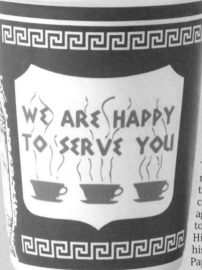

NYC businesses do buy the cups to serve higher-margin menu items, said Turback. A Brooklyn bar uses them to serve a specialty cocktail, for example, and a Greek frozen yogurt chain uses them for soft-serve.

Another big market: ex-New Yorkers who want a piece of home. One Philadelphia company owned by former New Yorkers buys cups by the

case for its employee break room, for example. An artist used them to make a lamp.

Then there's the film and video production companies who want the cups on hand to establish that a scene is taking place in New York City. In that way, the cups are a lot like Times Square and yellow taxis—still used to symbolize NYC even though they're no longer used by actual New Yorkers.

They've appeared in just about every NYC cop show, in movies such as *Goodfellas* and *Spiderman*, and in many episodes of *Mad Men*, of course.

"It's the film and the TV that keep the interest in the cup up enough that we continue to sell it," said Turback. "Our sales are very strong and consistent."

The Turback brothers no longer run a NYC-themed merchandise company—they long ago turned their efforts to a newer enterprise, History Company, selling history-inspired gifts. NY Paper Cup now operates as a stand-alone online shop. But it's profitable enough to keep going.

And it's also about the joy the business brings others, said Turback: "We can't let go of the cup! When people find them, they're so happy. There's so much goodwill in operating this relatively small section of what we do. We love selling them!"

NYC Feud:
Tony's Pier v. Johnny's Reef

MEREDITH CELESTE LAWDER

At the edge of Pelham Bay Park in the Bronx — a stretch past the Hutchinson River and the vaguely-remediated Pelham Bay landfill — sits City Island. Firmly lodged in the belly of the Long Island Sound, City Island has been home to many things over the years: the Siwanoy and Wiechquaeskeck bands of Lenape, Dutch and English settlers, generations of cops and firefighters, and today, a decades-long feud between two fried fish joints.

The rivalry on the southernmost tip of the island between Tony's Pier (est. ~1954) and

Johnny's Reef (est. 1974) is a quieter one, namely because the feud in question is one not between business owners but between the scores of New Yorkers, mostly from the Bronx and southern Westchester, who flock to the island off of Pelham Bay

Park to eat fried clam strips and profess their undying loyalty to one of the fried fiefdoms.

In the summer of 2024, I bribed a couple of friends with the lure of sun, food, and a trip to Orchard Beach, a stretch of sand that only a mother could love, to settle some questions that had long plagued me. Would I, a lifelong Tony's patron, betray my own integrity by eating at Johnny's? Was the food truly better at Tony's or would Johnny's surprise me? Would I run into anyone from high school and have the past and present collapse in on me while chomping on seafood that had very definitely been shipped in from hundreds of miles away? And, above all else, why did writing about this rift fill me with a sense of dread? What lurked beyond it?

Since I've often mistaken hunger for dread, I resolved to eat first,

deliberate later.

Driven purely by bias, I insisted on starting at Tony's Pier. The restaurant happens to be in pretty good shape these days. When Hurricane Sandy hit back in 2012, a transformer fell on the restaurant and burned the whole place down, so when the owners rebuilt, they were able to upgrade the seating area while retaining the old layout and charm. From the parking lot, one can peer over into Johnny's, where everything is like it is at

Tony's, just slightly larger. Their menus are effectively the same: smatterings of fried, steamed, broiled, or baked oysters, clams, lobster, calamari, shrimp, and more. Both also dole out generous pours of the infamous Henny Colada, a piña colada made with Hennessy instead of rum. But menu discrepancies do exist. At Tony's, for example, you can get a burger and some barbecue chicken; at Johnny's you can get fried frog legs. True loyalty, I hypothesized, must hinge on the quality of the breading, the seasoning, the salt-to-oil ratio. For a thorough investigation, I'd have to eat at Johnny's after all.

But first, Tony's. Inside sat Nancy J., 43, Randy C., 32, and a dozen members of their family and friends all from the Bronx. Nancy's dad first took her to Tony's in 1988 and passed away just a year later; since then, the fish joint has been her family's favorite place to eat, no matter the occasion. Case in point, today they'd come straight from her aunt's funeral. Coming here—and here only ever means Tony's—reminds Nancy of her family. She'd been to Johnny's once or twice just to try it, but the experience only reinforced her allegiance to Tony's. "I don't like it," she said of Johnny's, "it's too greasy for me."

Randy felt similarly. He'd been coming to Tony's since he was six years old and now takes his kids with him. It's such a family affair, in fact, that Randy's dad, having moved recently from the Bronx to Connecticut, drives all the way down I-95 just to rendezvous at Tony's. "The food is always the same," comforting in its consistency, Randy opined, which is what keeps drawing his whole family back.

Meanwhile, at Johnny's, Saul Boru and Moises Cabán, also from the Bronx, were chatting animatedly with a score of friends when I asked for their take. Half of the table were Johnny's purists, having never been to Tony's. They were, however, quietly curious. "What do they got over there? Is the food better?" whispered one, who preferred not to give his name.

Moises said he's been driving his motorcycle over the bridge to get to Johnny's for 45 years because, he professed, the food's better at Johnny's. He paused for a moment and then added, "Except the Henny Coladas. Those are better at Tony's." A few people at the table nodded in agreement and longing. At the next table over, Dylan Kelly and his family members, some of whom have been going to Johnny's for 50 years, were more impassioned: They'd never been to Tony's and wouldn't ever dream of going there. "Absolutely not."

It's reassuring, in a way, that these loyalties still hold firm. That — especially in the Bronx, where gentrification has recently accelerated — some things don't change. Something recognizable survives. Long-standing feuds like the one between Tony's and Johnny's create a private language of community, a schematic of interaction that is simple, legible, predictable. It anchors us in time, slows down time, offers us a window into a past that coexists with our present. A feud, like a basketful of deep fried calamari, can provide a kind of comfort.

While nostalgia and family are what bring people to Johnny's and Tony's as much as the seafood, not everyone is so diehard about where they end up.

Alex Reyes was sitting with two friends he'd brought

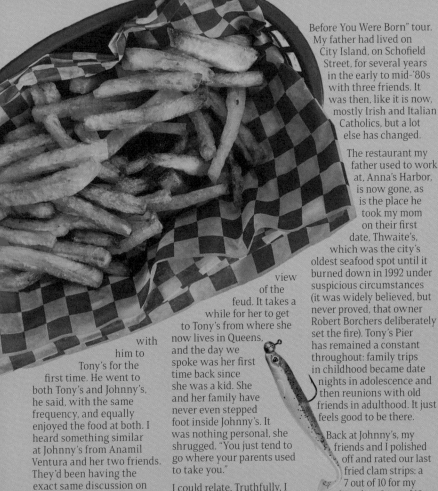

Before You Were Born" tour. My father had lived on City Island, on Schofield Street, for several years in the early to mid-'80s with three friends. It was then, like it is now, mostly Irish and Italian Catholics, but a lot else has changed.

The restaurant my father used to work at, Anna's Harbor, is now gone, as is the place he took my mom on their first date, Thwaite's, which was the city's oldest seafood spot until it burned down in 1992 under suspicious circumstances (it was widely believed, but never proved, that owner Robert Borchers deliberately set the fire). Tony's Pier has remained a constant throughout: family trips in childhood became date nights in adolescence and then reunions with old friends in adulthood. It just feels good to be there.

Back at Johnny's, my friends and I polished off and rated our last fried clam strips: a 7 out of 10 for my friends, a 9 out of 10 for me. We debriefed. The fried calamari at Tony's left a lot to be desired—as did the fries at both spots—but in the end, my friends' favorite dish ended up being the fried shrimp at Tony's. I sighed with relief that I hadn't completely led them astray.

After all the hand-wringing, I never did run into anyone from high school and I cannot definitively say which spot fries up the best seafood. But I think I know why writing about Tony's,

view of the feud. It takes a while for her to get to Tony's from where she now lives in Queens, and the day we spoke was her first time back since she was a kid. She and her family have never even stepped foot inside Johnny's. It was nothing personal, she shrugged. "You just tend to go where your parents used to take you."

I could relate. Truthfully, I don't know why or when we started going to Tony's, but, until that day, I'd never even thought about eating at Johnny's. Growing up, my parents would drive us to City Island from New Rochelle to walk around, eat seafood, and grab ice cream, which was all a pretense for what inevitably came later: the long and winding "Life

with him to Tony's for the first time. He went to both Tony's and Johnny's, he said, with the same frequency, and equally enjoyed the food at both. I heard something similar at Johnny's from Anamil Ventura and her two friends. They'd been having the exact same discussion on the car ride over about which place was better. Ms. Ventura has been coming since she was a kid and thinks they're both about the same when it comes to the fare. Maybe she goes to Johnny's more, she mused mildly, but not for any discernible reason.

Patrice Bradley, who was sitting outside at Tony's, offered a more expansive

Johnny's, and their feud triggers a deep foreboding in me.

In a city where restaurants come and go with increasing frequency, these two storied businesses are living monuments to resilience and to a version of New York that I can no longer see or hear or feel with any definition. Tony's and Johnny's are for working- and middle-class folks, while the city, awash in private and venture capital, is increasingly not. For now, they continue to serve the people they've always served: the people of the Bronx and lower Westchester who have kept them in business for over half a century. That the feud between Tony's and Johnny's still exists means that something of another New York survives. To celebrate this resilience, however, is also to acknowledge the pain and grief that suffuse a city under the influence of extreme capital.

This grief is nothing new; these processes are nothing new. They're the logical inevitability of decades of policy. While the next generation of activists and progressive politicians work to reverse the legacies of the Guilianis and the Bloombergs, Tony's and Johnny's — and the space they create for families, for memories, for generation-

spanning feuds — must be protected in the same way the rest of the city must be protected: Through community and a dogged sense of loyalty.

So you, too, can take a bus across the bridge or drive down to the end of City Island and choose whether to take a left (to Johnny's) or a right (to Tony's). If you take a left, after you've ordered some fried clam strips, make sure to peer over the barrier toward Tony's. You'll see me there and, while you can try to beckon me over, I'll wave and shake my head:
"Absolutely not."

A Eulogy for

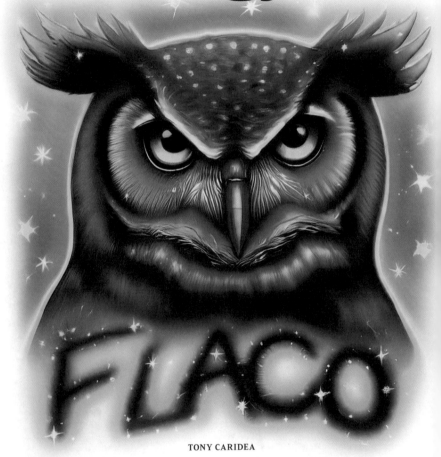

TONY CARIDEA

Early in 2024, we lost Flaco, the Eurasian eagle-owl who flew free for a year through the Manhattan skies. He has already been memorialized so many times and in so many forms: songs, Instagram posts, notes, drawings, murals, tattoos, and at least five different *New York Times* articles. But here, again, are the facts of his story: Flaco was born in captivity in North Carolina and lived most of his life, around 13 years, in an enclosure at The Central Park Zoo. In 2023, he escaped, flying into the silvery February sky, out in the open for the first time in his life. He lived mostly in the wider park at first. He thwarted several attempts at recapture. He was spotted, searched for, worried over, and cheered on by people from all over — the five boroughs and beyond. Monitored by zoo officials, it became clear that Flaco was adjusting well to his new life, catching and eating rats for food. They gave up the hunt, at which point Flaco was truly free. He sojourned to the Upper West Side and spent some weeks down in the East Village, soaking in the warmer weather. Some people would spend hours trying to track Flaco down; others would catch a serendipitous glimpse of him on a street corner when they looked up.

He became something of a mascot for the city, and much was made of his symbolic power: he simultaneously represented the city's immigrant communities and the post-lockdown joy of being back in the world — freedom, connection, resilience. Michiko Kakutani, the beloved former New York Times critic, placed him in a literary tradition of outlaw-heroes. It was undoubtedly Flaco's incredible face, expressive in a way that was impossible not to anthropomorphize, that captivated New Yorkers. In photos, his tufted ears could be upright and rigid, lie flat on his head, or blow freely in the breeze like cow-licks. His orange eyes, flashing under the ridge of his brow and the two fuzzy black plumes atop his head, were sometimes perfectly round, sometimes narrowed, sometimes closed into up-turned crescents, so that Flaco looked by turns shocked, bemused, furious, depressed, thoughtful, and overjoyed.

Flaco died on February 23, 2024, shortly after crashing into a building window on West 89th Street. It is estimated that approximately one billion birds in the United States die per year this way. They collide with the mirror-like glass that falsely promises more trees, more sky. In 2019, New York City passed legislation requiring buildings to take certain preventative measures against bird death. This year, more legislation was introduced, bearing Flaco's name. However, in a postmortem report, Bronx Zoo veterinary pathologists explained that Flaco was already extremely ill before he struck the building, due to ingesting large amounts of rat poison and contracting a fatal disease from eating pigeons. He survived as long as he could, the only one of his kind in an environment that, despite all his admirers, was invariably hostile.

In his life, Flaco was tenacious, brave, and curious. During his year of freedom, he took to perching on ledges and air conditioners and, as all New Yorkers love to do, peering into other people's windows. How lucky those residents were who, to their surprise and delight, saw Flaco's tilted head and speckled body out on the fire escape. And what did Flaco see, when he peered into all those different rooms at all those different people, at their lives, all the colors, shapes, lights, faces?

Thank you, Flaco, for uniting us in an increasingly rare experience: that of collective wonder.

FAUNA

Extinction Obituaries *2022-2023*

In 2023 (at the time of writing, the IUCN Red List has not yet been updated for 2024) we officially lost 75 species, mostly due to conditions created by us humans. Although some of the species we highlight died out years ago, *The Other Almanac* follows the lead of the Red List and goes by the date the extinction was published. Due to this discrepancy in timing as well usage rights the images we use are often of related species, not the species eulogized.

LABRADOR DUCK

CAMPTORHYNCHUS LABRADORIUS

Declared extinct in 2023, last recorded sighting in 1878.

After 145 years, we are ready to say our final goodbye to one of our country's most stereotypically introverted creatures. The Labrador Duck, once described as "the most enigmatic of all North American birds," is no longer flapping its way down the east coast, from Quebec to Maryland. Although we've heard more about their well-known avian cousins-in-extinction, the Passenger pigeon and Great auk, the Labrador duck was our first feathered-friend to go extinct in North America post-colonization.

While human snowbirds flock to Florida, our beady-eyed stocky ducks took their winter vacays on the coastal shores of the land known to Kathy Hochul as "West of Manhattan"—but more commonly as New York's favorite state to hate, New Jersey. It would be slightly easier for us to tell you that the last Labrador duck ever seen was killed and eaten in Hoboken, instead of by a teenager from our very own Elmira, NY. We are all still confused about what one of our beloved ducks was doing so far inland and why anyone was even eating these rare and famously bad-tasting, quick-to-rot birds.

But we did not hunt our charming

birds to extinction; it was our sudden presence post-colonization and the industry that came with us that changed the coastal ecosystem and contributed to a decline in mollusks, clamping down on our pied waterfowl's ability to survive.

We would like to blame their passing on their overly specialized soft-bill, made primarily for shellfish-hunting, sand-digging, and little else, but it's in difficult moments like these that we remember the quiet balance of ecosystems, and that just a few years of our carelessness can undo thousands of years of elegant co-evolution.

NIHO TREE SNAIL
PARTULA NODOSA
Declared extinct in the wild in 2022, reintroduced en masse April 2023.

It's rare for an obituary to be bittersweet, but in the case of the niho tree snail we would like to simultaneously grieve the loss of our tiny, peaceful land snail from its wild occurrence in Tahiti, while keeping our fingers crossed that the 2,413 snails, numbered with reflective paint and released into the valleys and forests where they once slid and slimed, will continue to thrive.

Our spiral shelled, pinky-nail sized, gastropod disappeared solely because of us, more specifically, because of the French government and their desire to have fresh escargot in French Polynesia. In 1967, they brought giant African land snails to Tahiti, these invasive snails escaped and wrought havoc on the native snail populations. Although not ideal, this wasn't the true end for our dear Partulas. In an effort to eradicate the African land snails, and clearly not heeding the message the rest of us learned in kindergarten from "There was an old lady who swallowed a fly," they introduced rosy wolf snails to eat

the African land snails. These new predatory snails ignored the invasive snails and feasted solely on the native snail population.

In 1986 only 26 of our beloved detritivores were still clinging, quaking with fear, to the undersides of the leaves their ecosystem benefitting, snaily-activities, helped flourish. They were scooped up and flown, hopefully first class, to the Detroit Zoo. We are overjoyed to give you some good news for once. After 38 years of care, their children and many generations of great-grandchildren have returned to Tahiti, where they are actually doing pretty well. Some are venturing out to see what the wide-world holds, while others prefer to stay safe and warm in their predator-proof preserves.

JAVA STINGAREE
UROLOPHUS JAVANICUS
Declared extinct in 2023, last recorded sighting in 1862.

We like to celebrate our "firsts"; birthdays, kisses, homes, but today we mourn the loss of the Java stingaree (Urolophus javanicus), the first confirmed marine fish to have gone extinct due to human activities. Some among you may be asking, "What about the smooth handfish?" Although we are not optimists, it would be irresponsible of us to not at least inform you that our grumpy, lumpy, Sympterichthys, with the face of an eternally disappointed grandma, has been delisted from utter annihilation due to

insufficient data.

This past December, exactly 161 years after the first—and only—recorded sighting of the Java stingaree, in a fish market in Jakarta, our flat, crescent-nostriled, venomous-tailed ray was officially declared extinct. Since many years have passed since we've received any news about our diminutive (just 13 leathery inches long) relative of the manta ray, we cannot pinpoint exactly which of our innately destructive activities led to their demise. We suspect that unregulated over-fishing in combination with our all-time-fan-favorite extinction method *habitat destruction* ultimately led to the death of the last Java stingaree to flow gracefully through the Jakarta waters.

FLORA
Extinction Obituaries *2022-2024*

ĀLULA
BRIGHAMIA INSIGNIS
Declared extinct in the wild in 2023.

Alula, Ōlulu, Cabbage on a Stick, Hawaiian Palm, Pū aupaka, or Vulcan Palm: no matter which name you knew them by, our dear bellflower no longer stands tall on the rocky cliffs they once frequented. The last one ever spotted—from out of a helicopter window in 2012, ostensibly by someone with impeccable eyesight—grew in the verdant hills of the Ho'olulu Valley. Sadly, after extensive surveying, they are confirmed to truly be gone.

Alula had almost as many names as it had major threats to its well-being, a veritable laundry list of "how-to-cause-extinction-rates-to-soar"—things like predation and habitat degradation by non-native animals, goats that graze on pretty much anything, causing a marked increase in landslides; and their extreme vulnerability to climate change, hurricanes, and displacement by introduced opportunistic plant species.

Thanks to the international plant trade, botanic gardens, and a random plant store in the Netherlands, thousands of Alula exist in people's homes and gardens. But even though they're thriving in captivity, reintroduction efforts in Hawaii have failed. The concurrent decline in a species of hawk moth, presumed to be our awkward but endearing succulent's only pollinator, has made it impossible for them to reproduce without human intervention.

While we encourage everyone who is close to Alula's surviving grandchildren to hold them near during these hard times, we are broken-hearted to inform you that this joyous, sweet smelling plant, which looks oddly identical to a child's first attempt at drawing a tree, will no longer sway in the wind on the coasts of Kaua'i.

PRIDE OF BURMA
AMHERSTIA NOBILIS
Declared extinct in the wild in 2024.

With the passing of the last wild Pride of Burma, we mourn not only the loss of a rare and special tree, but also that the world has been made a little uglier. Sadly, we didn't know them well, but their lush green foliage and cascading red flowers, pollinated by iridescent purple and yellow sunbirds, will live on in our hearts.

In 1865 one lone Pride of Burma tree was found in Myanmar growing along the Yoonzalin River. We wish we could tell you more about their life, their joys, their accomplishments, and their heartbreaks, but very little is known because this was the only recorded sighting in recorded history. The reason(s) for their disappearance is currently unknown and may never be understood.

If you'd like to pay your respects to their surviving, cultivated kin, you can find them growing in partial shade in many monasteries, temples, and places of worship throughout the tropics.

COLECILLO
DENDROSERIS GIGANTEA
Declared extinct in the wild in 2023.

With tears in our eyes and hearts like lead, we say goodbye to the Colecillo of Alejandro Selkirk Island. The very last of our beloved, wild Asteraceae deep in the understory of the myrtle forest on Selkirk Island, 375 miles off the coast of Chile, died in March 2014.

These palm-like shrubs were found nowhere else in the world and came into existence through one million-ish years of isolated island co-evolution. Colecillo were perfectly adapted for their remote life, until 400 years ago, when us humans docked on their shores. With us came hungry goats, cats, rats, and rabbits looking for snacks and finding them in abundance. Forests were devoured, burnt, or cut for logging, and it was hard for our long-leaved, distant relative of the dandelion, to stay alive.

After all but one lone Colecillo was left standing, biologists and park rangers stood vigil throughout the year, measuring the weather and soil conditions, and collecting enough seeds to plant 50 trees that are safe and sound in a nearby national park. While these patient children wait for the day when all the rats have been poisoned and all the goats shot from helicopters, we hope that the 137 other plant species that can only be found on the Juan Fernándes Islands won't be making an appearance in our pages anytime soon.

TECH

Extinction Obituaries *2023*

SALLY DEWIND

NETFLIX DVDS

1997-2023

It is with heavy hearts that we report the passing of Netflix DVDs. The company sent out their final physical DVD, a copy of the Coen brothers' *True Grit*, in September 2023. In these times of Marvel-ification and the rise of AI, many expressed their nostalgia for the films they were able to discover through the early days of the service. We also mourn that little thrill, that simple, perfect pleasure of getting something good you've been waiting for in the mail.

LIGHTNING
2012-2023

We must announce the death of the Lightning connector, Apple's proprietary charging cable. The European Parliament banned it, in a storm of regulations, requiring all phones to use compatible ports. Apple bolted to its defense, decrying the e-debris that the discontinuation would leave in its wake (as well as the loss of revenue for Apple, no longer able to force iPhone users to exclusively buy their product). But they couldn't strike the ruling down. With thunderous sobs, Apple execs grieve the passing of Lightning.

GOOGLE GLASS
2011-2023

We bid farewell to Google Glass. Google's dream of a screen in every eyeball was shattered in March of 2023, amid many privacy concerns. Among them: Google Glass' potential to steal phone passwords, use facial recognition software, and secretly record people (one program allowed users to take a photo by winking an eye). Google Glass will be remembered for its ability to make a user look simultaneously like a dork and a supervillain, and for contributing a new word to the English language. Rest in peace, glassholes.

Tree Data Across Various U.S. Cities

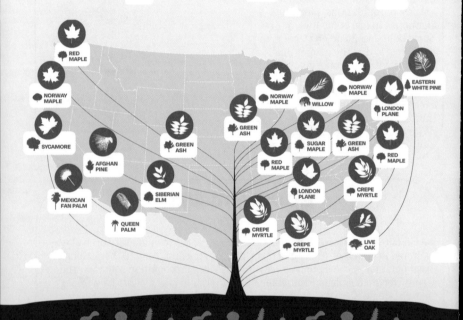

Top Tree Species of American Cities

Seattle, WA · Portland, OR · San Francisco, CA · Los Angeles, CA · Las Vegas, NV · Phoenix, AZ · Albuquerque, NM · Denver, CO · Madison, WI · St. Louis, MO · Houston, TX · Detroit, MI · Louisville, KY · Nashville, TN · New Orleans, LA · Buffalo, NY · New York, NY · Boston, MA · Sioux Falls, SD · Washington, D.C., Durham, NC · Orlando, FL

Data: McCoy, Dakota et al. (2022). A dataset of 5 million city trees from 63 US cities: species, location, nativity status, health, and more. Dryad.

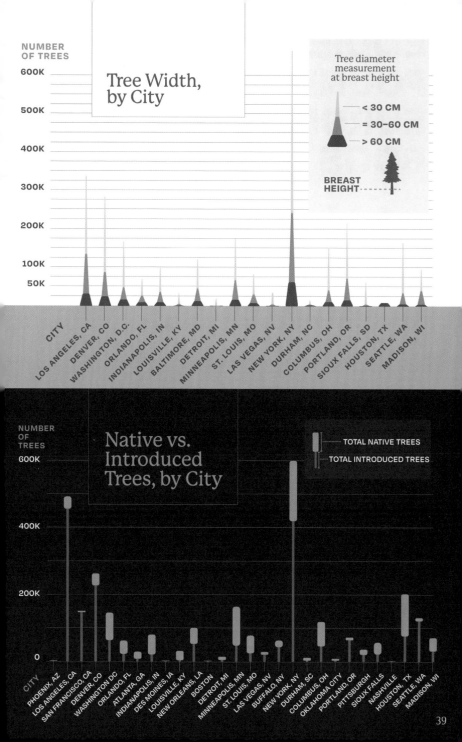

NUMBER OF TREES

Tree Width, by City

Tree diameter measurement at breast height

- < 30 CM
- = 30–60 CM
- > 60 CM

BREAST HEIGHT

600K
500K
400K
300K
200K
100K
50K

CITY

LOS ANGELES, CA · DENVER, CO · WASHINGTON, D.C. · ORLANDO, FL · INDIANAPOLIS, IN · LOUISVILLE, KY · BALTIMORE, MD · DETROIT, MI · MINNEAPOLIS, MN · ST. LOUIS, MO · LAS VEGAS, NV · NEW YORK, NY · DURHAM, NC · COLUMBUS, OH · PORTLAND, OR · SIOUX FALLS, SD · HOUSTON, TX · SEATTLE, WA · MADISON, WI

NUMBER OF TREES

Native vs. Introduced Trees, by City

- TOTAL NATIVE TREES
- TOTAL INTRODUCED TREES

600K
400K
200K
0

CITY

PHOENIX, AZ · LOS ANGELES, CA · SAN FRANCISCO, CA · DENVER, CO · WASHINGTON DC · ORLANDO, FL · ATLANTA, GA · INDIANAPOLIS, IN · DES MOINES, IA · LOUISVILLE, KY · NEW ORLEANS, LA · BOSTON · DETROIT, MI · MINNEAPOLIS, MN · ST. LOUIS, MO · LAS VEGAS, NV · BUFFALO, NY · NEW YORK, NY · DURHAM, SC · COLUMBUS, OH · OKLAHOMA CITY · PORTLAND, OR · PITTSBURGH · SIOUX FALLS · NASHVILLE · HOUSTON, TX · SEATTLE, WA · MADISON, WI

39

BODIES FOUND IN EUROPEAN BOGS

NUMBER OF INDIVIDUALS FOUND

60
30
10
1

INDIVIDUALS FOUND BY COUNTRY

Denmark	Netherlands	Sweden
182	**98**	**94**

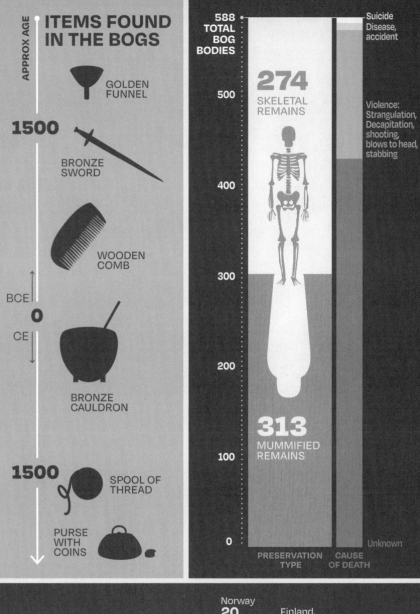

ITEMS FOUND IN THE BOGS

APPROX AGE

GOLDEN FUNNEL

1500

BRONZE SWORD

WOODEN COMB

BCE
0
CE

BRONZE CAULDRON

1500

SPOOL OF THREAD

PURSE WITH COINS

588
TOTAL BOG BODIES

500

274
SKELETAL REMAINS

400

300

200

313
MUMMIFIED REMAINS

100

0

PRESERVATION TYPE

CAUSE OF DEATH

Suicide Disease, accident

Violence: Strangulation, Decapitation, shooting, blows to head, stabbing

Unknown

Germany **74**

United Kingdom **65**

Ireland **46**

Norway **20**

Finland, Poland, Eastonia **3**

Lithuania **1**

41

FIRES

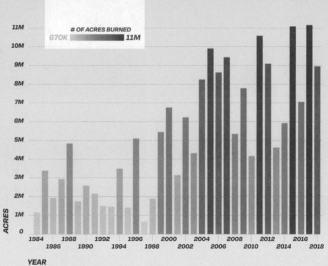

TOTAL ACRES BURNED BY YEAR

OF ACRES BURNED

670K ████ 11M

Y axis: ACRES (0, 1M, 2M, 3M, 4M, 5M, 6M, 7M, 8M, 9M, 10M, 11M)

X axis: YEAR (1984, 1986, 1988, 1990, 1992, 1994, 1996, 1998, 2000, 2002, 2004, 2006, 2008, 2010, 2012, 2014, 2016, 2018)

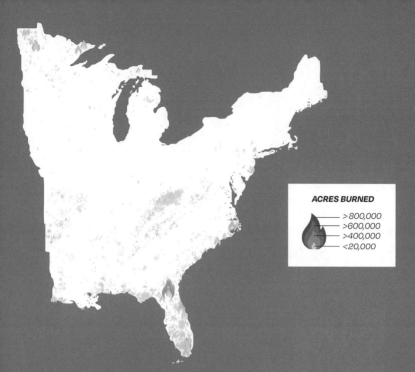

ACRES BURNED

- >800,000
- >600,000
- >400,000
- <20,000

ACROSS AMERICA

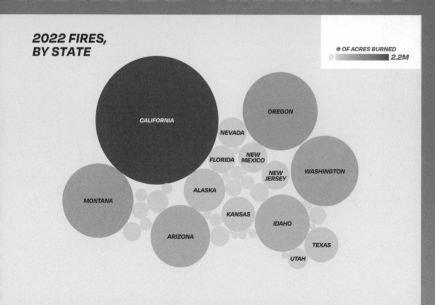

2022 FIRES, BY STATE

OF ACRES BURNED
0 ——— 2.2M

CALIFORNIA
OREGON
NEVADA
NEW MEXICO
FLORIDA
NEW JERSEY
WASHINGTON
MONTANA
ALASKA
KANSAS
IDAHO
ARIZONA
TEXAS
UTAH

Ice Sheet's Ice Loss, 2002–2022

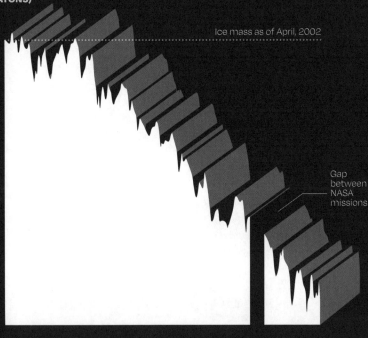

ANTARCTICA'S ICE MASS LOSS (IN GIGATONS)

AVERAGE LOSS
150
billion metric tons of ice per year

Ice mass as of April, 2002

Gap between NASA missions

0
-500
-1000
-1500
-2000
-2500

2002 2006 2010 2014 2018 2022
YEAR

Top 10 baby names in the U.S., 1910–2014

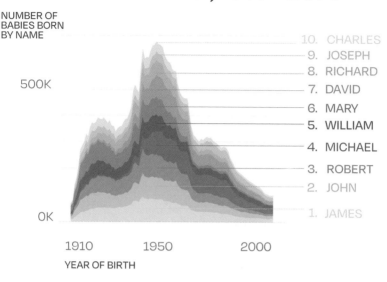

NUMBER OF
BABIES BORN
BY NAME

500K

0K

1910 1950 2000

YEAR OF BIRTH

10. CHARLES
9. JOSEPH
8. RICHARD
7. DAVID
6. MARY
5. WILLIAM
4. MICHAEL
3. ROBERT
2. JOHN
1. JAMES

The most popular of names of the 20th century begin to level off in the early 21st century, when the trend in popular names changes. The top ten names remained similar at the very begnning of the 2000's, but began to shift by the twenty-teens (see the top names of 2010–2014 to the right).

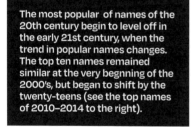

Top 10 baby names, 2010-2014

Sophia	Mason
Emma	Noah
Isabella	William
Jacob	Ethan
Olivia	Jayden

2010 2011 2012 2014

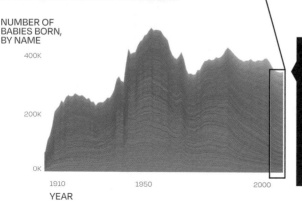

NUMBER OF
BABIES BORN,
BY NAME

400K

200K

0K

1910 1950 2000

YEAR

The graph is charted by name—as time goes on, one can see the top names of mid-century flatten out, and different names start to become popular

Meteor Showers Seen From Northern Hemisphere

zhr = zenithal hourly rate (average)

Quadrantid - Peak: January 2rd - Active: December 28th - January 12th - 110 zhr

Lyrid - Peak April 21st - Active April 14th - April 30th - 18 zhr

Eta Aquarid - Peak May 6th - Active April 19th - May 28th - 40 zhr

Perseid - Peak August 12th - Active July 17th - August 24th - 150 zhr

Orionids - Peak October 21st - Active October 2nd - November 7th - 15 zhr

North Taurids - Peak November 12th - Active October 20th - December 10th - 5 zhr

Leonid - Peak November 17th - Active November 6th - November 30th - 15 zhr

Geminid - Peak December 14th - Active December 4th - December 17th - 110 zhr

Ursid - Peak December 22nd - Active December 17th - December 26th - 10 zhr

New Moons

January 29th 7:35 am
February 27th 7:44 pm
March 29th 6:57 am
April 27th 3:31 pm
May 26th 11:02 pm
June 25th 6:31 am
July 24th 3:11 pm
August 23rd 2:06 am
September 21st 3:54 pm
October 21st 8:25 am
November 20th 1:47 am
December 19th 8:43 pm

Biomass Percentage of Animals on Earth

Arthropods - 46.3%
Fish - 27%
Annelids - 7.7%
Mollusks - 7.7%
Livestock - 3.9%
Cnidarians - 3.9%
Humans - 2.3%
Nematodes - 0.8%
Wild mammals - 0.3%
Wild birds - 0.1%

Full Moons

January 13th 5:26 pm
February 12th 8:53 am
March 14th 2:54 am
April 12th 8:22pm
May 12th 12:55 pm
June 11th 3:43am
July 10th 4:36 pm
August 9th 3:55 am
September 7th 2:08 pm
October 6th 11:47 pm
November 5th 8:19 am
December 4th 6:14 pm

Most Commonly Grown Crops Worldwide

Sugarcane
1.966 billion tons

Rice
1 billion tons

Soybean
388.09 million

Corn
1.4 billion tons

Wheat
907.82 million tons

Cassava
319 million tons

Climate Data

Atlantic Tropical Storms and Hurricanes (2023) - 20 storms
Current Global Carbon Dioxide (CO2) Levels (May 2024) - 425.82 ppm
Current Global Methane (CH4) Levels (January 2024) - 1930.55
Sea Level Rise (September 2022 - September 2023) - .88 cm
Oxygen Level (September 2023) - -727.8 O2 per meg

Equinoxes and Solstices

Vernal Equinox - March 20th 2025 5:01 AM EDT
Summer Solstice - June 20th 2025 10:42 PM EDT
Autumnal Equinox - September 22nd 2024 2:19 pm EDT
Winter Solstice - December 21st 2024 10:03 AM EST

Growing Season NYC

First Frost - October 19th

Last Frost - April 3rd

Growing Season Length 199 days

How to Calculate Temperature Based on Cricket Chirps

FAHRENHEIT: Count how many chirps are heard in 14 seconds and add 40. This is an approximation.

FOR EXAMPLE: 20 chirps + 40 = 60 degrees.

CELSIUS: Count how many chirps are heard in 25 second then divide that number by 3 and then add 4.

FOR EXAMPLE: 36 chirps/3 + 4 = 16 degrees.

Eclipses

Total Solar Eclipse - March 14th, 2025

Partial Lunar Eclipse - March 29th, 2025

Partial List of the 413,100 lbs of Trash and Objects Left on the Moon

125 mini-moons by "artist" Jeff Koons

1 discarded tube that previously contained the American Flag

Thread with the blood of Paul Georgopulos from a needle prick while sewing a protective Kapton foil for the Apollo 11 mission.

1 nickel based time-capsule containing nano engravings of the entirety of Wikipedia, the secrets to David Copperfield's greatest magic tricks, an archive of 7000 human languages and more.

Columbia Sportswear "Omni-Heat Infinity" thermal jacket liners

1 "Moon Museum" (allegedly) ceramic wafer with drawings by Robert Rauschenberg, David Novros, John Chamberlain, Claes Oldenburg, Forrest Myers and Andy Warhol

The ashes of Gene Shoemaker in a capsule inscribed with the words "AND, WHEN HE SHALL DIE, TAKE HIM AND CUT HIM OUT IN LITTLE STARS, AND HE WILL MAKE THE FACE OF HEAVEN SO FINE, THAT ALL THE WORLD WILL BE IN LOVE WITH NIGHT, AND PAY NO WORSHIP TO THE GARISH SUN."

Moon Calendar 2025

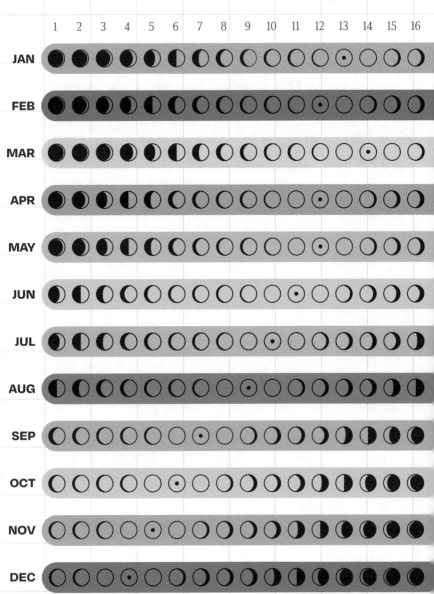

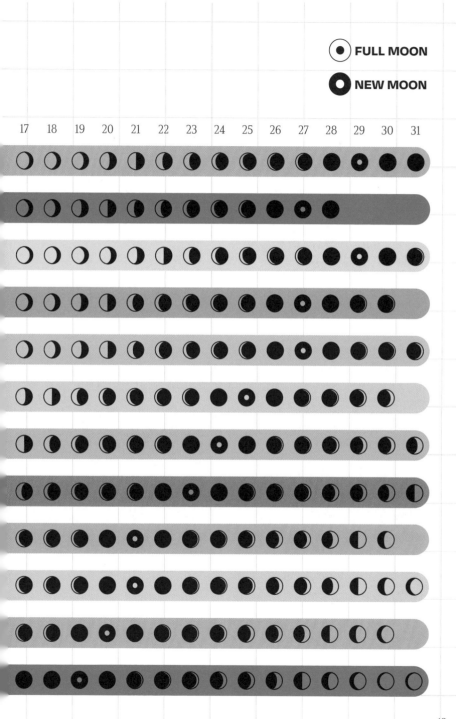

2025

JANUARY

S	M	T	W	T	F	S
			1	3	4	5
5	6	7	8	9	10	11
12	13	14	15	16	17	18
19	20	21	22	23	24	27
26	27	28	29	30	31	

FEBRUARY

S	M	T	W	T	F	S
						1
2	3	4	5	6	7	8
9	10	11	12	13	14	15
16	15	16	17	18	19	20
23	24	25	26	27	28	

MAY

S	M	T	W	T	F	S
				1	2	3
4	5	6	7	8	9	10
11	12	13	14	15	16	17
18	19	20	21	22	23	24
25	26	27	28	29	30	31

JUNE

S	M	T	W	T	F	S
1	2	3	4	5	6	7
8	9	10	11	12	13	14
15	16	17	18	19	20	21
22	23	24	25	26	27	28
29	30					

SEPTEMBER

S	M	T	W	T	F	S
	1	2	3	4	5	6
7	8	9	10	11	12	13
14	15	16	19	20	21	22
21	22	23	24	25	26	27
28	29	30				

OCTOBER

S	M	T	W	T	F	S
			1	2	3	4
5	6	7	8	9	10	11
12	13	14	15	16	17	18
19	20	21	22	23	24	25
26	27	28	29	30	31	

2025 is the year of the Wood Snake and the International Year of Cooperatives and Glaciers' Preservation

MARCH

S	M	T	W	T	F	S
						1
2	3	4	5	6	7	8
9	10	11	12	13	14	15
16	17	18	19	20	21	22
23	24	25	26	27	28	29
30	31					

APRIL

S	M	T	W	T	F	S
		1	2	3	4	5
6	7	8	9	10	11	12
13	14	15	16	17	18	19
20	21	22	23	24	25	26
27	28	29	30			

JULY

S	M	T	W	T	F	S
		1	2	3	4	5
6	7	8	9	10	11	12
13	14	15	16	15	16	17
20	21	22	23	24	25	26
27	28	29	30			

AUGUST

S	M	T	W	T	F	S
					1	2
3	4	5	6	7	8	9
10	11	12	13	14	15	16
17	18	19	20	21	22	23
24	25	26	27	28	29	30
31						

NOVEMBER

S	M	T	W	T	F	S
						1
2	3	4	5	6	7	8
9	10	11	12	13	14	15
16	17	18	19	20	21	22
23	24	25	26	27	28	29
30						

DECEMBER

S	M	T	W	T	F	S
	1	2	3	4	5	6
7	8	9	10	11	12	13
14	15	16	17	18	21	22
21	22	23	24	25	26	27
28	29	30	31			

January

THE 1ST MONTH | 31 DAYS

WOLF MOON

Named for the sound of the hungry howling wolves.

National Soup Month

Key

SUNRISE ☼	SUNSET ☼→
MOONRISE ☽	MOONSET ☾
DAY LENGTH ↔☼	

SUNDAY	MONDAY	TUESDAY	WEDNESDAY	THURSDAY	FRIDAY	SATURDAY
			1	**2**	**3**	**4**
			☼ 7:20 am	☼ 7:20 am	☼ 7:20 am	☼ 7:20 am
			☼→ 4:39 pm	☼→ 4:40 pm	☼→ 4:41 pm	☼→ 4:42 pm
			↔☼ 9:19:35	↔☼ 9:20:22	↔☼ 9:21:12	↔☼ 9:22:07
			☽ 9:01 am	☽ 9:35 am	☽ 10:03 am	☽ 10:28 am
			☾ 6:27 pm	☾ 7:41 pm	☾ 8:54 pm	☾ 10:07 pm
			♒ Aquarius	♒ Aquarius	♒ Aquarius	♓ Pisces
5	**6**	**7**	**8**	**9**	**10**	**11**
☼ 7:20 am	☼ 7:20 am	☼ 7:20 am	☼ 7:19 am	☼ 7:19 am	☼ 7:19 am	☼ 7:19 am
☼→ 4:43 pm	☼→ 4:44 pm	☼→ 4:45 pm	☼→ 4:46 pm	☼→ 4:47 pm	☼→ 4:48 pm	☼→ 4:49 pm
↔☼ 9:23:05	↔☼ 9:24:07	↔☼ 9:25:13	↔☼ 9:26:21	↔☼ 9:27:34	↔☼ 9:28:50	↔☼ 9:30:09
☽ 10:51 am	☽ 11:14 am	☽ 12:32 am	☽ 1:46 am	☽ 3:03 am	☽ 4:19 am	☽ 5:32 am
☾ 11:19 pm		☾ 11:39 am	☾ 12:07 pm	☾ 12:41 pm	☾ 1:23 pm	☾ 2:16 pm
♓ Pisces	♈ Aries	♈ Aries	♉ Taurus	♉ Taurus	♊ Gemini	♊ Gemini

12 ☼ 7:18 am · ☼ 4:50 pm · ☼ 9:31:31 · ☾ 6:35 am · ☾ 3:18 pm · ♋ Cancer

13 ☼ 7:18 am · ☼ 4:51 pm · ☼ 9:32:56 · ☾ 7:28 am · ☾ 4:28 pm · ♋ Cancer

14 ☼ 7:18 am · ☼ 4:52 pm · ☼ 9:34:25 · ☾ 8:09 am · ☾ 5:39 pm · ♌ Leo

15 ☼ 7:17 am · ☼ 4:53 pm · ☼ 9:35:56 · ☾ 8:41 am · ☾ 6:49 pm · ♌ Leo

16 ☼ 7:17 am · ☼ 4:54 pm · ☼ 9:37:31 · ☾ 9:08 am · ☾ 7:55 pm · ♌ Leo

17 ☼ 7:16 am · ☼ 4:56 pm · ☼ 9:39:08 · ☾ 9:30 am · ☾ 8:59 pm · ♍ Virgo

18 ☼ 7:16 am · ☼ 4:57 pm · ☼ 9:40:49 · ☾ 9:50 am · ☾ 10:00 pm · ♍ Virgo

19 ☼ 7:15 am · ☼ 4:58 pm · ☼ 9:42:32 · ☾ 10:08 am · ☾ 11:00 pm · ♎ Libra

20 ☼ 7:15 am · ☼ 4:59 pm · ☼ 9:44:17 · ☾ 10:28 am · ♎ Libra

21 ☼ 7:14 am · ☼ 5:00 pm · ☼ 9:46:05 · ☾ 12:00 am · ☾ 10:48 am · ♎ Libra

22 ☼ 7:13 am · ☼ 5:01 pm · ☼ 9:47:56 · ☾ 1:02 am · ☾ 11:11 am · ♏ Scorpio

23 ☼ 7:13 am · ☼ 5:03 pm · ☼ 9:49:49 · ☾ 2:05 am · ☾ 11:39 am · ♏ Scorpio

24 ☼ 7:12 am · ☼ 5:04 pm · ☼ 9:51:45 · ☾ 3:10 am · ☾ 12:13 pm · ♐ Sagittarius

25 ☼ 7:11 am · ☼ 5:05 pm · ☼ 9:53:43 · ☾ 4:15 am · ☾ 12:57 pm · ♐ Sagittarius

26 ☼ 7:10 am · ☼ 5:06 pm · ☼ 9:55:43 · ☾ 5:16 am · ☾ 1:51 pm · ♐ Sagittarius

27 ☼ 7:10 am · ☼ 5:07 pm · ☼ 9:57:45 · ☾ 6:10 am · ☾ 2:55 pm · ♑ Capricorn

28 ☼ 7:09 am · ☼ 5:09 pm · ☼ 9:59:50 · ☾ 6:56 am · ☾ 4:07 pm · ♑ Capricorn

29 ☼ 7:08 am · ☼ 5:10 pm · ☼ 10:01:56 · ☾ 7:33 am · ☾ 5:23 pm · ♒ Aquarius

30 ☼ 7:07 am · ☼ 5:11 pm · ☼ 10:04:04 · ☾ 8:04 am · ☾ 6:39 pm · ♒ Aquarius

31 ☼ 7:06 am · ☼ 5:12 pm · ☼ 10:06:14 · ☾ 8:31 am · ☾ 7:54 pm · ♓ Pisces

January WINTER

Astrology
MORGAN LETT

Happy New Year, friends! Welcome to January, a month filled with promise, prosperity, and potential for the year ahead. Do your best to surrender to this reset, as the transits could get rocky. With Venus—the planet of love, beauty, and prosperity—slipping into peaceful Pisces on Jan. 2 and Mars Rx entering sensual Cancer on Jan. 6, pay attention to how you can best cater to your emotional needs and prioritize self-nurturing activities this month.

While consistency and discipline are essential ingredients for success, the North Node's entrance into Pisces on Jan. 11 is a gentle reminder that spiritual and emotional growth is equally as important. Take this healing energy as an opportunity to experiment with emotional regulation practices like meditation, yoga, and breathwork. You may have practiced breathwork before, but now you'll really feel the difference. The more you pour into your inner world, the more you will get out during this transit. On Jan. 19, the sun will transition from conservative Capricorn to progressive Aquarius, pulling your focus toward cultivating community and innovation. What social causes have you felt passionate about? What group events or experiences have you been eager to try? The Aquarius new moon on Jan. 29 is an excellent opportunity to implement these new interests.

WHO TATTOO

Phenology Calendar
KAY KASPARHAUSER

In January, black bears go into hibernation. Ancient radiators relentlessly hiss and clang, signaling that cuffing season is officially underway. Apartments are either 10th-street-bathhouse steamy, or there is frost on the inside of the windows; everyone scrambles to find a person whose body heat they can share.

Seasonal Birding

When it is below 40 degrees most people in Brooklyn are not frequenting Brooklyn Botanic Gardens (BBG). If you don't mind the cold, this is a great time to bird New York City's endemic species in relative isolation, uninterrupted by students on a school trip or folks conversing and walking through the garden grounds. With less people out in the cold, you can hear more of the birds' movements and their vocalizing. You may see an American Robin feeding on berries of a Winterberry of English Holly plant. Or a Cedar Waxwing, with their yellow tipped back feathers, feeding on crabapple fruits. On days when snow covers branches, the male Northern Cardinal's vibrant red is a must see seasonal phenomenon. Though I've seen a Bufflehead duck in waters of the Japanese Garden, you won't find many species of waterfowl at BBG. Luckily, Prospect Park is just across the street, and their lakes are home to many species of ducks, gulls, and geese during the winter months.

At Prospect Park lake you're likely to spot Northern Shovelers moving in a circular motion in the water, stirring up food and using their wide beak to scoop (or "shovel") up. I've sat on a bench facing the Lullwater by the Boathouse to enjoy the quiet stillness of the partial frozen lake, watching a Mute Swan curled up, head tucked back in its wings, looking like a large ball of white surrounded by ice. It feels like just me and the birds are outdoors enjoying the cold.

Herbal Tips

ADRIANA AYALES

RECIPE: MUSHROOM MISO IMMORTALITY SOUP

Mineralize the body through the winter for immune protection and longevity! This is the kind of soup you make for serious rejuvenation, recovery and deep immune protection. It can be made with any number of vegetables, mushrooms, seaweeds and/or meats. Feel free to get creative and add what is local and seasonally available to you. The recipe below can act as a base, and you can work your way up from there.

INGREDIENTS:

· 1 large onion, chopped
· 1 medium-bell pepper, sliced
· 4–6 garlic cloves
· 2 teaspoons coconut oil or extra virgin olive oil
· 8 cups water or homemade veggie stock
· 1 large sweet potato, peeled and cut
· 2 large carrots, peeled and sliced into rounds
· A handful of fresh medicinal mushrooms, like maitake, shiitake, lion's mane, or agaricus*
· 1 small piece of fresh ginger, minced
· 1 tsp Chickpea Miso (or miso of choice)
· 2 jujube dates (optional)
· Fresh herbs of choice: cilantro, basil, etc.

In a large pot, sauté the onions, bell pepper, and garlic in oil. Right before they caramelize, add the water or stock. Add the sweet potato, carrots, mushrooms, ginger, ginseng, and dates (optional). Let it simmer for an hour. For variety, you can add other vegetables here, and your choice of protein or seaweed. After 1.5-2 hours, turn the heat off and add the miso *once the heat is off*; stir it in until dissolved. Add your fresh culinary herbs of choice, along with your favorite greens such as kale, sprouts, and/or arugula. Place the top back on for soup to infuse a couple minutes with the heat off. Serve in a bowl and enjoy immediately!

Wilder Sauerkraut

PASCAL BAUDAR

Ingredients

- 1 medium head of cabbage (about 1 3/4 pounds or 1 kilo)
- 1-1.5 tablespoons (15 to 18 grams) of pure salt (sea salt or kosher salt)
- Optional: ¼ pound of shredded wild or store-bought mustard greens.

Equipment

- A large mixing bowl
- A quart-sized (1 L) mason jar (or larger, depending on how much cabbage you have)

Instructions

1. Slice or shred the cabbage and mustard leaves.

2. Salt and Massage
 - Place the shredded cabbage and mustard leaves in a large mixing bowl. Sprinkle the salt over the cabbage. Using clean hands, massage the salt into the cabbage for about 5 to 10 minutes until it becomes watery and limp, as the salt helps extract moisture to create the brine.

3. Pack the Jar
 - Tightly pack the salted cabbage into the mason jar, pressing down to eliminate air pockets and ensure the content is submerged under its own brine. Leave about 1 inch (2.5 cm) of space at the top of the jar.

4. Seal the jar

5. Burp and Shake Regularly
 - Over the next few days, "burp" and "shake" the jar twice daily to release the build-up of fermentation gasses by opening the top briefly and redistribute the brine and cabbage using a clean fork or your fingers. Usually pressing down does the work. Check it periodically to ensure the content remains submerged. Ferment for around 10 days or until there are no more fermentation gasses.

6. Taste and Store
 - Taste the sauerkraut to see if it has reached your desired level of tartness and flavor. Once it's to your liking, store the sauerkraut in the refrigerator with the lid tightly sealed. It will keep for several months.

Sauerkraut is a fantastic source of vitamin C and probiotics. Traditionally sauerkraut was made just before the arrival of Winter and would be stored in the basement for its duration. For added nutrition and flavor, I like to add some of the local wild mustard greens that are still available where I live. You can also purchase regular mustard greens at your local supermarket, but it's not a must.

A Prayer for Burial & Rebirth

SONYA RENEE TAYLOR

Sacred Web of Life, of whose architecture we are both the weaver and the woven, we honor you, knowing that to honor you is to honor ourselves. We cannot be separated from what is us, which means we are indeed the land. We are indeed the water. We are indeed the tree and its flowers. We are indeed the bee and its nectar. We are indeed the song. We are indeed the drum and its insistent pulse. All of this, indeed. Oh, Sacred Life, we offer this prayer not only in word but in deed. And so it is written. And so it is done. Therefore, we call forth that in us that knows genocide is over. Empire is over. Patriarchy, capitalism, colonization, Zionism, the delusion of white supremacy, and hegemony is over.

Profound Life, we are mad and wise enough to thank these horrors for what they have given birth to. Thank you, oh, violent teachers. We have learned from you so that we may never again require such harrowing lessons. Gracious Life, may we know in truth, that we have tired of these weapons of atrocity. May we retire them, for they are from a time before; the grievous time when we did not know we were love.

And so, we, in our wild wonder, no longer judge these pains but lay them at the feet of our own divinity and blanket them with our tears. We bury them here, in the soil of our becoming, not with shame but with reverence. Oh destruction, we place you in the ground, knowing you hold the ready seeds of creation. Oh famine and fear, we lay you to rest here such that bravery and abundance may come forth in this season of our renewal. We offer to the land the marrow of our

discontent such that we might reap joy. Oh Glorious Life, we know so little grace. Teach us. We know so little of wonder. Awe us. We know so little of freedom. Release us of the tyranny of what has been, that we might unlock in ourselves the dormant light of our own miraculous becoming.

May BEING chase us down. May it pursue us with the devotion of new infatuation. May we bow humbly at the altar of change and welcome its birthing; the small bird, the infants yawn, the peonies first petals, the ground soft after a season's rain. May the Grandmother's and Grandfather's wisdom flood the buildings of brick and marble. May we become new by becoming ancient. May we retrieve what was stolen, buried, lost. May a parade of our thriving herald our arrival in every place.

Oh Abundant Verdant Life, may we meet you and kiss your sweet sweet face. May we see you in everything. May we grieve what is ours to grieve, oh Precious Source, such that we might remember what is ours to remember. Relieve us of the malaise of our amnesia. Restore in us the truth of our reflections such that everywhere we look is love. All that we see is love. Oh breath, pulse, heartbeat, Oh Startling Life, reconcile us to love that we might know the truth of ourselves again. May we recall that we are only one thing, have ever been but one thing, and must return to one thing. May we remember that we are love. This I pray in the mighty truth of our oneness.

Aśe, ¡Jallalla!, Amen

I NEED TO BE IN YOUR ARMS

JEFFREY GIBSON

60

February

THE 2ND MONTH | 29 DAYS

Free & Open Source Software Month

Hunger Moon
Named for the scarcity of food at this time of year.

Key

SUNRISE	SUNSET	DAY LENGTH	MOONRISE	MOONSET

SUNDAY	MONDAY	TUESDAY	WEDNESDAY	THURSDAY	FRIDAY	SATURDAY
						1 ☼ 7:05 am ☼ 5:14 pm ☼ 10:08:26 ☽ 8:55 am ☽ 9:08 pm ♓ Pisces
2 ☼ 7:04 am ☼ 5:15 pm ☼ 10:10:40 ☽ 9:18 am ☽ 10:22 pm ♈ Aries	**3** ☼ 7:03 am ☼ 5:16 pm ☼ 10:12:55 ☽ 9:42 am ☽ 11:37 pm ♈ Aries	**4** ☼ 7:02 am ☼ 5:17 pm ☼ 10:15:12 ☽ 10:09 am ♉ Taurus	**5** ☼ 7:01 am ☼ 5:19 pm ☼ 10:17:30 ☽ 12:53 am ☽ 10:41 am ♉ Taurus	**6** ☼ 7:00 am ☼ 5:20 pm ☼ 10:19:50 ☽ 2:09 am ☽ 11:20 am ♊ Gemini	**7** ☼ 6:59 am ☼ 5:21 pm ☼ 10:22:11 ☽ 3:22 am ☽ 12:08 pm ♊ Gemini	**8** ☼ 6:58 am ☼ 5:22 pm ☼ 10:24:34 ☽ 4:27 am ☽ 1:07 pm ♋ Cancer

9
- ☼ 6:56 am
- ☼ 5:23 pm
- ☼ 10:26:58
- ☽ 5:22 am
- ☽ 2:13 pm
- ♋ Cancer

10
- ☼ 6:55 am
- ☼ 5:25 pm
- ☼ 10:29:23
- ☽ 6:06 am
- ☽ 3:22 pm
- ♋ Cancer

11
- ☼ 6:54 am
- ☼ 5:26 pm
- ☼ 10:31:49
- ☽ 6:41 am
- ☽ 4:32 pm
- ♌ Leo

12
- ☼ 6:53 am
- ☼ 5:27 pm
- ☼ 10:34:16
- ☽ 7:09 am
- ☽ 5:40 pm
- ♌ Leo

13
- ☼ 6:52 am
- ☼ 5:28 pm
- ☼ 10:36:45
- ☽ 7:33 am
- ☽ 6:44 pm
- ♍ Virgo

14
- ☼ 6:50 am
- ☼ 5:30 pm
- ☼ 10:39:14
- ☽ 7:53 am
- ☽ 7:47 pm
- ♍ Virgo

15
- ☼ 6:49 am
- ☼ 5:31 pm
- ☼ 10:41:45
- ☽ 8:12 am
- ☽ 8:48 pm
- ♎ Libra

16
- ☼ 6:48 am
- ☼ 5:32 pm
- ☼ 10:44:16
- ☽ 8:31 am
- ☽ 9:48 pm
- ♎ Libra

17
- ☼ 6:46 am
- ☼ 5:33 pm
- ☼ 10:46:48
- ☽ 8:51 am
- ☽ 10:49 pm
- ♎ Libra

18
- ☼ 6:45 am
- ☼ 5:34 pm
- ☼ 10:49:21
- ☽ 9:13 am
- ☽ 11:52 pm
- ♏ Scorpio

19
- ☼ 6:44 am
- ☼ 5:36 pm
- ☼ 10:51:55
- ☽ 9:38 am
- ♏ Scorpio

20
- ☼ 6:42 am
- ☼ 5:37 pm
- ☼ 10:54:30
- ☽ 12:56 am
- ☽ 10:09 am
- ♏ Scorpio

21
- ☼ 6:41 am
- ☼ 5:38 pm
- ☼ 10:57:05
- ☽ 2:00 am
- ☽ 10:47 am
- ♐ Sagittarius

22
- ☼ 6:39 am
- ☼ 5:39 pm
- ☼ 10:59:41
- ☽ 3:01 am
- ☽ 11:36 am
- ♐ Sagittarius

23
- ☼ 6:38 am
- ☼ 5:40 pm
- ☼ 11:02:18
- ☽ 3:58 am
- ☽ 12:34 pm
- ♑ Capricorn

24
- ☼ 6:36 am
- ☼ 5:41 pm
- ☼ 11:04:55
- ☽ 4:47 am
- ☽ 1:42 pm
- ♑ Capricorn

25
- ☼ 6:35 am
- ☼ 5:43 pm
- ☼ 11:07:33
- ☽ 5:28 am
- ☽ 2:56 pm
- ♒ Aquarius

26
- ☼ 6:34 am
- ☼ 5:44 pm
- ☼ 11:10:12
- ☽ 6:01 am
- ☽ 4:13 pm
- ♒ Aquarius

27
- ☼ 6:32 am
- ☼ 5:45 pm
- ☼ 11:12:51
- ☽ 6:30 am
- ☽ 5:30 pm
- ♓ Pisces

28
- ☼ 6:31 am
- ☼ 5:46 pm
- ☼ 11:15:30
- ☽ 6:56 am
- ☽ 6:47 pm
- ♓ Pisces

February

Astrology

Welcome to the month of romance, compassion, and emotional warmth. February's astrological skies offer the chance to deepen connections and express healthy affection regardless of your relationship status. This is especially true since flirty Jupiter—the planet of generosity, abundance, and wisdom—will station direct in thought-provoking Gemini on Feb. 4. After four months of reflecting and refining how you connect with others, Jupiter's forward motion signals a new period of expansion and growth in communication and learning. This direct movement is excellent for relaunching a project, reconnecting with an old friend, or revisiting a previous hobby or pastime. You also have the power to recommit to a romantic interest or release self-doubt during the lively Leo full moon on Feb. 12. Maybe you should text your crush you've been ghosting or wear that sexy outfit you love. What makes you feel fierce and confident? This fiery lunation empowers you to do more of that. Finally, the sun will ease into sleepy Pisces on Feb. 18, granting you permission to end the month (astrological year) on a chill note. Use this intuitive energy to rest and tap into your dreams. What realities are you ready to manifest? Be brave and ask the universe for what you want. There's no limit to what you can achieve.

Herbal Tips

PISCES: THE HEALER, THE DREAMER, SERVICE, THE
MYSTICAL

In medical astrology, the sign of Pisces is governed
by the watery planet Neptune: ruling the pineal,
pituitary and hypothalamus glands which are
essential for metabolism, growth, circadian rhythm,
and more; the limbic system which regulates emotion
and memory; as well as the kidneys and urinary
system which filter and flush toxins from the body.
Pisces is also associated with creativity, intuition,
empathy and the subconscious.

HERBS OF PISCES

Passionflower helps to enhance one's intuitive
abilities + connect with higher states of consciousness.

Lavender resonates with the Pisces gentle +
empathetic nature.

Mugwort enhances dreams and intuition. It can be
enjoyed as a tea, in a ceremonial smoke blend, or
added to herbal vinegars.

Bobinsana helps us access and heal emotional
wounds. It is used in shamanic rituals to facilitate
communication with spirits and the spiritual world.

Kava Kava is a sacred herb from the Pacific Islands.
It's traditionally drunk as a tea in social gatherings
and ceremonies to awaken spiritual insight through
storytelling.

Poppy has a long history of use as a symbol of sleep
and dreams, and is used to calm anxiety.

Calea is traditionally used by the Chontal Indians of
Mexico to obtain divinatory messages during dreaming.
It can also guide you towards inner reflection,
imagination, and soul gazing in your dream world.

Phenology Calendar

In February, raccoons,
minks, river otters,
gray and red foxes,
coyotes, and skunks
all take time off from
their winter hunting
to prowl for partners.
Groundhogs peak out of
their dens and start to
look around, longingly,
after their long winter's
sleep. Perpetual ice
slush collects in
crosswalks and acts
as the city's last line
of defense against the
second installment of
the biannual Fashion
Week invasion. The
slush clings to the
backs of seven inch
heels, the bottoms
of dragging garment
bags; it's tracked into
pristine marble hotel
lobbies and sits front
row at every show.
Those permanent
trash-snow heaps
that the plows leave
behind settle in for six
weeks of resilience,
impervious to weather
or temperature change.

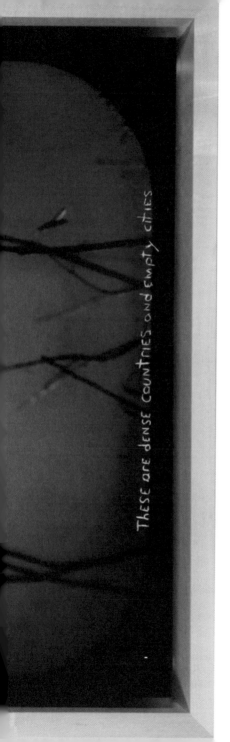

These are dense countries and empty cities

SKY HOPINKA

Phantom Mapping

SPENCER TILGER

It is 1558—the Age of Exploration. European explorers chart the so-called New World and send back maps so the aristocrats on the continent can marvel over their ever-expanding possessions. Most of the lands the Europeans come across have been explored before, lived on before, are living still.

Some of the lands do not exist.

Maps are created using other maps. When one has an error, it gets passed along to those that follow. A stray sea monster here, a rogue island there, the equivalent of geographic gossip. The island of Frisland appears southwest of Iceland in maps as late as the 1700s, despite no claimed sightings since 1560. People are loath to admit error, and cartographers are no different. For years, they mark the phantom as the "submerged isle of Frisland," a splotch of ink near the mouth of the Northwest Passage, that fabled waterway which would allow Europeans to cross the American continent by boat.

As the planet warms and the Arctic sea ice melts, the Northwest Passage is becoming a self-fulfilling prophecy of the colonial imagination. By the end of the 21st century, the formerly unnavigable waters of Northern Canada will be free of ice and full of shipping containers traveling between Europe and Asia, cutting trade routes in half.

"Shorter transport routes means less pollution," says one Norwegian Arctic researcher. Turns out, even climate change can be sold as sustainable.

~

La Isla de Bermeja, a phantom first recorded by Spanish cartographers, resembles a marble that rolled down the eastern coast of Mexico, up the ramp formed by the Yucatán, and then plunged into the depths of the Caribbean sea. Who is to blame for its submergence: volcanoes, earthquakes, the CIA?

It is 2007 and the Mexican government intends to find Bermeja. A country cannot have whole chunks of itself disappearing, after all. But this newfound interest in the underwater island is rooted less in a 500-year-old mystery than in the contemporary quest for oil. If Bermeja *doesn't* exist, Mexico's control over the lucrative waters of the Caribbean could be challenged, even reduced.

Most wealth is founded on dubious claims.

~

In around 1325, the Mexica people see the sign: An eagle, perched upon a prickly pear cactus, carrying a snake in its beak. This will be their capital. They build Tenochtitlan on a series of islands in the middle of Lake Texcoco and expand it by creating chinampas in the shallow lakebed: artificial islands made of mud and compost on which to grow crops. Layer by layer, Tenochtitlan emerges, connected by a complex canal system and series of dams keeping salty water out of the fields.

When the Spanish arrive, they proclaim its gardens and canals the "Venice of the New World," but Tenochtitlan is larger than any European city. In 1521, the Spanish destroy the dams and destroy Tenochtitlan. They then drain the lake, fill in the canals, and

dig deep wells to siphon freshwater to the residents of what is now Mexico City. By the late 20th century, the aquifer is nearly dry and collapsing upon itself, sinking into the phantom lake.

Today, buildings appear tilted. Window panes shatter without warning. Doors won't close. Drainage pipes flow upwards. Window panes shatter without warning.

Miraculously, the central cathedral has sunk less than the rest of the city. Is it the will of God, or perhaps La Virgen? No: the structure was built partially atop the pyramid of Huitzilopochtli and Tlaloc, the sun and rain gods, using stones from the temples of Tenochtitlan.

Islands never truly disappear.

Every country in the world is assigned a distinct Internet domain. In 2000, the Pacific island-nation of Tuvalu sells the licensing rights to its domain—.tv—for $50 million. Using money from the sale, Tuvalu joins the United Nations. At last, the islands have a voice in the international community.

The celebration is tempered by the knowledge that the country's very existence may be short-lived. Tuvalu lies less than four meters above sea level. As carbon floods the atmosphere, more of Tuvalu's shoreline disappears beneath the waves.

Two years later, Tuvalu sues the United States and Australia. Neither country signed the Kyoto Protocol to curb greenhouse gas emissions. The prime minister compares them to terrorists committing his people to a slow death by drowning. Scientists believe the mass murder will occur around 2050.

What will happen to the country's nearly 12,000 citizens?

An exile community forms in Auckland, Aotearoa—aka New Zealand. Long before it was New-anything, Aotearoa was home to the Māori, Polynesians who arrived by canoe around 1250. Today, Tuvaluans migrate by plane on tourist visas. "Overstayers," the New Zealand government calls them. Where else can they stay? In a few years, there will be nowhere to deport them.

Will the cartographers of the future note the submerged islands of Tuvalu?

~

The Svalbard archipelago is administratively part of Norway, but it's a geopolitical anomaly: a visa-free zone in a world of borders.

Most residents are Norwegian; others come from Russia or Ukraine. A pizzeria is run by a pair of brothers from Iran. Many of the cleaners are Thai. Some are asylum seekers whose applications were rejected on the mainland. Few others travel to humanity's northernmost outpost of year-round habitation, where winter temperatures reach -40º Celsius.

The extreme cold is one reason the Norwegian government chooses Svalbard to host the world's "doomsday" seed vault, which opens in 2008 to archive seeds from around the globe. The seeds are buried 120 meters into the mountains and preserved at -18º Celsius for use in case of emergency. However, in 2017, inspectors discover melted permafrost blocking the vault's entrance. They clear the debris and install 24/7 surveillance and flood control.

Doomsday arrives not with a bang but a drip.

Greenland is the world's largest island. It's also the world's largest island colony. An autonomous region of the Kingdom of Denmark, the island is called Grønland in Danish, Kalaallit Nunaat in Greenlandic. 88% of the population is Inuit. 80% of the land is ice.

Greenland has one of the highest suicide rate in the world. One in four young women have attempted suicide, while more than half the population says they've considered it. Most deaths occur in the spring, when the days grow longer and the ice begins to melt.

In 2019, researchers warn that Greenland's ice sheets are melting at four times the rate previously believed. It will soon reach a tipping point, after which stopping further ice loss will be impossible. If the entirety of Greenland's ice melts, global sea levels will rise by 20 feet. Humanity's oil addiction may seem self-destructive, but when Tuvalu sinks beneath the waves, it won't be its own residents—or Greenland's—who caused it.

In the 1950s, the Danish government begins moving the indigenous population from their villages to European-style centralized towns. Some children are taken from their families and sent to Denmark

"The map's full outline can only be discerned from above, but look closer and you'll see: the islands are sinking. Economically, physically, eroding into the sea by 0.2 inches every year."

to learn to become "little Danes." Among other things, the next generations learn to kill themselves. Between 1970 and 1980, Greenland's suicide rate quadruples.

Murder reported as suicide.

In early-2000s Dubai, the impossible feels possible. Using dredged coastline and imported sand, migrant laborers construct artificial archipelagos in the form of increasingly ambitious concepts: palm trees, The World, even The Universe. They are to be the ultimate luxury real estate destination until the 2008 financial crisis tanks property values by 50%. International capital's claim to The Universe is thwarted; construction remains on hold, indefinitely.

The World islands are built, but most of them sit empty. Greenland contains a model villa, while the developers of the so-called Heart of Europe plan to house artificial climates: a rainy street, a snowy plaza, even an underwater living experience—the perfect escape from the city's ever-rising temperatures. Instead of continents, The World is atomized into islands named after countries, regions, even a Formula One driver, each shrunken landmass designed to maximize buyers' access to beachfront property.

The map's full outline can only be discerned from above, but look closer and you'll see: the islands are sinking. Economically, physically, eroding into the sea by 0.2 inches every year.

Soon, The World may no longer exist.

In 2019, UN-Habitat's Executive Director endorses the idea of building floating cities as a climate adaptation strategy. He believes artificial islands could shelter climate refugees in the near future.

It's easier to imagine living on the ocean than stopping what's causing its rise.

A startup developing these archipelagos says its prototype will be the world's first "resilient and sustainable floating community." The floating hexagonal platforms will grow their own organic food through high yield permaculture, and will be tethered to the land like boats during a permanent high tide. One headline declares it the dawn of "humanity's next frontier."

It's often said that a rising tide lifts all boats, but it is never asked who is in the boats, or who is pushed over the sides.

~

Île de Sable, La Nouvelle-Calédonie, France: An address almost specific enough to send a postcard. The whaling ship Velocity "discovers" the island in 1876, and it persists on Google Maps as a series of black pixels until 2012, when Maria Seton, a scientist researching tectonic plates, formally vanquishes the phantom. A month after Seton's "undiscovery," *National Geographic* makes a statement: "Full evidence has finally been presented. 'Sandy Island' has now been officially stricken from all National Geographic map products." The announcement strikes France's colonial possessions shrink by about the size of Manhattan.

Was Île de Sable a trick of the eye, the hallucination of land-starved whalers as far from sanity as they were from home? Perhaps it was a pumice raft, floating agglomerates of ash generated by volcanoes in the Pacific. But why did it endure? These phantom islands haunt maps; they haunt us.

Perhaps you are a phantom. Are you mapped? Who can confirm your existence? Which colonial power has a vested interest in your body?

If full evidence is presented, can you be stricken from this world?

Spilhaus XIX

TAUBA AUERBACH

March

THE 3RD MONTH | 31 DAYS

National Umbrella Month

MARCH 9TH
Spring forward 1 hour.

SUNDAY	MONDAY	TUESDAY	WEDNESDAY	THURSDAY	FRIDAY	SATURDAY
						1 ☿ 6:29 am ♀ 5:47 pm ☿ 11:18:10 ☾ 7:20 am ☾ 8:03 pm ♈ Aries
2 ☿ 6:27 am ♀ 5:48 pm ☿ 11:20:50 ☾ 7:44 am ☾ 9:21 pm ♈ Aries	**3** ☿ 6:26 am ♀ 5:49 pm ☿ 11:23:31 ☾ 8:11 am ☾ 10:39 pm ♉ Taurus	**4** ☿ 6:24 am ♀ 5:51 pm ☿ 11:26:12 ☾ 8:42 am ☾ 11:58 pm ♉ Taurus	**5** ☿ 6:23 am ♀ 5:52 pm ☿ 11:28:53 ☾ 9:19 am ♉ Taurus	**6** ☿ 6:21 am ♀ 5:53 pm ☿ 11:31:34 ☾ 1:14 am ☾ 10:05 am ♊ Gemini	**7** ☿ 6:20 am ♀ 5:54 pm ☿ 11:34:16 ☾ 2:22 am ☾ 11:00 am ♊ Gemini	**8** ☿ 6:18 am ♀ 5:55 pm ☿ 11:36:58 ☾ 3:20 am ☾ 12:04 pm ♋ Cancer
9 ☿ 7:16 am ♀ 6:56 pm ☿ 11:39:40 ☾ 5:07 am ☾ 2:12 pm ♋ Cancer	**10** ☿ 7:15 am ♀ 6:57 pm ☿ 11:42:23 ☾ 5:44 am ☾ 3:21 pm ♌ Leo	**11** ☿ 7:13 am ♀ 6:58 pm ☿ 11:45:05 ☾ 6:13 am ☾ 4:29 pm ♌ Leo	**12** ☿ 7:12 am ♀ 6:59 pm ☿ 11:47:48 ☾ 6:37 am ☾ 5:33 pm ♍ Virgo	**13** ☿ 7:10 am ♀ 7:00 pm ☿ 11:50:30 ☾ 6:58 am ☾ 6:36 pm ♍ Virgo	**14** ☿ 7:08 am ♀ 7:02 pm ☿ 11:53:13 ☾ 7:17 am ☾ 7:37 pm ♍ Virgo	**15** ☿ 7:07 am ♀ 7:03 pm ☿ 11:55:56 ☾ 7:36 am ☾ 8:38 pm ♎ Libra

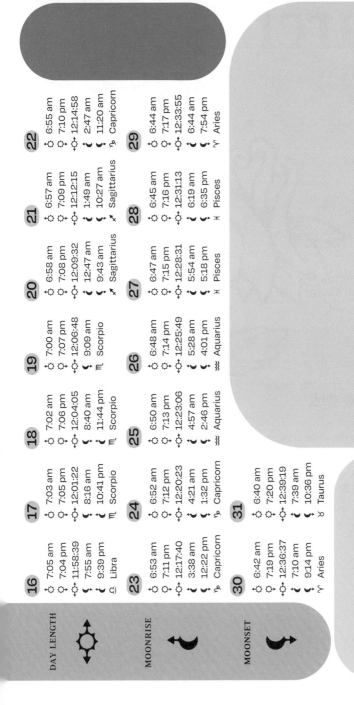

DAY LENGTH

MOONRISE

MOONSET

	16	17	18	19	20	21	22
☼	7:05 am	7:03 am	7:02 am	7:00 am	6:58 am	6:57 am	6:55 am
☼	7:04 pm	7:05 pm	7:06 pm	7:07 pm	7:08 pm	7:09 pm	7:10 pm
↔	11:58:39	12:01:22	12:04:05	12:06:48	12:09:32	12:12:15	12:14:58
☾	7:55 am	8:16 am	8:40 am	9:09 am	12:47 am	1:49 am	2:47 am
☾	9:39 pm	10:41 pm	11:44 pm		9:43 am	10:27 am	11:20 am
	♎ Libra	♏ Scorpio	♏ Scorpio	♏ Scorpio	♐ Sagittarius	♐ Sagittarius	♑ Capricorn

	23	24	25	26	27	28	29
☼	6:53 am	6:52 am	6:50 am	6:48 am	6:47 am	6:45 am	6:44 am
☼	7:11 pm	7:12 pm	7:13 pm	7:14 pm	7:15 pm	7:16 pm	7:17 pm
↔	12:17:40	12:20:23	12:23:06	12:25:49	12:28:31	12:31:13	12:33:55
☾	3:38 am	4:21 am	4:57 am	5:28 am	5:54 am	6:19 am	6:44 am
☾	12:22 pm	1:32 pm	2:46 pm	4:01 pm	5:18 pm	6:35 pm	7:54 pm
	♑ Capricorn	♑ Capricorn	♒ Aquarius	♒ Aquarius	♓ Pisces	♓ Pisces	♈ Aries

	30	31
☼	6:42 am	6:40 am
☼	7:19 pm	7:20 pm
↔	12:36:37	12:39:19
☾	7:10 am	7:39 am
☾	9:14 pm	10:36 pm
	♈ Aries	♉ Taurus

Worm Moon

Named for the earthworms that break through the soil this time of year.

March
SPRING

Seasonal Birding

If winter birding is about solitude, Spring birding is about community. You'll likely spot many birders out in NYCs natural spaces—a pit stop along the Atlantic Flyway, a major migratory corridor for birds—binoculars in tow, following a birdsong for its source, head tilted high, searching the treetops for warblers, small songbirds, making quick movements in the leaves. Many bird clubs and organizations will be scheduling guided group bird walks. They'll be searching for those migratory bird species that are only in town for a short period of time. Some are expected every Spring, and are easily spotted, such as the Prairie Warbler, with its mostly yellow body and black streaks down the sides of its body. Other migratory birds are more difficult to spot and may not stop in your area every Spring. The Orange-Crowned Warbler is one of these, but I was able to spot one in the Native Flora Garden at BBG with my friend. Spring is a great time to take full advantage of well-known hotspots, where many bird species have been spotted. I would recommend birding at Greenwood Cemetery in Brooklyn if only one day during spring. At Greenwood Cemetery, with my community of birders in Brooklyn, I've been able to see nesting Great Horned owls, nesting Bald Eagles, a molting red Summer Tanager, and many other species.

Central Park is also a must bird location during Spring migration, not just for the diversity of species there but for the community of birders that call Central Park home. Notably, on a Spring group outing, I was able to see a male Blackburnian Warbler. This male had a bright orange throat and face and was in the treetop.

Herbal Tips

The liver is like a purification plant for the blood: the more we rid toxins from it, the more we avoid excess build-up that contributes to classic stressors such as lethargy, depressive moods, food allergies, colds and flus, and more. Here are some potent herbal allies for supporting liver health:

Milk Thistle helps to eliminate the buildup of heavy metals, prescription medications, environmental pollutants and alcohol in the liver. The active ingredient silymarin helps to strengthen the cell walls in the liver, while supporting healthy regeneration.

Turmeric is a potent anti-inflammatory which can help reduce joint pain; uplift mood; aid in digestion; help to restore a healthy blood sugar balance; and support healthy liver tissue and liver metabolism.

Dandelion root has a natural diuretic effect, allowing your liver to more quickly eliminate toxins. It also helps to strengthen the immune system, balance blood sugar levels, relieve heartburn, and soothe digestive upset.

Burdock is another option in the same plant family as Dandelions that can help detox your system by cleansing the blood, therefore helping to support liver function.

Pau D'Arco is a powerful blood detoxifier that has liver protective properties, along with being a renowned immune protector. It's also said to help eliminate harmful bacteria while protecting good bacteria in the gut.

Phenology Calendar

In early March, maple syrup begins to flow; it's time to tap, collect, boil, and enjoy. Wisteria begins to bloom. Seeing the pink and purple flowers climb up the sides of Brooklyn brownstones will remind you that you should call your mom, because it's almost Mother's Day. This may bring up a lot of emotional turmoil. You swear to yourself some day you will buy her a brownstone.

Astrology

As we step into March, embrace the energy of transition as we pivot from winter to spring, both in nature and our lives. To begin a month filled with transformation, Venus—the planet of relationships and values—will kick off a six-week retrograde transit through assertive Aries on Mar. 1. Venus's backward motions may prompt you to review how you are asserting your needs and supporting others. Use this energy to have honest conversations with loved ones and reevaluate your priorities. You'll be grateful for the extra self-care and patience once eclipse season officially begins, starting with the total Virgo lunar eclipse on Mar. 14 and ending with the partial Aries solar eclipse on Mar. 29. To close out the month on an upbeat note, the sun will rush into Aries on Mar. 20, inviting you to celebrate the spring equinox and new astrological year. This transit is excellent for setting new intentions, starting projects, and strengthening your body. Focus on bringing your ideas to life by taking practical steps towards them.

Nettle Soup

PASCAL BAUDAR

Nettle soup is packed with nutrients, including vitamins A and C, iron, and protein, which can help boost your immune system and improve overall health. Historically, it was a popular dish in late Winter or early Spring in the old days due to the abundance of nettles in the wild.

Ingredients

- 1 tbsp (15ml) olive oil or butter
- 1 onion, finely chopped
- 1 garlic clove, minced
- 1 celery stalk chopped
- 1 potato, peeled and chopped
- 1 liter (about 4 cups) vegetable or chicken stock
- 400 grams (about 4 cups) fresh nettle leaves, washed and tough stems removed
- Salt and pepper, to taste.
- A splash of cream or yogurt (optional, for serving)
- ¼ teaspoon of nettles seeds from last year per bowl (optional, for serving). Roasted sesame seeds will work too.

Equipment

- Gloves (to avoid getting stung by the nettles!)
- One large soup pot
- One blender (I use an immersion blender, but you don't have to)

Directions

1. Prepare the Nettles

- Wash the nettles thoroughly, removing any tough stems.
- Blanch the nettles in a pot of boiling water for 1-2 minutes to remove the sting. Drain and rinse with cold water to stop the cooking process. Squeeze out excess water and set aside.

2. Cook the Vegetables

- In a large pot, heat the olive oil or butter over medium heat. Add the onion and garlic, sautéing until the onion is translucent.
- Add the chopped celery stalk and potato to the pot and cook for a couple more minutes.

3. Add Stock and Simmer

- Pour in the stock and bring the mixture to a boil. Reduce the heat to a simmer and let it cook until the potato and celery are tender, about 15 minutes.

4. Add Nettles

- Add the blanched nettles to the pot just before you are ready to blend the soup. Let them warm in the hot soup for a minute.

5. Blend the Soup

- Blend the soup until smooth. If you're not using an immersion blender, blend it in batches, and then return it to the pot.
- Season with salt and pepper to taste.

6. Serve

- Serve the soup hot. If desired, add ¼ teaspoon seeds per bowl and a splash of cream or yogurt for extra creaminess.

Unseen

OR ZUBALSKY

I wrote this text in November of 2023 as a response to the assault on Gaza. I felt like the history of paramilitary Zionist violence in British Mandatory Palestine was missing from the public discourse. At the time, an art organization committed to publish this text. After a few months, they informed me that they will not publish the piece. I asked, what version of this text would be considered for publication. The response was, "maybe if the personal narrative was not there." This is a time where critical voices are being silenced both publicly and behind the scenes. I am sharing this text here in hope that it circulates and finds its public.

cw // trauma, violence, murder, ethnic cleansing, genocide

I grew up in a small apartment building in Israel. The building housed twelve families. The kids played together in a field across the street. It used to be a strawberry field. My family lived south of the field. The Shubaki family used to live north of the field.

The Shubaki family was one of many Palestinian families who lived in the area. In the 1920s, the American Zion Commonwealth donated money so Zionist settlers could purchase land in British Mandatory Palestine. Zionist settlers founded my hometown in the area of the villages Alharam, Ijlil, Abu Kishek, Arab al-Akabshe Bedouin, Shitake, and Arab al-Asuat. Growing up, I received a barrage of messaging telling me that the land I was living on used to be barren and empty. I know now this is false. There was active life and culture in the area before the arrival of Zionist settlers. At the peak of the ongoing Palestinian Nakba (Catastrophe) in 1948, hundreds of thousands of Palestinians were displaced. The residents of the various Palestinian villages around my hometown were among them.

On November 20, 1947, Stern Gang terrorists set out to my hometown. The Stern Gang, also known as Lehi (לח״י), was a paramilitary Zionist terrorist organization active in the decades prior to the establishment of Israel. That morning, a few members dressed up in British uniforms and executed members of the Shubaki family. Five people were murdered. I can't find much information about the massacre but I do know where it took place. It was right there, by the north edge of the field.

Three miles from the site of the massacre, in my hometown, there is a street named Lehi, honoring the Stern Gang. Nearby, there is another street named Etzel (אצ״ל), commemorating another prominent

"There was active life and culture in the area before the arrival of Zionist settlers."

Found Israeli highway sign

Zionist terrorist organization active at the same time. Approximately 50% of Israeli cities have streets named after both Lehi and Etzel. There are hundreds of streets named after the leaders of both organizations. Actions carried out by Lehi and Etzel prior to the establishment of Israel have set historical precedent and established the concrete foundation for Jewish settler terrorism. Following the establishment of Israel, Lehi and Etzel leaders went on to become military commanders, prime ministers, and policymakers in Israel. Their legacy is celebrated symbolically on street signs. It is enacted by Jewish settler terrorists in the West Bank, and by present-day Israeli leaders, who follow their footsteps.

Lehi and Etzel members originally belonged to Haganah, the biggest Zionist Jewish militia in Mandatory Palestine. Haganah's policy regarding Palestinian-Zionist tensions in the 1930s was to abstain from retaliatory and indiscriminate violence. Haganah leadership set out to prioritize defense against external threats. The ever-present argument that Israel has the right to defend itself stems from this policy. While this was Haganah's official policy, it is Haganah leaders who formalized "Plan D," which directed Israeli soldiers to expel Palestinians from their homes in 1948, leading to the Palestinian Nakba. The supposed nonviolent Haganah approach, which claims Israel only defends itself against

active external threat, continues to dominate the discourse despite Israel's aggressive displacement of Palestinians in 1948, its occupation of the West Bank and Gaza in 1967, and its continued policies of Palestinian home demolitions and Jewish Settlement building. Roughly 80% of Israeli cities have a street named after Haganah.

Lehi and Etzel members aimed to instill fear in the Palestinian residents of Mandatory Palestine. Their violent activity is well documented. During British rule, members of the organizations kidnapped and assassinated British officers, attacked British embassies abroad, and bombed the British headquarters at King David Hotel in Mandatory Palestine, killing 91 people. While Lehi and Etzel conducted violent resistance to British rule in Mandatory Palestine, most of their actions in the 1930s and 1940s targeted Palestinians. Lehi and Etzel members shot and killed civilians on multiple occasions. They detonated bombs in marketplaces, cafes, movie theaters, and buses. Following Israel's declaration of independence In 1948, Lehi and Etzel were invited to join the newly formed Israeli military. They agreed to join on the condition they could form their own units within the military.

Lehi and Etzel members are responsible for massacres in Palestinian villages, including the Deir Yassin massacre in 1948. In Deir Yassin, members

of the two organizations massacred over a hundred Palestinian residents and caused others to flee in terror. Historian Benny Morris found a report by a witness describing a devastatingly familiar scene: "The conquest of the village was carried out with great cruelty. Whole families—women, old people, children—were killed. ... Some of the prisoners moved to places of detention, including women and children, were murdered viciously by their captors." Word of the Deir Yassin massacre traveled quickly to other Palestinian villages and towns. It was one of many events that created an atmosphere of fear and terror that led many Palestinians to flee their homes. Neither the residents nor their descendants were allowed to return.

During World War II, my Ashkenazi Jewish grandfather left his home to escape the Nazis. When he went back to his family home after the war, he found another family living in it. My grandfather was told by a non-Jewish neighbor that his family members were taken outside their home and were murdered on the street by the Nazis. My three other grandparents are Holocaust survivors as well. Each of them was scarred with trauma I cannot possibly imagine. My mother's parents arrived in Acre in 1948 after the establishment of Israel. My father's parents arrived in 1961. They all had recently lost their home, their family, and their community. They understood their existence to be in jeopardy. They arrived at a place already boiling with violence. They didn't have the time or the space to heal. They passed their trauma to me. I carry it in my body.

I was two years old when the first Palestinian Intifada started and eight years old when it ended. During most of this time, Yitzhak Shamir was Israel's Prime Minister as a member of the Likud party. This is the same political party led by Israel's current prime minister, Benjamin Netanyahu. Yitzhak Shamir's parents and siblings were murdered in the Holocaust. Prior to 1948, Shamir was a member of Etzel, and then he joined Lehi and became one of the organization's leaders. During the years of British Mandatory

Cut Israeli history textbook

Palestine, Shamir was arrested by the British and spent time in prison. In 1948, Shamir helped plan the assassination of Folke Bernadotte, the United Nations representative (chosen to mediate between Palestinians and Zionist Settlers in the Middle East. In response, the provisional government in Israel itself declared Lehi a terrorist

Jewish settlements, stationed in checkpoints around occupied Palestine, or patrolling the wall that was erected around it as a response to the second Palestinian Intifada.

I was fifteen years old when the second Palestinian Intifada started and twenty when it ended. During most of this time, Ariel Sharon was Israel's prime minister as a member of the Likud party. Ariel Sharon's parents escaped the persecution of Jews in Russia in the 1920s and emigrated to British Mandate Palestine. Sharon was the founder of Unit 101, a special force unit of the Israeli army known for raids against Palestinian civilians in 1950s. Members of the unit were responsible for the Qibya massacre, where more than 69 Palestinians, two-thirds of whom were women and children, were murdered. Sharon helped found the Likud party. Sharon also bears personal responsibility for the Sabra and Shatila massacre in 1982 in Beirut. In 2005, Sharon resolved that withdrawing Israeli troops and citizens from occupied Gaza would allow the expansion of Jewish settlements in the West Bank and would allow Israel to hold on to its control of the entirety of Jerusalem. As part of the process, 21 Jewish settlements in Gaza were disbanded. Benjamin Netanyahu led a strong opposition to the move, backed by Jewish settlers in Gaza and the West Bank. Some Jewish settlers wore a Star of David badge to associate their displacement from the Gaza strip with the Holocaust. The following years saw a spike in Jewish settlement building and development in the West Bank. Ariel Sharon passed away in 2014. Roughly 23% of Israeli cities have a street named after him.

"At the age of eighteen, most Jewish citizens become soldiers."

organization. Lehi members were put in prison. A few months later, they were given a state pardon. Yitzhak Shamir passed away in 1992. Roughly 20% of Israeli cities have a street named after him.

When I was in middle school, we went on a field trip in the middle of the night. We went to a nearby beach to reenact a common scenario from British Mandatory Palestine. A third of the students pretended to be the British patrolling the beach, finding and arresting Jewish migrants who entered through the sea illegally. The second group pretended to be Jewish migrants, fearing for their lives. The last group pretended to be members of the paramilitary Zionist groups, aiding migrants and fighting the British. In high school, a year before the age of mandatory military service, most students go on a field trip to spend the night in a military base, doing drills and pretending to be soldiers. At the age of eighteen, most Jewish citizens become soldiers. Many of them remain on reserve forces until they turn forty. They may find themselves guarding

The two Palestinian Intifadas took place during formative years of my life. I found myself surrounded by intense violence without much explanation for why it is taking place. All I knew at the time was that my existence was in jeopardy. I received a barrage of messaging across generations telling me so. The messaging was reinforced by my lived reality. I knew that if I went to the market there was a chance it would explode, if I took a bus there was a chance it would explode, if I went to a restaurant there was a chance it would explode, if I walked outside there was a chance I would be attacked. There was no information available to me to contextualize these events outside of the logic of Zionism and settler colonialism. I had access to various official repositories of memory—Israeli

Cover of "On the Timeline", a teacher handbook retrieved from the Aviezer Yellin Archive of Jewish Education in Israel and the Diaspora, Tel Aviv University Custody. Flipped.

news, state archives, state-approved history curricula—but none of them provided me with sufficient explanations to why I am the target of such violence. On the contrary, they continuously reasserted a narrative of Israeli victimhood and justified Israel's actions.

My own experience and family interactions offered some insight, even though it was often abstract. I was exposed to one family member's severe PTSD on a regular basis. It manifested with such intensity and fractured the family. Witnessing it from up close instilled a deep fear in me that becoming a soldier would destroy me. I recognized similar symptoms, varying in their degree of severity, in so many people around me. Participation in the military scarred people close to me for life. They didn't have the time or the space to heal. I was lucky to be able to avoid it. I was lucky to have a grandmother who was radically kind to any person in need and who held me every day during the first years of my life. I was lucky to have a mother who taught me to see through the fog and cherish the life and dignity of all people, no matter who they are and what circumstances they were born into. I was lucky to be born with a different gender than the one I was assigned, which oriented me towards not belonging, eventually leading to my emigration at the age of 22. I was lucky to have met brilliant and generous teachers and friends where I landed, who cared about me and my wellbeing, supporting me over years of healing.

The actions of Lehi and Etzel were condemned by individuals such as Albert Einstein and Hannah Arendt. The assassination of Folke Bernadotte was condemned. The Qibya massacre was condemned. Yet, the legacy of Jewish settler terrorism is the de facto politics of the ruling ultra-rightwing government of Israel, led by the Likud party. Jewish settler terrorism targeting Palestinians and their homes happens on a daily basis. These incidents used to be condemned by the government, but nowadays they are literally encouraged. The leader of the Likud party, Benjamin Netanyahu, speaks of two role models: Ze'ev Jabotinsky and Menachem Begin. Jabotinsky grew up in between pogroms targeting Jewish people. He founded Revisionist Zionism, which advocated for maximum territorial expansion for Jewish settlers and created the grounds for the establishment of Etzel and Lehi. Menachem Begin's parents and brother were murdered in the Holocaust. He was one of Etzel's leaders before his career in politics. During the 1950s, he was considered a terrorist by the United Kingdom and was not allowed to travel there.

Sara Ahmed writes, "unseen violence is not simply violence that is not seen. Unseen violence is an action. You have to unsee something because it is seen. A complaint can be an effort to make the violence seen, to bring it out. A protest, also, can be an effort to bring the violence out, to make it public by creating a public." It is my hope that by witnessing the settler violence of the past, I can contextualize the settler violence of the present.

Settler colonial violence is enacted on multiple levels, through territorial expansion, demolishing Palestinian homes, physically assaulting Palestinian civilians, limiting access to natural resources, controlling movement of Palestinians, controlling Palestinian trade, threatening and blackmailing LGBTQIA+ Palestinian youth, and having the descendants of 1948 Palestinians live on streets named after the people who had displaced their ancestors. This violence, carried out by a colonizing force against a colonized people who are trying to liberate themselves, is an ongoing event. At this moment, settler colonial violence is happening at a terrifying scale that amounts to ethnic cleansing.

point out the 1929 Hebron Massacre, or the 1938 Tiberias massacre, in which Zionist settlers were targeted by Palestinians, and which had direct influence on the formation and strategy of Etzel. But what kind of context could legitimize mass displacement, dispossession, and death? In 1948, the so-called defensive approach was turned into a direct order calling for mass expulsion of Palestinians. In 2023, this is being repeated. There is no justification for ethnic cleansing. I write about what I know. The past violence enacted by Jewish settlers really did happen. This history is important in understanding the present violence enacted by the Israeli state. The loss is impossible to contain. I stare inwards into the unspeakable memory gap of my own family's history and culture. An early memory emerges from within the gap. I remember the texture of my grandmother's skin as she is holding me. She, too, experienced horrific trauma. Somehow, she managed to witness the suffering of others and respond with defiant compassion. She must have learned that from the people who were close to her. How do I piece my past together so I do not fall into pieces?

When I was ten years old, I was still living in that same building south of the field. A development company bought the land across the street. It started building a complex of tall apartment buildings where

"I mourn what my ancestors and I lost due to the world's inability to act quickly enough"

When I see an oppressed people facing a continuous process of ethnic cleansing, I am confronted with my family's experience in the Holocaust. I mourn what my ancestors and I lost due to the world's inability to act quickly enough. Millions of lives. Generations upon generations of local knowledge and culture. What am I to do with the trauma that continues to reside in me? What does it mean to be from the place that my ancestors fled to and I fled from? I mourn what my ancestors did not and could not know. They did not have the time or space to heal. They arrived as refugees and grew older in a colonizing state ridden with violence. This violence follows the same logic of the violence that harmed them: violence that springs from devaluing and dehumanizing an entire ethnic group.

The violent acts carried out by members of Etzel and Lehi did not happen in a vacuum. Some may say that my accounts of these events are one-sided without enough context. They could

the field stood. The property value of apartments in my hometown skyrocketed. The original plans for the building complex included a new Holocaust museum. More than twenty five years later, the museum has not yet been built due to legal battles. The part of the field reserved for commemoration remains empty.

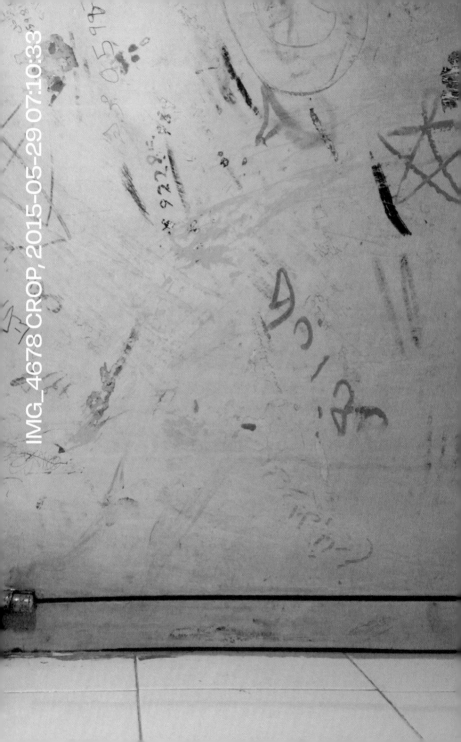

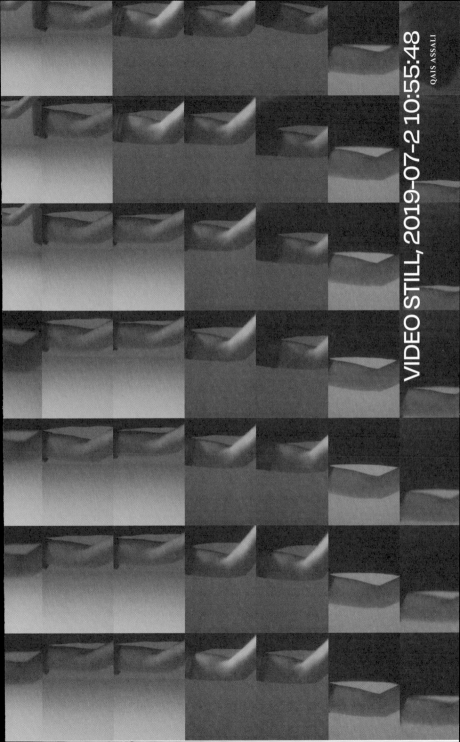

VIDEO STILL, 2019-07-2 10:55:48

QAIS ASSALI

April

THE 4TH MONTH | 30 DAYS

Pink Moon

Named for the pink phlox flowers that begin to bloom.

Key

SUNRISE	☼
SUNSET	☼→
DAY LENGTH	☼↕

SUNDAY	MONDAY	TUESDAY	WEDNESDAY	THURSDAY	FRIDAY	SATURDAY
		1 ☼ 6:39 am ☼→ 7:21 pm ☼↕ 12:42:00 ☽ 8:15 am ☾ 11:57 pm ♉ Taurus	**2** ☼ 6:37 am ☼→ 7:22 pm ☼↕ 12:44:41 ☽ 8:59 am ♊ Gemini	**3** ☼ 6:35 am ☼→ 7:23 pm ☼↕ 12:47:21 ☽ 1:11 am ☾ 9:52 am ♊ Gemini	**4** ☼ 6:34 am ☼→ 7:24 pm ☼↕ 12:50:02 ☽ 2:15 am ☾ 10:55 am ♋ Cancer	**5** ☼ 6:32 am ☼→ 7:25 pm ☼↕ 12:52:42 ☽ 3:06 am ☾ 12:03 pm ♋ Cancer
6 ☼ 6:30 am ☼→ 7:26 pm ☼↕ 12:55:21 ☽ 3:46 am ☾ 1:13 pm ♌ Leo	**7** ☼ 6:29 am ☼→ 7:27 pm ☼↕ 12:58:00 ☽ 4:17 am ☾ 2:21 pm ♌ Leo	**8** ☼ 6:27 am ☼→ 7:28 pm ☼↕ 13:00:39 ☽ 4:42 am ☾ 3:26 pm ♌ Leo	**9** ☼ 6:26 am ☼→ 7:29 pm ☼↕ 13:03:17 ☽ 5:04 am ☾ 4:29 pm ♍ Virgo	**10** ☼ 6:24 am ☼→ 7:30 pm ☼↕ 13:05:54 ☽ 5:24 am ☾ 5:29 pm ♍ Virgo	**11** ☼ 6:23 am ☼→ 7:31 pm ☼↕ 13:08:31 ☽ 5:42 am ☾ 6:30 pm ♎ Libra	**12** ☼ 6:21 am ☼→ 7:32 pm ☼↕ 13:11:08 ☽ 6:01 am ☾ 7:30 pm ♎ Libra

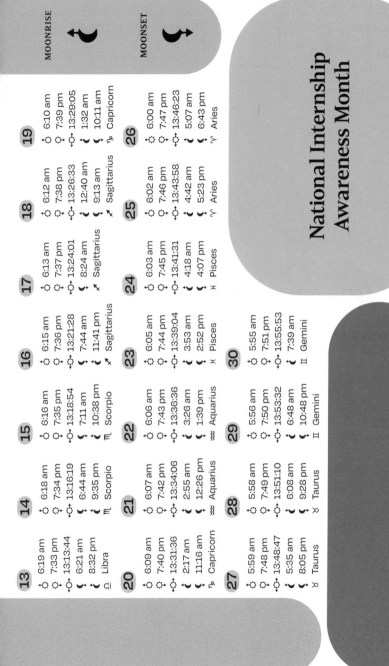

MOONRISE

MOONSET

National Internship Awareness Month

13
☉ 6:19 am
☽ 7:33 pm
☌ 13:13:44
☾ 6:21 am
☽ 8:32 pm
☽ ♎ Libra

14
☉ 6:18 am
☽ 7:34 pm
☌ 13:16:19
☾ 6:44 am
☽ 9:35 pm
☽ ♏ Scorpio

15
☉ 6:16 am
☽ 7:35 pm
☌ 13:18:54
☾ 7:11 am
☽ 10:38 pm
☽ ♏ Scorpio

16
☉ 6:15 am
☽ 7:36 pm
☌ 13:21:28
☾ 7:44 am
☽ 11:41 pm
☽ ♐ Sagittarius

17
☉ 6:13 am
☽ 7:37 pm
☌ 13:24:01
☾ 8:24 am
☽ ♐ Sagittarius

18
☉ 6:12 am
☽ 7:38 pm
☌ 13:26:33
☾ 12:40 am
☽ 9:13 am
☽ ♐ Sagittarius

19
☉ 6:10 am
☽ 7:39 pm
☌ 13:29:05
☾ 1:32 am
☽ 10:11 am
☽ ♑ Capricorn

20
☉ 6:09 am
☽ 7:40 pm
☌ 13:31:36
☾ 2:17 am
☽ 11:16 am
☽ ♑ Capricorn

21
☉ 6:07 am
☽ 7:42 pm
☌ 13:34:06
☾ 2:55 am
☽ 12:26 pm
☽ ♒ Aquarius

22
☉ 6:06 am
☽ 7:43 pm
☌ 13:36:36
☾ 3:26 am
☽ 1:39 pm
☽ ♒ Aquarius

23
☉ 6:05 am
☽ 7:44 pm
☌ 13:39:04
☾ 3:53 am
☽ 2:52 pm
☽ ♓ Pisces

24
☉ 6:03 am
☽ 7:45 pm
☌ 13:41:31
☾ 4:18 am
☽ 4:07 pm
☽ ♓ Pisces

25
☉ 6:02 am
☽ 7:46 pm
☌ 13:43:58
☾ 4:42 am
☽ 5:23 pm
☽ ♈ Aries

26
☉ 6:00 am
☽ 7:47 pm
☌ 13:46:23
☾ 5:07 am
☽ 6:43 pm
☽ ♈ Aries

27
☉ 5:59 am
☽ 7:48 pm
☌ 13:48:47
☾ 5:35 am
☽ 8:05 pm
☽ ♉ Taurus

28
☉ 5:58 am
☽ 7:49 pm
☌ 13:51:10
☾ 6:08 am
☽ 9:28 pm
☽ ♉ Taurus

29
☉ 5:56 am
☽ 7:50 pm
☌ 13:53:32
☾ 6:48 am
☽ 10:48 pm
☽ ♊ Gemini

30
☉ 5:55 am
☽ 7:51 pm
☌ 13:55:53
☾ 7:39 am
☽ ♊ Gemini

April

In April, the daffodils bloom. You'll see people enjoying preemptive wine picnics in Central Park, where everyone will pretend to be less chilly than they are. Wild ramps emerge—you can even smell them in Riverside Park.

Astrology

April's cosmic canvas paints the picture of a fun-filled month of playfulness, optimism, and renewal after an emotionally charged retrograde and eclipse season. Try your best to welcome this much-needed vibe shift and enjoy the lightness this month brings, especially on Apr. 4 when Saturn—the planet of structure and discipline—joins forces with Uranus—the planet of risk and innovation. Together, these two celestial bodies invite you to approach your daily responsibilities and long-term goals with a fresh perspective. With Mercury turning direct in Pisces on Apr. 7, communication becomes clearer, and decisions can be made more confidently. Relationships may also get a reboot when Venus—the planet of prosperity and relationships—ends a six-week backspin and stations direct in generous Pisces on Apr. 7. While growth is inevitable, be kind with yourself and others as the Libra full moon on Apr. 12 encourages you to find balance in your partnerships and let go of lingering conflicts or imbalances. If feeling stagnant, get outside and ground when the sun officially enters earthy Taurus on Apr. 20. Channel this laid-back energy into practical activities such as financial planning, home organization, and enjoying the pleasures of the physical world.

Herbal Tips

Struggling with allergies this season? Turn to Mother Nature's pantry for some much-needed relief! From ancient remedies to modern marvels, these herbal allies are here to help you breathe easy and enjoy the season to the fullest.

RAVENSARA

A lesser-known gem in allergy relief, this essential oil packs a powerful punch against congestion and respiratory discomfort.

MULLEIN

Say goodbye to coughs and congestion with Mullein, a natural expectorant that helps clear the airways and ease breathing.

ELDER

Elderberry's immune-boosting properties make it a must-have during allergy season, helping your body fight off allergens more effectively.

ASTRAGALUS

Strengthen your body's defenses with this adaptogenic herb that enhances immune function and reduces allergic reactions.

GINGER

Spice up your allergy relief routine with this natural antihistamine that can alleviate symptoms like sneezing and nasal congestion.

REISHI

This mushroom superstar isn't just for immune support – it also helps modulate allergic responses, keeping them in check for a more comfortable season.

GOLDENROD

Don't let its golden hue fool you – Goldenrod is a potent ally against allergies, thanks to its anti-inflammatory and decongestant properties.

NETTLE

Last but not least, Nettle is a true herbal hero when it comes to allergy relief. Its natural antihistamine properties can bring fast relief from sneezing, itching, and watery eyes.

Made in India, Found in Egypt

BASEERA KHAN

Future Memory Work

NORA N. KHAN

Memory technologies, sometimes called mnemotechnics, are tools that cultures invent to memorialize, to whisper to the future. Narrative is a type of mnemotechnic device. So are counting objects, memory beads, and engravings on tombs and urns, pictograms around ancient burial sites, and Mesopotamian seals. When we look at a many thousand-year-old burial urn now, it feels timeless. Detailed elements about the dead were left out in favor of an overarching story. One gets a sense that the memory keeper who engraved it knew there would be readers in the future tasked with remembering, actively constructing this past being's memory in the context of their present.

Today computing seems to promise a perfect way to offload our memory work, one of our many cognitive commitments. Our artificial memories seem to stretch on forever, countless moments that we need not actively retain once captured. Each of our endless-seeming data archives offers a promise of everlasting memory, to be retrieved at will. The promise of the artificial storehouse is that our memory storage becomes more complete and secure over time. This posits 'memory' as something entirely held in photographs, in our interactions documented through digital technologies alone.

Of course, we know these archives are not infallible. We lose our phones; e-mail servers are shut down; we lose access to Dropbox accounts. Our outer storehouses are shaky, like all our hardware. But the promise of a 'place' more capacious, more resilient than our minds creates an escape valve: a real or imagined externalized storehouse for offloaded memories.

As with many new and strange experiences with technology, there's often not perfect or even existing terms for the phenomenon. Many people have to observe it, to create contours around it, mark and place it, before it can be named. In the spirit of speculative or predictive wisdom, I want to mark this storehouse as one such phenomenon. Even as we spend time on the aspects of technology we can point to—surveillance, algorithmic overdetermination, automated violence at scale—we might also be curious about the ways our technological devices serve as artifacts that we outsource our memory to, along with many aspects of cognition. This interplay, hard to see and track, has social, psychological, cultural, and political stakes. It changes our relationship to individual and collective memory work.

There are few popular cultural critiques of the mnemonic aspect of technology, on our reliance on these databases for augmentation of our memory. It's unclear how much of a role the consideration of memory plays in the design of technological tools. Rather than focusing on technology's individual tools alone, we might be better served by a theory of the full collection of technologies we use as externalized memory spaces. This is a key point of contestation and self-definition between our social selves and our technical extensions we agonize about. As we offload our memory processing to these external memory spaces, we make them vulnerable to the extractive platforms that hold them. If our individual and collective memory is changing, we might consider the cognitive skills we've developed to hold, retrieve, and interpret all this new information.

Decades after the first dreams of cybernetics, our memories exist in relation to a vast external storehouse of real memories (our photos, our utterances, our footprints intentional and accidental), alongside artificial and generated memories. Now, generative images and media daily enter the slipstream of our shared collective memory. As these images enter our feeds, they shape headlines, news stories, spur snap judgments, and prompt political action. New *kinds* of memories—memories of unreal or generated images, or stories— are collectively constructed in their wake. Even if the 'tell' comes, and the media is shown to have been generated by AI, by machine learning, a new kind of memory has taken root.

When the source material is constructed, not rooted in reality, what does it mean to remember this elusive source? It demands a new category of remembrance. We can't exactly gauge these memories as false or unreal, as they took root in individual minds, and had material effects in the world. What kind of memories, then, are these, of an image embedded in the media glimmer stream as truth, for a day, a week, to then be discarded? Or circulated endlessly, even after proven false?

Artificial memories have long been a staple of science fiction predictions of the future. Think of *Bladerunner* (both versions), in which the hero rehashes implanted memories of childhood. The villains control replicants through management of artificial memories. Offscreen, artificial memory has huge potential in trauma recovery. Scientists studying how memory forms in the brain are using neural networks to decode trauma memory hubs.

In the next few years, AI-generated images, headlines, videos, and a whole range of synthetic 'visual evidence' will shape collective memory alongside 'the real.' Artificial bodies of real actors hop around generated shows, creating memories for real people that are somewhere in the shadowland between real and artificial. Images, visual representations of our memories, are tweaked, polished, Magic Erased, and edited in pursuit of the promise of perfected memories, the mess of life or an unreadable image tucked away, folded behind the cloth. Generative AI smooths,

"**In the next few years, AI-generated images, headlines, videos, and a whole range of synthetic 'visual evidence' will shape collective memory alongside 'the real.'**"

[1] Ursula Franklin, in *The Real World of Technology*, writes that "Technology is not the sum of the artifacts, of the wheels and gears [...] Technology is a system [which] involves organization, procedures, symbols, new words, equations, and, most of all, a mindset." I'm curious, here, about the cognitive aspect of offloading memory, or the *mental work* of memory retrieval, offset to external prostheses.

fills in gaps, adds in sunsets or rain or mist where deemed fit to perfect the past. The memory is aspirational, the way the moment should have been.

As we train to surf the deluge of complex media there is a play, an exchange, between external memory banks and our internal memory landscapes.[1] The smartphone camera roll shows this play clearly. When we find a perfect image we chose to upload to Instagram, unearthed from a buried folder in our archive, we have a mark of what we wished to have looked like, in tones and saturation we'd have preferred, from the angles which we'd originally wished to be seen from. Slowly, we only remember polished images.

Further, machine learning elevates select events and images. At what point do the cognitive devices that allowed us to make and write our internal history, take on new tasks to account for these external memory-shaping operations? Presented with the landscape of generative images and moments, new cognitive skills are necessary to interpret them. These skills embed an awareness of the corporate-owned systems that we shift memories onto, a knowledge of their control and design: an ambient awareness that we must hide aspects of ourselves from and present certain sides of ourselves to these systems.

Naturally, the associations we create with images in our mind are mnemonic devices that correlate to verbal information, to concrete facts and connections. The question of what associations we make with hundreds of images we may capture and upload a day is trickier. This is a relationship of pattern recognition, of scale, of adjustment to scale. The external

storehouse is an extended memory base *and* a different kind of mnemonic device—a synthetic record—which also reflects the tools of our time. The storehouse could be scanned and read post-mortem, far in the future, as it functioned, as an augmentation of our cognitive abilities.

Memory machines which stress capture and totality alter the texture of memory. What we remember is augmented by the promise— true or not — of a transcribed, perfect, immovable memory in code. Our outsourced storehouses are fragile, so when the edited albums and memory retrieval triggers (think of the automated On This Day albums we are fed each day) are removed or lost, we will need to fall back on our minds. One might speculate on whether the new cognitive recall skills developed alongside the externalized storehouse will serve us still, if the archive disappears.

Circling back: a highly edited photo of us seen in the future will always be remarkable just for the embedded study of composition, forms, for the narrative of the moment it took place within, for the emotional landscape represented, for our connections to or exile from the scene represented. In the future, the highly edited photo should also be notable for the way it was edited—with which app, with what type of AI model, adjusting for what type of ideal—and for what was edited away. The edits gesture to both the photograph owner's ideals and the ideals of a culture in a specific time. There might also be a 'spatialized 3D capture' of that moment (at the time of this writing, Apple notes users can "see into a moment" of an image imagined in 3D).

> **"Our memories are actively constructed. They shift in relation to new contexts, experiences, and information."**

Discussions of ML and AI and their increased proficiency in learning by the day have prompted discussions of 'catastrophic forgetting,' in which machine 'memory loss' has become the new block to machine learning progressing. Some researchers note this machine remembering (and forgetting) to be a process akin to human memory, which also loses details over time. Human memories, however, do not just fade or disappear or become 'more blurry,' like a picture becoming smudged. Instead, new details might arise with time. Their narratives shift. Memories evolve and change in meaning. Our memories are actively constructed. They shift in relation to new contexts, experiences, and information. A once unthinkable memory, buried deep, lessens in impact with trauma-informed processing. An embarrassing early memory becomes less cringe with perspective, and maybe even a little grace for one's younger self.

Some critics suggest that in holding our memories in data, in visual evidence, in digital storehouses, we are more likely to sidestep the rich, layered, associative processing that is remembering. When our memories are held in data, we remember less actively; we contextualize the data with less precision. We might step back and look at the underlying claims here: 1) that we had an 'uninterrupted' process of memory-making before the large-scale externalization of photographs as memories, which is now being damaged; 2) that our datasets of photographs *are* our memories, not, instead, prompts for memory retrieval, and 3) that we offload the work of memory to the database, as opposed to having much more complete, 'intact' memories without it.

Taken a step further, a culture's collective memory-making is vigorously shaped by ideology, political movements. Historical knowledge—what is left in the record—is as much riddled with acts of forgetting as remembering. Further, algorithms are socio-technical forces that have their own cultural edits and historical erasures. Algorithms intervene in and construct our memory storehouses, while we collect and upload towards the promise of the 'complete bank' of stored memory.

We might refine our capacity to close-read and scan photographic archives as our own 'source dataset' and turn it to the cultural storehouse, practicing our heightened pattern recognition and retrieval to focus on mood, identifying the gaps between our contextual interpretation and how an LLM 'interprets,' or deems what is worth looking at.

An Eco-Somatic Resilience Practice with Dandelion

CY X

When the sun begins to rise and the heat fills our atmosphere, the Common Dandelion is one of the first plants to emerge from the depths of the soil in the spring. Its bright yellow flowerhead is a visual reminder of changes yet to come, encouraging us to shake off the throes of the winter and embrace a new sense of vitality.

Seasonal changes are an invitation to be in conversation with our inner selves and the way we relate to the worlds around us. It can inspire excitement and renewal but also discomfort and conflict. It also becomes ever more difficult to change with the seasons: how can we follow their lead when our warming climate obliterates the very idea of seasonal change? For the last three years, to help me adjust and attune to the wisdom of the earth, I've leaned on creating eco-somatic practices to prepare my body, mind, and spirit for the energies around me.

Somatics is a practice of embodied transformation that supports us in aligning our individual and collective values and actions. A big part of Somatics is building nervous system resiliency, which according to Staci Haines, the founder of Generative Somatics, is "the ability to somatically, holistically renew ourselves during and after oppressive, threatening, or traumatic experiences." Instead we ask - how might we transform our internal stories, memories, and experiences so that we can move away from numbness, collapse, and hypervigilance?

Observing the Dandelion is also a good way to learn how to build resilience, reflected in its growing patterns. Since it has the reputation of being an unwanted "weed," many humans fight to get rid of them in the name of a perfect lawn, yet they continue to pop up abundantly as if an act of loving defiance. They find refuge in compact spaces, like in cracks on the sidewalk, or in untended fields, spreading as wildly as they please.

They grow nice and bright, harnessing as much sun energy as they can muster and bolstering their nutritive qualities. They represent abundance and second chances—because, unlike other flowers, they get to bloom twice. After harnessing as much wisdom as they can from soil and ether, they take a moment to turn inward, a hermit-like state, before opening back up into the air and spreading their wisdom far and wide.

The Dandelion holds a medicinal bitter taste in its roots and leaves

This practice is specifically designed to help you adjust to the transition from winter to spring, from cold to hot, from stillness to movement. It may also help you if you're experiencing sluggish digestion or spending too much time in a state of inertia.

Everything here is a suggestion meant to be a source of inspiration. Although these practices are designed to be gentle, only you know your body. Remember: anything can be adapted, skipped, or adjusted to meet your needs.

WARM-UP

1. BODY TAPPING

Gently tap, and pat your entire body with your hands, moving from your feet all the way up to your head. Make sure to give attention to the inner side and back of your legs. Use flat palms for the stomach. For your lower back, ball your hands into fists and gently yet firmly rub in a clockwise motion. For your arms and your head, use your fingertips. Imagine with clear intention filling your body with gratitude to bring more energetic flow.

2. SHOULDER ROLLS

Beginning with relaxed arms, shrug your shoulders up towards your ears and then roll backwards. Repeat this motion 6 times before switching to the other direction.

3. NECK ROLLS

Start with a forward gaze; then gently drop your head down and roll slowly to the right, holding for 20 seconds. Bring your head back to a neutral position, take a nice, deep breath, and then gently drop your head down and slowly roll your neck to the left, holding again for 20 seconds.

4. HIP CIRCLES

Bring your hands to your hips. With your feet firmly planted on the ground and shoulder-width apart, rotate your hips in big circles. Repeat this motion at least 6 times before moving in the opposite direction.

5. KNEE CIRCLES

Bring your attention again to your feet, this time placing them together. Introduce a slight bend to the knees, place your hands on your knees and slowly make circles with them. Repeat this motion at least 6 times before moving in the opposite direction.

SEND ROOTS

Close your eyes and deepen your breathing as you prepare to enter your inner worlds. Bring your mind's eye down to your feet, feeling their contact with the Earth beneath you. As you continue to breathe, imagine that your feet have the ability to grow roots, and those roots want to travel into the soil and dirt beneath you, interacting with nutrients, deep time, and ancestral memory.

GATHER ENERGY

1. Begin with your arms by your side and feet now firmly rooted into the Earth beneath you.

2. Raise your arms horizontally with your palms facing the sky. When your hands meet above your head, your palms will temporarily face each other. Hold for 20 seconds and imagine you have the ability to grab energy from the Sun above.

3. Turn your palms to face the earth and slowly begin to lower the palms down in front of your face, chest, belly. Imagine that your hands have the ability to distribute this bright loving solar energy throughout the rest of your body.

4. Repeat this motion three more times and once you are complete, return to a still upright position with your feet firmly planted on the ground.

BLOSSOM

1. Bring your attention to your breath. On your next inhale, stretch upward on your tiptoes, as you move your arms upward toward the sky.

2. As you exhale, twist your body to the left and plant your heels back on the earth, while slowly and deliberately lowering your hands down to your side.

3. Inhale, twisting your body back to a forward neutral position, and stretch again upward to the sky.

4. Exhale, twist your body to the right, and plant your heels back on the earth, while slowly and deliberately lowering your hands down to your side.

5. Do this 6 times.

REFLECT

1. **FORWARD FOLD**

 Shift your arms downward and begin to fold forward, bending at the hips. You can touch your hands to the ground or grab your arms. While in this position, reflect on anything you learned from your first Bloom.

2. **ROLL BACK UP**

 Slowly move upwards, back to a neutral standing position. Once you're standing upright, do a full-body scan. Is there anything you need to let go of or move out of your system in order to show up for yourself and your communities right now?

DISPERSE

Continue this practice, reaching toward the sky, twisting, and pulling the energy back down toward the Earth, but this time allow yourself to travel throughout your space however your body wishes. Imagine that every time you reach upward, you grow and stretch higher into the sky. You are connecting to deep magic; every time you grow, you can infuse that magic into a seed. Continue moving, playing around with speed and distance, eventually coming to a place that you are curious about temporarily settling in.

SEAL ENERGY

1. Send your Roots into this new place.

2. Repeat Body Tapping

3. Take three deep diaphragmatic breaths and thank yourself for showing up.

May

THE 5TH MONTH | 31 DAYS

Milk Moon

Named for the rich and abundant milk of animals eating fresh May growth.

SUNDAY	MONDAY	TUESDAY	WEDNESDAY	THURSDAY	FRIDAY	SATURDAY
				1 ☼ 5:54 am ☼ 7:52 pm ◇ 13:58:12 ☽ 12:00 am ☾ 8:41 am ♋ Cancer	**2** ☼ 5:53 am ☼ 7:53 pm ◇ 14:00:30 ☽ 12:58 am ☾ 9:50 am ♋ Cancer	**3** ☼ 5:51 am ☼ 7:54 pm ◇ 14:02:46 ☽ 1:44 am ☾ 11:01 am ♌ Leo
4 ☼ 5:50 am ☼ 7:55 pm ◇ 14:05:01 ☽ 2:19 am ☾ 12:11 pm ♌ Leo	**5** ☼ 5:49 am ☼ 7:56 pm ◇ 14:07:15 ☽ 2:46 am ☾ 1:18 pm ♌ Leo	**6** ☼ 5:48 am ☼ 7:57 pm ◇ 14:09:27 ☽ 3:09 am ☾ 2:22 pm ♍ Virgo	**7** ☼ 5:47 am ☼ 7:58 pm ◇ 14:11:37 ☽ 3:30 am ☾ 3:23 pm ♍ Virgo	**8** ☼ 5:45 am ☼ 7:59 pm ◇ 14:13:45 ☽ 3:49 am ☾ 4:23 pm ♎ Libra	**9** ☼ 5:44 am ☼ 8:00 pm ◇ 14:15:52 ☽ 4:07 am ☾ 5:23 pm ♎ Libra	**10** ☼ 5:43 am ☼ 8:01 pm ◇ 14:17:57 ☽ 4:27 am ☾ 6:24 pm ♎ Libra
11 ☼ 5:42 am ☼ 8:02 pm ◇ 14:20:01 ☽ 4:49 am ☾ 7:27 pm ♏ Scorpio	**12** ☼ 5:41 am ☼ 8:03 pm ◇ 14:22:02 ☽ 5:15 am ☾ 8:30 pm ♏ Scorpio	**13** ☼ 5:40 am ☼ 8:04 pm ◇ 14:24:01 ☽ 5:45 am ☾ 9:33 pm ♐ Sagittarius	**14** ☼ 5:39 am ☼ 8:05 pm ◇ 14:25:59 ☽ 6:23 am ☾ 10:34 pm ♐ Sagittarius	**15** ☼ 5:38 am ☼ 8:06 pm ◇ 14:27:54 ☽ 7:10 am ☾ 11:28 pm ♐ Sagittarius	**16** ☼ 5:37 am ☼ 8:07 pm ◇ 14:29:47 ☽ 8:05 am ♑ Capricorn	**17** ☼ 5:36 am ☼ 8:08 pm ◇ 14:31:38 ☽ 9:08 am ♑ Capricorn

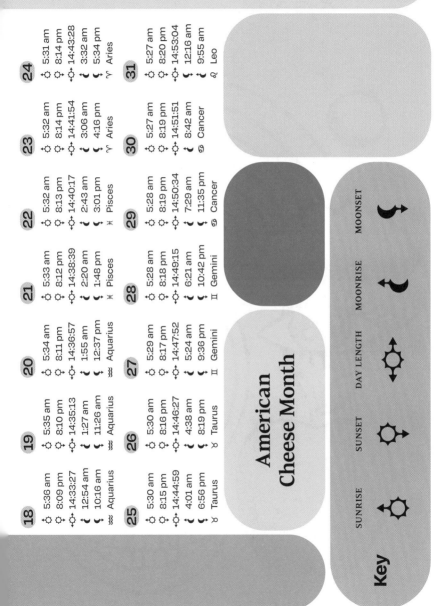

18
- ☼ 5:36 am
- ☼ 8:09 pm
- ☼ 14:33:27
- ☾ 12:54 am
- ☾ 10:16 am
- ♒ Aquarius

19
- ☼ 5:35 am
- ☼ 8:10 pm
- ☼ 14:35:13
- ☾ 1:27 am
- ☾ 11:26 am
- ♒ Aquarius

20
- ☼ 5:34 am
- ☼ 8:11 pm
- ☼ 14:36:57
- ☾ 1:55 am
- ☾ 12:37 pm
- ♒ Aquarius

21
- ☼ 5:33 am
- ☼ 8:12 pm
- ☼ 14:38:39
- ☾ 2:20 am
- ☾ 1:48 pm
- ♓ Pisces

22
- ☼ 5:32 am
- ☼ 8:13 pm
- ☼ 14:40:17
- ☾ 2:43 am
- ☾ 3:01 pm
- ♓ Pisces

23
- ☼ 5:32 am
- ☼ 8:14 pm
- ☼ 14:41:54
- ☾ 3:06 am
- ☾ 4:16 pm
- ♈ Aries

24
- ☼ 5:31 am
- ☼ 8:14 pm
- ☼ 14:43:28
- ☾ 3:32 am
- ☾ 5:34 pm
- ♈ Aries

25
- ☼ 5:30 am
- ☼ 8:15 pm
- ☼ 14:44:59
- ☾ 4:01 am
- ☾ 6:56 pm
- ♉ Taurus

26
- ☼ 5:30 am
- ☼ 8:16 pm
- ☼ 14:46:27
- ☾ 4:38 am
- ☾ 8:19 pm
- ♉ Taurus

27
- ☼ 5:29 am
- ☼ 8:17 pm
- ☼ 14:47:52
- ☾ 5:24 am
- ☾ 9:36 pm
- ♊ Gemini

28
- ☼ 5:28 am
- ☼ 8:18 pm
- ☼ 14:49:15
- ☾ 6:21 am
- ☾ 10:42 pm
- ♊ Gemini

29
- ☼ 5:28 am
- ☼ 8:19 pm
- ☼ 14:50:34
- ☾ 7:29 am
- ☾ 11:35 pm
- ♋ Cancer

30
- ☼ 5:27 am
- ☼ 8:19 pm
- ☼ 14:51:51
- ☾ 8:42 am
- ♋ Cancer

31
- ☼ 5:27 am
- ☼ 8:20 pm
- ☼ 14:53:04
- ☾ 12:16 am
- ☾ 9:55 am
- ♌ Leo

American Cheese Month

Key

SUNRISE	SUNSET	DAY LENGTH	MOONRISE	MOONSET
☼	☼	✛	☽	☾

May

Phenology Calendar

May is morel season. Riverside Park is full of hyacinths and tulips. It rains so much, so often, you won't even notice that the Washington Square Park fountain is turned on.

Astrology

Prepare for a month of revelations and personal growth as May unfolds and the abundant energy of Taurus season continues to bloom. With Pluto stationing retrograde in inquisitive Aquarius on May 4, you may feel invited to dig deeper into your subconscious and address any underlying patterns or issues affecting your social network, technological pursuits, or future aspirations. Fortunately, the Scorpio flower full moon on May 12 supports your desire to confront your emotions and release what no longer serves you. Channel this dramatic energy into confronting hidden truths and embracing uncomfortable transformation. While the first half of the month is ideal for moving at a slower pace, expect a major energetic shift to occur when the sun officially prances into thrill-seeking Gemini on May 20. But that doesn't mean you have to go skydiving or randomly decide to move across the country. Saturn—the planet of restriction and responsibility—will also ingress into a new sign on May 24 when it enters Aries. With Saturn exploring this area of your chart until 2028, consider pursuing new leadership roles and creative ventures. Invest in yourself!

Herbal Tips

SPRING FLOWER MAGIC: BUTTERFLY PEA (CLITORIA TERNATEA)

In Ayurveda, a holistic system of medicine that's been practiced in India for thousands of years, Butterfly Pea Flower tea is called *Anchan* tea. It's used in devotional ceremonies to represent protection, love and peace. It's associated with the powerful Hindu goddess named Aparajita (whose name means "the undefeated one").

In addition to having spiritual significance, Butterfly Pea Flower is full of health-promoting compounds, including antioxidants and anti-inflammatories, as well as pigments that allow it to naturally color foods and beverages.

Butterfly Pea Flower tea is also used for beauty purposes, contributing to healthy-looking skin, hair and eyes. Its rich blue color is utilized as a natural dye. It's sometimes combined with water plus an acidic ingredient, such as lemon, which changes the pH of water, changing its color from rich blue to vibrant violet. Give it a try, it's amazing!

To Know Yourself, Consider Your Doppelgänger

First published in the New York Times, Sept 13, 2023

NAOMI KLEIN

This past July, Merriam-Webster announced on X, the platform formerly known as Twitter, that "'doppelgänger' is currently one of our top lookups."

The doppelgänger—defined by Merriam-Webster as a "person who resembles someone else, or a ghostly counterpart of a living person"—is suddenly unavoidable. Social media platforms are crowded with videos of that moment when a pair of uncanny look-alikes come face-to-face at a friend's wedding or in a Las Vegas swimming pool or on a plane. A Taylor Swift doppelgänger has collected 1.6 million followers on TikTok, and the real Ms. Swift performs multiple alter-ego versions of herself in the "Anti-Hero" video. Rachel Weisz doubles herself in the remake of "Dead Ringers," and Netflix's latest season of "Black Mirror" begins with an episode wherein computer-generated versions of celebrities impersonate ordinary people.

Tere has even been a burst of doppelgänger-on-doppelgänger violence. Last year, a woman in Germany was accused of murdering her glamorous beauty-blogger look-alike with the aim of using the body to fake her own death. And in February, a Russian-born New Yorker was convicted of attempted murder: She had fed poisoned cheesecake to her doppelgänger in hopes of stealing her identity.

Though doppelgängers reliably elicit feelings of vertigo, I find the sudden prevalence of doubles oddly comforting. For years I struggled privately with a problem I considered rather niche: being perennially confused and conflated with another writer and outspoken political analyst named Naomi, Naomi Wolf, even though I bear only a passing resemblance to her. (And I would see the same thing happening to her.) Once best known for best-selling feminist books like "The Beauty Myth" and for a controversial role advising Al Gore's presidential run, Ms. Wolf has more recently distinguished herself as an industrial-scale disseminator of vaccine-related medical misinformation, as well as a fixture on pro-Trump shows like the one hosted daily by Steve Bannon.

I sometimes wondered what I had done to deserve my doppelgänger woes. With popular culture feeling increasingly like a house of mirrors with duplicated and simulated and similar selves endlessly contorted, many more of us may soon be dealing with versions of doppelgänger confusion. What role is this proliferation of doubles, twins and clones playing? Doppelgängers, which combine the

To Know Yourself, Consider Your Doppelgänger

First published in the New York Times, Sept 13, 2023

NAOMI KLEIN

German words "doppel" (double) and "gänger" (goer), are often regarded as warnings or omens.

In an attempt to better understand the warnings carried by my doppelgänger experience, I spent many evenings immersing myself in the rich repertory of doppelgänger films. One that proved particularly helpful was Jordan Peele's "Us." This 2019 horror film imagines a society much like our own, only sitting on top of a shadowy underworld, inhabited by warped doubles of everyone living aboveground. Every move above is mirrored below in darkness and misery. Until the underground doppelgängers get tired of the arrangement and wreak havoc.

Who are these underground people? one terrified character asks.

"We're Americans," comes the gut punch of an answer.

The film has been interpreted as an allegory for capitalism's entanglements with racial and other forms of oppression, with the comforts of the few requiring the exploitation of a shadow world. That understanding landed particularly hard during the pandemic, when I watched the film. Those of us who were part of the lockdown class were able to shelter in place because we were being served by essential workers, many of whom did not have the ability to call in sick. Doubles often play this role, offering viewers and readers uncomfortable ways into their own story. By showing us a character facing her doppelgänger, we are exposed to parts of ourselves we can least bear to see, but at a slight angle and through a warped mirror.

Perhaps that's why representations of doubles seem to surge during moments of extreme violence and change. The first major piece of theoretical work on the subject was an essay, titled "Der Doppelgänger," by the Austrian psychoanalyst Otto Rank, then a protégé of Sigmund Freud. Postulating that doppelgängers were tools to express sublimated desires and terrors, it was written in 1914, just as World War I began. In a reissue of the essay in 1971, Rank's translator, Harry Tucker Jr., wondered, "Is there some relationship between extensive disruptions of society, with their concomitant unsettling effects upon the individual, and the interest of the literate public in descriptions of doubles imaginatively portrayed?"

Certainly, the rise of Nazism and the atrocities of the Holocaust inspired another such wave, as artists deployed doubles to grapple with

"The figure of the doppelgänger has been used for centuries to warn us of shadow versions of our collective selves, of these monstrous possible futures."

the transformation of previously liberal and open societies. Children into soldiers. Colleagues into killers. Neighbors into mobs. As if a switch had been flipped. It's the intimacy and familiarity of these transformations that are so ominous —and what is more intimate and familiar than a person's double?

We are, once again, at a historical juncture where our physical and political worlds are changing too quickly and too consequentially for our minds to easily comprehend. This is why I decided to start regarding my own doppelgänger as a narrow aperture through which to look at forces I consider dangerous and that can be hard to confront directly.

Rather than worry about people thinking that she and I were one and the same, I got interested in the ways she seems to have become a doppelgänger of her former self. Because I have been getting confused with Ms. Wolf for close to a decade and a half, I knew that she had been dabbling in conspiracy culture for years. (I would periodically get harangued online for positions she had taken.)

Before the pandemic, her underlying values seemed somewhat stable: feminism, sexual freedom, democracy, basic liberalism. Then, rather suddenly, they

appeared less so. In a matter of months, I watched her go from questioning masks in schools to questioning election results alongside Mr. Bannon. Next she was engaging in Jan. 6 revisionism, condoning the Supreme Court's assault on abortion rights, posting about her firearms and also warning that "war is being waged upon us."

This is a phenomenon far larger than Ms. Wolf, of course. A great many of us have witnessed it in people we know, once respected and even still love. We tell one another that they have disappeared down the rabbit hole, lost to conspiratorial fantasies, embracing apocalyptic language, seemingly unreachable by affection or reason.

These changes are redrawing political maps, shifting parts of the traditional liberal and New Age left over to the hard right. Trucker convoys in Canada in January 2022. A conspiracy-fueled coup attempt in Germany at the end of that year. The war my doppelgänger keeps warning about in the United States.

Which brings me to the form of doppelgänger that preoccupies me most: the fascist clown state that is the ever-present twin of liberal Western democracies, perpetually threatening to engulf us in its fires of selective belonging and ferocious

despising. The figure of the doppelgänger has been used for centuries to warn us of shadow versions of our collective selves, of these monstrous possible futures.

Have our doppelgängers overtaken us? Not yet, not all of us, anyway. But the pandemic, layered on top of so many other long-repressed emergencies, has taken humanity somewhere we have not been before, a place close but different, a kind of doppelgänger world. This is what accounts for the strangeness so many of us have been trying to name—everything so familiar and yet more than a little off. Uncanny people, upside-down politics, even, as artificial intelligence accelerates, a growing difficulty discerning who and what is real.

That feeling of disorientation—of not understanding whom we can trust and what to believe—that we tell one another about? Of friends and loved ones seeming like strangers? It's because our world has changed but, as if we're having a collective case of jet lag, most of us are still attuned to the rhythms and habits of the place and selves we left behind. It's past time to find our bearings.

Doppelgängers, by showing us the supremacist values and violent behaviors that pose the greatest threats to our societies, can spur us to more stable ground.

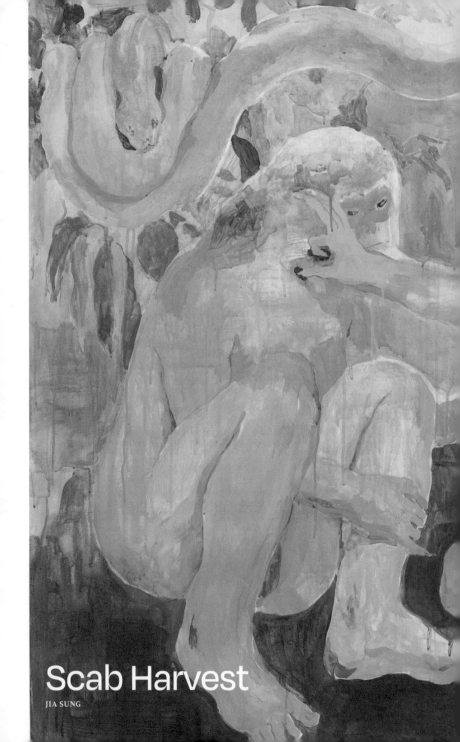

Scab Harvest

JIA SUNG

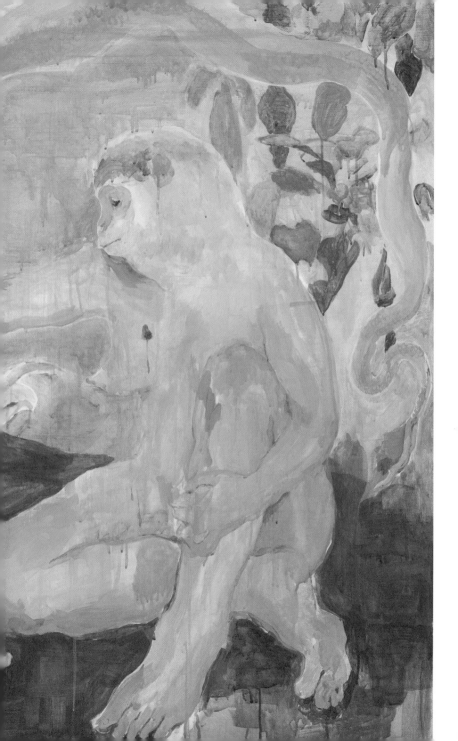

June

THE 6TH MONTH | 30 DAYS

Strawberry Moon
Named for the strawberries that ripen in June.

Key

SUNRISE ☼ SUNSET ☼ DAY LENGTH ☼ MOONRISE ☽ MOONSET ☾

SUNDAY	MONDAY	TUESDAY	WEDNESDAY	THURSDAY	FRIDAY	SATURDAY
1 ☼ 5:27 am ☼ 8:21 pm ☼ 14:54:14 ☽ 12:47 am ☾ 11:05 am ♌ Leo	**2** ☼ 5:26 am ☼ 8:21 pm ☼ 14:55:21 ☽ 1:12 am ☾ 12:11 pm ♍ Virgo	**3** ☼ 5:26 am ☼ 8:22 pm ☼ 14:56:25 ☽ 1:34 am ☾ 1:14 pm ♍ Virgo	**4** ☼ 5:25 am ☼ 8:23 pm ☼ 14:57:26 ☽ 1:53 am ☾ 2:15 pm ♍ Virgo	**5** ☼ 5:25 am ☼ 8:23 pm ☼ 14:58:23 ☽ 2:12 am ☾ 3:15 pm ♎ Libra	**6** ☼ 5:25 am ☼ 8:24 pm ☼ 14:59:17 ☽ 2:32 am ☾ 4:16 pm ♎ Libra	**7** ☼ 5:25 am ☼ 8:25 pm ☼ 15:00:07 ☽ 2:53 am ☾ 5:18 pm ♏ Scorpio
8 ☼ 5:24 am ☼ 8:25 pm ☼ 15:00:54 ☽ 3:17 am ☾ 6:21 pm ♏ Scorpio	**9** ☼ 5:24 am ☼ 8:26 pm ☼ 15:01:38 ☽ 3:46 am ☾ 7:25 pm ♏ Scorpio	**10** ☼ 5:24 am ☼ 8:26 pm ☼ 15:02:18 ☽ 4:22 am ☾ 8:26 pm ♐ Sagittarius	**11** ☼ 5:24 am ☼ 8:27 pm ☼ 15:02:54 ☽ 5:06 am ☾ 9:23 pm ♐ Sagittarius	**12** ☼ 5:24 am ☼ 8:27 pm ☼ 15:03:27 ☽ 6:00 am ☾ 10:13 pm ♑ Capricorn	**13** ☼ 5:24 am ☼ 8:28 pm ☼ 15:03:56 ☽ 7:01 am ☾ 10:55 pm ♑ Capricorn	**14** ☼ 5:24 am ☼ 8:28 pm ☼ 15:04:22 ☽ 8:08 am ☾ 11:29 pm ♒ Aquarius

15
- ☿ 5:24 am
- ☉ 8:29 pm
- ☿ 15:04:43
- ☾ 9:18 am
- ☾ 11:58 pm
- ≈ Aquarius

16
- ☿ 5:24 am
- ☉ 8:29 pm
- ☿ 15:05:02
- ☾ 10:28 am
- ≈ Aquarius

17
- ☿ 5:24 am
- ☉ 8:29 pm
- ☿ 15:05:16
- ☾ 12:23 am
- ☾ 11:38 am
- ⊬ Pisces

18
- ☿ 5:24 am
- ☉ 8:30 pm
- ☿ 15:05:27
- ☾ 12:46 am
- ☾ 12:48 pm
- ⊬ Pisces

19
- ☿ 5:24 am
- ☉ 8:30 pm
- ☿ 15:05:34
- ☾ 1:09 am
- ☾ 2:00 pm
- ♈ Aries

20
- ☿ 5:24 am
- ☉ 8:30 pm
- ☿ 15:05:38
- ☾ 1:33 am
- ☾ 3:15 pm
- ♈ Aries

21
- ☿ 5:25 am
- ☉ 8:30 pm
- ☿ 15:05:37
- ☾ 1:59 am
- ☾ 4:32 pm
- ♉ Taurus

22
- ☿ 5:25 am
- ☉ 8:30 pm
- ☿ 15:05:33
- ☾ 2:31 am
- ☾ 5:52 pm
- ♉ Taurus

23
- ☿ 5:25 am
- ☉ 8:31 pm
- ☿ 15:05:25
- ☾ 3:12 am
- ☾ 7:11 pm
- ♊ Gemini

24
- ☿ 5:25 am
- ☉ 8:31 pm
- ☿ 15:05:14
- ☾ 4:03 am
- ☾ 8:23 pm
- ♊ Gemini

25
- ☿ 5:26 am
- ☉ 8:31 pm
- ☿ 15:04:58
- ☾ 5:06 am
- ☾ 9:22 pm
- ♋ Cancer

26
- ☿ 5:26 am
- ☉ 8:31 pm
- ☿ 15:04:40
- ☾ 6:18 am
- ☾ 10:08 pm
- ♋ Cancer

27
- ☿ 5:27 am
- ☉ 8:31 pm
- ☿ 15:04:17
- ☾ 7:33 am
- ☾ 10:44 pm
- ♌ Leo

28
- ☿ 5:27 am
- ☉ 8:31 pm
- ☿ 15:03:51
- ☾ 8:46 am
- ☾ 11:12 pm
- ♌ Leo

29
- ☿ 5:27 am
- ☉ 8:31 pm
- ☿ 15:03:21
- ☾ 9:55 am
- ☾ 11:36 pm
- ♍ Virgo

30
- ☿ 5:28 am
- ☉ 8:31 pm
- ☿ 15:02:47
- ☾ 11:01 am
- ☾ 11:57 pm
- ♍ Virgo

National Pollinators Month

June
SUMMER

Seasonal Birding

Summer is a great time to bring your binoculars with you to those seasonal NYC destinations. Not only have I seen dolphins at a Rockaway beach in Queens, but I was able to lay on the sand while watching American Oystercatchers search the rocks for, well, oysters. Their long bright orange reddish bill makes them easy to identify. It's also a great time to see Double-Crested Cormorants. You're likely to see these black birds diving for fish, then holding their wings out to dry in the sun on the rocks.

Governors Island is also a great place to bird whilst enjoying the island's other attractions. I saw my first Killdeer here. This shorebird, with two black bands on its breast, was walking the paved path between trees, possibly searching for insects. There are many Barn Swallows flying fast over the long grass catching insects. If you make your way to the shoreline, you'll likely see Common Terns with their black cap and reddish bill flying over the water.

Along with birding on vacation, Summer is also a great time to bird your "backyard" and learn the field markings of those common in your area. This may mean noting the brown striking on a Song Sparrow or listening to the many sounds of a Blue Jay so when other species arrive in the Fall, you can use a process of elimination to identify species that are new to you.

Astrology

Prepare for a dynamic month ahead as June's planetary movements inspire a sense of emotional depth and spontaneity within the collective. While Gemini season is top-tier for supporting your favorite local artists, testing out new coffee shops, and checking new destinations off your bucket list, Jupiter's big move into domesticated Cancer drops a spotlight on your private life. Whether you channel this energy into deepening familial relationships, creating a harmonious home environment, or exploring personal development through introspection, Jupiter in Cancer offers you expansion through consistent nurturance, not excessive ideation. Thankfully, speaking and following your truth will come easier on Jun. 11 once the straightforward Sagittarius full moon illuminates the sky. This fearless full moon energy can be used to pursue educational opportunities, travel, or engage in philosophical discussions that widen your perspectives. Keep in mind that a restrictive square between Saturn and Jupiter on Jun. 15 urges you to find a middle ground between optimism and practicality. Seek calm and quiet spaces to retreat and relax once Cancer season kicks off on Jun. 20. Prioritize regulating your nervous system instead of trying to accomplish all your summer goals simultaneously. Less is more!

Phenology Calendar

Roses start to flower in June. School is out and a jubilant, mischievous adolescence fills the air. Ice cream trucks emerge from their winter hibernation and chirp loudly on corners. In 1966, on 72nd and Central Park West, Rosemary Woodhouse bore the child of the devil. Mulberries are ready for picking, baking, and jarring. This is your last chance to use a NYC park bathroom for the next three months, as the lines will be ten to fifteen people long, through the rest of summer.

Herbal Tips

RECIPE: HIBISCUS MANGO SWIRLED POPSICLES

Embrace the essence of summer with our Hibiscus Mango Swirled Popsicles! As the warmer months approach, harness the cooling properties of Hibiscus and the luscious sweetness of Mango to create a perfect summer treat. *Makes 10 popsicles*

INGREDIENTS

MANGO LAYER

- 2 1/2 cups cubed mango (fresh or frozen) (375g)
- 3/4 cup full fat canned coconut milk (80g)
- 1 heaping Tbsp Belly Love powder
- 1 Tbsp honey

HIBISCUS BERRY LAYER

- 2 1/2 cups red fruits, such as strawberries, raspberries or cherries (fresh or frozen) (375 g)
- 1/3 cup water (80g)
- 1 Tbsp Mangosteen Hibiscus powder
- 2 Tbsp honey

INSTRUCTIONS

MANGO LAYER

Add mango, coconut milk and Belly Love to a blender. Puree until completely smooth, adding additional coconut milk as needed. Pour the mango mixture into a liquid measuring cup or small pitcher and set aside while you make the red layer.

HIBISCUS BERRY LAYER

Mix together water and Mangosteen Hibiscus powder. Add red fruits, Mangosteen Hibiscus liquid, and honey to a blender. Puree until completely smooth.

ASSEMBLE

Alternate scoops of the mango mixture and the red berry mixture into popsicle molds. Insert popsicle sticks and freeze until completely solid, about 3-4 hours. To remove popsicles from the popsicle mold, run the sides of each well of the popsicle mold under cool water for a few seconds, then gently wiggle the popsicle stick side to side to loosen the pop. Enjoy!

Elderflower Sparkling Wine

PASCAL BAUDAR

Equipment

- One large bowl
- One fermentation container (jar?)
- Recycled soda bottles or swing-top glass bottles

Ingredients

- 1/2 gallon water (use 2 liters)
- 250 to 300 gr (1 1/2 cup) white sugar
- 1-2 lemons, zested and sliced
- 1 tablespoon vinegar (I use apple cider vinegar)
- 15 large flower heads from Mexican elder or 10 flower heads from regular elder trees.
- Champagne or wine yeast (optional – Wild yeast is usually present on the flowers)

Instructions

1. Pick the elderflowers when they're fresh and full of pollen. I remove the stems as much as possible. Place the flowers in a bowl outside for an hour to let the little bugs vacate.

2. Place water in a container, add the sugar and stir with a clean spoon to make sure it is dissolved.

3. Add lemon zest and lemon slices, the elderflowers and vinegar to the container and stir briefly with a clean spoon. Some people add yeast at this stage.

4. Close the container but not so tight that fermentation gases can't escape or place a clean towel on top.

5. Let it stand anywhere between 24 to 48 hrs. If you didn't use yeast, you should see some bubbles indicating the fermentation from wild yeast is active. If this doesn't occur, then add some commercial champagne yeast and let it ferment for another 3-4 days.

6. Personally, I like to strain it after 48 hrs then let the fermentation go for another 4 days.

7. Bottle in recycled soda bottles or swing-top glass bottles. Let it ferment for a week before enjoying. You can check the pressure from time to time by unscrewing or opening slightly the bottle to make sure it's not excessive.

Baby, Bird

INDIGO GOODSON-FIELDS

As two Common Nighthawks flew over the lake at Prospect Park, I screamed and laughed with excitement. My son, who was only 5 months old at the time, giggled at my reaction to seeing this species of hawk for the first time, a lifer. Dusk was approaching, and my husband, Justin, sat with our son on his lap on the low stone wall that lines the edge of the lake across from the skating rink. I stood up, focusing on the patch of white that adorns each long wing of this hawk named for the time of day it's most active. The Common Nighthawk had been elusive to me for a couple years, which made me want to spot it even more.

I love catching glimpses of feathers, a silhouette, or a familiar birdsong, and searching through my proverbial bird file for an ID. The first time I catch a glimpse of a species I haven't seen before is exhilarating, but even when it's a one I've already seen many times, there are always new angles from which to view a bird, and new bird behaviors (new to me at least) that I've yet to see. Over the past two years, I've become obsessed with the bird species in my area that I haven't seen yet. Some birders refer to these as their nemesis birds: Those species that, by all statistical probability, you should have seen by now, but still they

elude you. In the case of the Common Nighthawk, it's not that I had been tirelessly searching for it, but I knew it was most active at dusk and dawn, when I'm usually not birding—at least lately.

These past two years have also been marked by the constant nausea and weakness I felt while pregnant, the pain and discomfort I felt for weeks after giving birth, and the exhaustion and adjustment to being a full-time caregiver to my beautiful child. He seemed to respond to my energy. When I came down with COVID-19, he laid by my side as if to stave off my fatigue, and his eyes seemed sympathetic to my discomfort. When I was mostly a solo birder, I spent long periods of time staring at a bush, tree, or patch of ground at Brooklyn Botanical Garden (BBG) searching for movement from what would likely be a Winter Wren or Chestnut-sided Warbler. I stood in one place and scanned the open skies of the Cherry Esplanade to spot a Bald-eagle. I went out in 20 degree weather, fingers and feet numb with cold, and in the summer, drenched in sweat and ridden with mosquito bites. I committed my time to birding with little regard for my own comfort. The anticipation and joy I felt out there superseded

any discomfort I felt outdoors. Once I had my son, his comfort became paramount.

I gave birth in the early part of Spring migration, the time of year when you can see about 80 bird species in one day. So yes, I was birding at BBG with my mom the day before I went into labor. I wanted to see every migratory bird I could before I began mothering 24 hours a day. After giving birth and still on painkillers, my hospital window ajar, I could hear birds calling to their prospective mates. From there, I lay processing what bringing this new life into the world with my husband meant for me.

A few days after we brought our son home from the hospital, we made our inaugural trip as a family to Prospect Park. My anxiety was heightened. At times I feel an overwhelming desire to bird and may not realize how much I need to be in nature until I'm outdoors. This time, I was so nervous bringing him outside and so far from home (a mere 10 minute walk), even though my mom and my husband were there. I felt the need to remain vigilant of any possible threats, and my mind conjured up endless doomsday scenarios. What if a car doesn't see us in the crosswalk? What if an off-leash dog attacks the stroller? What if someone gets too

close to me while I'm holding him? What if he starts to choke? This was one of the few times since becoming a birder that I actually tuned out the birds while outside, but I did notice how much greener the park was. It felt like Spring was passing me by. Blossoms had come and gone, along with a host of migratory birds I would likely never see.

It took over a month before I felt comfortable taking my son along with Justin on the 20 minute walk to the BBG. I still wasn't ready to focus on birding—not while my son was so small and vulnerable—but then, a Gray Catbird came close to us while I was holding him. That was our first of the season (FOS)! And for our baby, this was a lifer. He won't remember this moment, this bird, but I hope the joy of that encounter remains. I felt like holding him there, next to this Gray Catbird, was me introducing him to birding.

We took another step in Ithaca, an 8-hour drive from our home. Before I had given birth, a creative agency had contracted me to bird in the Finger Lakes region and share my experience on Instagram. With the date fast approaching, our newborn just over a month old, I considered telling them I couldn't do it. Exciting as it was to be *paid* to bird, never mind taking our first trip as a family of three, I was terrified.

It went better than I could have imagined. We had binoculars, bottles, and a baby-size bucket hat to keep the sun out of his eyes. We changed his diaper in our rental car. I spotted Eastern Bluebirds, which I've yet to see in NYC; an Osprey nest; Rose-breasted Grosbeaks; Barn Swallows; Eastern Kingbirds; Scarlet Tanagers; and many others, from multiple locations! I was Spring Birding! We were Spring birding! And with our newborn. We left with proof that birding with him over 200 miles from our home was possible, which gave me the reassurance that he and I would be okay birding 20 minutes down the street for a few hours.

Late that June, I began to bird weekly again. I was still worried about navigating the foot traffic and many cars that make up Flatbush Avenue, but I knew once I made it to Brooklyn Botanic Garden I could let go of the tension and ease into birding, enjoying the natural open space with my baby. It has become our routine together—once a week, just me and my son, and a second day, Tina, my neighbor and unofficial birding advisor will join us. Some weekends, Justin joins in. I feel the urge to go out bird a minimum of two days a week, not just to maintain my ability to identify birds, but more importantly, my mental wellbeing.

Before I became a birder I loved being out in nature. Sitting on the grass in front of the lake in Prospect Park, walking the grounds of Brooklyn Botanic Garden, wading in the water of one of Rockaway's many beaches—there's always been a sense of calm that being outdoors gave me. When I started birding, this existing sense of calm multiplied, or rather it transformed into a kind of love that was capable of dramatically shifting my mood. I've cried tears of joy on multiple occasions while birding. At times it's because I've seen a species for the first time, because I find a bird so beautiful, because I've seen a species I haven't seen in a while, or simply because I recognize, in the moment, how happy birding is making me. That day I spotted the Common Nighthawk, my joy of birding was felt by my son.

For me, birding is a form of self-care. It nourishes me and puts me in a good mental space as I care for my son. Just as my son responds to my energy, I must attune to him as well. It no longer matters how long I'm able to walk around to bird if he isn't comfortable. I want him to be engaged with the outdoors. So now, often when I'm birding, I stop to play with him on the grass or point out flowers or insects. It's a joy to notice what catches his attention in nature. He seems to enjoy watching people and interacting with other babies, but he also often reaches out to plants, and slowly but surely he's beginning to react to birds.

DAY BRIÈRRE

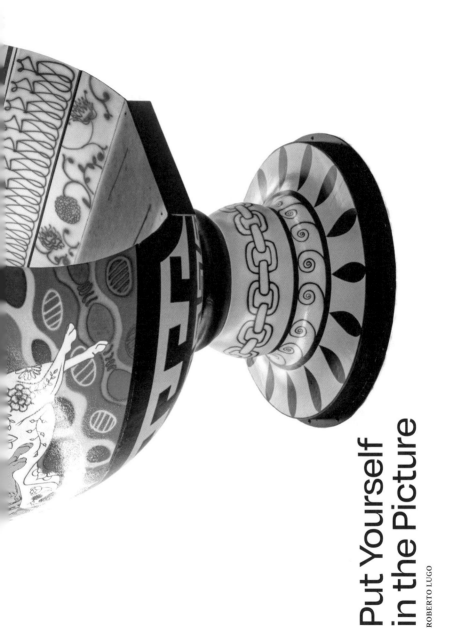

Put Yourself in the Picture

ROBERTO LUGO

July
THE 7TH MONTH | 31 DAYS

122

Buck Moon
Named for the antlers that start to grow on deer bucks heads.

Key

SUNRISE ☼◄

SUNSET ☼►

DAY LENGTH ☼↔

SUNDAY	MONDAY	TUESDAY	WEDNESDAY	THURSDAY	FRIDAY	SATURDAY
		1	**2**	**3**	**4**	**5**
		☼◄ 5:28 am	☼◄ 5:29 am	☼◄ 5:29 am	☼◄ 5:30 am	☼◄ 5:31 am
		☼► 8:31 pm	☼► 8:30 pm	☼► 8:30 pm	☼► 8:30 pm	☼► 8:30 pm
		☼↔ 15:02:10	☼↔ 15:01:30	☼↔ 15:00:46	☼↔ 14:59:58	☼↔ 14:59:07
		☾ 12:04 pm	☾ 12:16 pm	☾ 12:35 am	☾ 12:56 am	☾ 1:19 am
		☾ ♍ Virgo	☾ 1:05 pm	☾ 2:06 pm	☾ 3:07 pm	☾ 4:10 pm
			♎ Libra	♎ Libra	♏ Scorpio	♏ Scorpio
6	**7**	**8**	**9**	**10**	**11**	**12**
☼◄ 5:31 am	☼◄ 5:32 am	☼◄ 5:32 am	☼◄ 5:33 am	☼◄ 5:34 am	☼◄ 5:35 am	☼◄ 5:35 am
☼► 8:29 pm	☼► 8:29 pm	☼► 8:29 pm	☼► 8:28 pm	☼► 8:28 pm	☼► 8:27 pm	☼► 8:27 pm
☼↔ 14:58:13	☼↔ 14:57:15	☼↔ 14:56:14	☼↔ 14:55:10	☼↔ 14:54:03	☼↔ 14:52:53	☼↔ 14:51:39
☾ 1:46 am	☾ 2:20 am	☾ 3:01 am	☾ 3:51 am	☾ 4:51 am	☾ 5:57 am	☾ 7:08 am
☾ 5:14 pm	☾ 6:17 pm	☾ 7:16 pm	☾ 8:09 pm	☾ 8:53 pm	☾ 9:31 pm	☾ 10:01 pm
♏ Scorpio	♐ Sagittarius	♐ Sagittarius	♑ Capricorn	♑ Capricorn	♑ Capricorn	♒ Aquarius

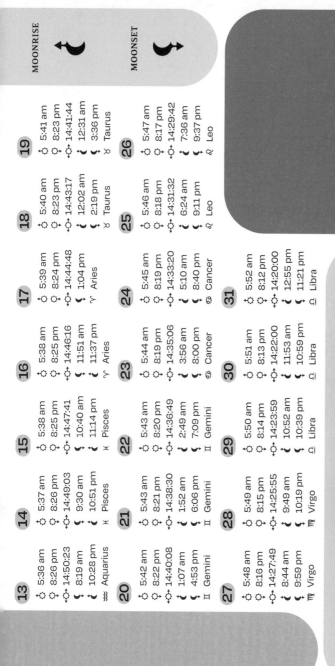

13
☼ 5:36 am
☼ 8:26 pm
☽ 14:50:23
☾ 8:19 am
☾ 10:28 pm
♒ Aquarius

14
☼ 5:37 am
☼ 8:26 pm
☽ 14:49:03
☾ 9:30 am
☾ 10:51 pm
♓ Pisces

15
☼ 5:38 am
☼ 8:25 pm
☽ 14:47:41
☾ 10:40 am
☾ 11:14 pm
♓ Pisces

16
☼ 5:38 am
☼ 8:25 pm
☽ 14:46:16
☾ 11:51 am
☾ 11:37 pm
♈ Aries

17
☼ 5:39 am
☼ 8:24 pm
☽ 14:44:48
☾ 1:04 pm
♈ Aries

18
☼ 5:40 am
☼ 8:23 pm
☽ 14:43:17
☾ 12:02 am
☾ 2:19 pm
♉ Taurus

19
☼ 5:41 am
☼ 8:23 pm
☽ 14:41:44
☾ 12:31 am
☾ 3:36 pm
♉ Taurus

20
☼ 5:42 am
☼ 8:22 pm
☽ 14:40:08
☾ 1:07 am
☾ 4:53 pm
♊ Gemini

21
☼ 5:43 am
☼ 8:21 pm
☽ 14:38:30
☾ 1:52 am
☾ 6:06 pm
♊ Gemini

22
☼ 5:43 am
☼ 8:20 pm
☽ 14:36:49
☾ 2:49 am
☾ 7:09 pm
♊ Gemini

23
☼ 5:44 am
☼ 8:19 pm
☽ 14:35:06
☾ 3:56 am
☾ 8:00 pm
♋ Cancer

24
☼ 5:45 am
☼ 8:19 pm
☽ 14:33:20
☾ 5:10 am
☾ 8:40 pm
♋ Cancer

25
☼ 5:46 am
☼ 8:18 pm
☽ 14:31:32
☾ 6:24 am
☾ 9:11 pm
♌ Leo

26
☼ 5:47 am
☼ 8:17 pm
☽ 14:29:42
☾ 7:36 am
☾ 9:37 pm
♌ Leo

27
☼ 5:48 am
☼ 8:16 pm
☽ 14:27:49
☾ 8:44 am
☾ 9:59 pm
♍ Virgo

28
☼ 5:49 am
☼ 8:15 pm
☽ 14:25:55
☾ 9:49 am
☾ 10:19 pm
♍ Virgo

29
☼ 5:50 am
☼ 8:14 pm
☽ 14:23:59
☾ 10:52 am
☾ 10:39 pm
♎ Libra

30
☼ 5:51 am
☼ 8:13 pm
☽ 14:22:00
☾ 11:53 am
☾ 10:59 pm
♎ Libra

31
☼ 5:52 am
☼ 8:12 pm
☽ 14:20:00
☾ 12:55 pm
☾ 11:21 pm
♎ Libra

MOONRISE

MOONSET

National Cell Phone Courtesy Month

July

Astrology

With the summer sun beaming in its full glory, July's horoscope invites you to soak up the small moments of joy this month brings, especially with four major retrograde stations happening throughout the month (Neptune, Saturn, Mercury, and Chiron). To kick off the summer retrograde season, Neptune—the planet of illusions and imagination—will begin its four-month backspin through Aries on Jul. 4.

During Neptune retrograde in Aries, it's important to be mindful of negative mental chatter and to avoid making impulsive decisions as things are usually not what they appear to be. Then, on Jul. 13, Saturn—the planet of discipline and responsibility—will also station retrograde in assertive Aries for the first time, encouraging you to reassess your approach to challenges and consider if any adjustments are needed to achieve your

objectives more effectively. For example, do you automatically become defensive or defiant during conflict? How would you rate your level of self-control? While retrograde energy dominates this month, Leo season begins on Jul. 22, and this influx of fiery confidence empowers you to practice gratitude for your uniqueness. Try not to get discouraged by envy or pride.

Herbal Tips

Blue Chamomile essential oil is blue because of its high content of chamazulene, one of the more potent anti-inflammatory compounds used in aromatherapy. This oil is very gentle for skin conditions, and highly compatible with all skin types.

Frankincense has been made into salves, poultices, balms and unguents for thousands of years, in addition to its ancient use as a purifying incense for religious and spiritual purposes. Frankincense promotes wound healing; relieves muscular, nerve and joint pains; and reduces pain of rheumatism, arthritis and fibromyalgia.

Geranium and Rose essential oils are similar in many ways and are often used together. Because they balance sebum production, these oils are useful in skin conditions associated with both excessive dryness and excessive oil, and are highly compatible with all skin types.

Helichrysum is famous for preventing and removing scar tissue, and is considered a superior anti-inflammatory and skin regenerator with potent cicatrizing properties.

Sandalwood is often used in Ayurvedic Pancha Karma treatments to detoxify the skin, improve circulation, and benefit the musculoskeletal system. It is highly compatible with dry, scaly, and chapped skin specifically.

Phenology Calendar

July marks the beginning of mushroom season, and the beginning of the two-month-long firework season, a constant percussive companion. Their crackles and booms will not cease until school starts in September. The local seasonal nutcracker beverage can now be found at your local beach, sold in unmarked plastic bottles.

The Intoxicating Garden

MICHAEL POLLAN

Every garden tells a story about nature, written by our species and starring an obliging cast of plants. In our time, most of these stories are idylls of one kind or another, with the plants chosen for their beauty or fragrance or outward form, but always for their willingness to gratify human desire and do our bidding. It wasn't always this way. There was a time, before the industrial revolution lulled us into believing that the human conquest of nature was something to celebrate, when gardens told much more ambiguous stories about nature. The medieval and renaissance "physic garden" was less concerned with the beauty of plants than with their spooky powers: whether to heal or poison, they could change us in some way, in body or in mind.

I suppose we will always go to the garden to idealize our relationship to nature, but lately I've been looking to my garden to do something a little more like the old physic gardens, paying more attention to the invisible chemistries percolating through it than to its outward forms and pleasures. What you first see as you come through the gate are flowering plants and tasty things to eat—another garden telling that comforting old story in which nature gratifies human desires for beauty and nourishment. But mixed in is a group of plants that have a very different agenda and speak to a more ambiguous desire: altering human consciousness.

This season I'm growing opium poppies (Papaver somniferum); wormwood (Artemisia absinthium), the source of thujone, the alleged hallucinogen in absinthe; cannabis (which it is now legal to grow in California); morning glory, tobacco and three species of mescaline-producing cacti that go under the common name San Pedro or Wachuma: trichocereus pachanoi, t. bridgesii and t. macrogonus. Wanting to add caffeine to my garden's collection of psychoactive molecules, I recently added a tea plant (Camellia sinensis). Though it turns out caffeine is already being produced by my lemon tree, albeit in quantities too small to be of any use to me. Researchers recently discovered that several species of flowering plants, including members of the citrus family, produce caffeine in their nectar. This came as a surprise, since caffeine is a defense chemical, a toxin evolved to poison pests and discourage other plants from germinating nearby. But the genius of plants is such that they can deploy the same chemistry to attract or repel, please or poison, depending on their objectives.

It seems honeybees exhibit a preference for blossoms that offer them a shot of caffeine, and are more likely to recall and reliably return to the flowers that supply it. Caffeinated nectar thus improves the performance of pollinators, which means that caffeine does for bees what it does for us. Yet the benefits flow mainly to the plants,

É Tão Triste Cair

PAULA QUERIDO

since the bees are so avid for caffeine they will return to blossoms long after they've been depleted of nectar, cutting into honey production. It's an eerily familiar story: a credulous animal drugged by a plant's clever neurochemistry to act against its interests.

So I am not the only animal in this garden with an interest in plant drugs. But for me, ingesting them is not the point. (Or at least not the whole point.) When I first grew cannabis and opium poppies 30 years ago, it was mainly to see if I could. One of the greatest satisfactions of gardening is the sense of independence it can confer—from the greengrocer, the florist, the pharmacist and, for some of us, the drug dealer.

I sense you, reader, wondering about the whole question of legality. It's complicated— and slightly different in the US and the UK. According to Nell Jones, the head of plant collections at the Chelsea Physic Garden in London, "You can grow whatever you like as long as you don't prepare it as a drug," with a few notable exceptions: cannabis, khat and coca, the cultivation of which require a license from the government that only an institution is likely to secure.

In my American garden, all of the psychoactive plants currently in residence are legal to grow here in California, with one unsettling caveat: it's a felony to grow papaver somniferum with the intent to manufacture a narcotic. How would the authorities prove such intent? One way would be if your seed pods have been slit by a razor; the milky sap the pods bleed is opium. Another would be if you were in possession of an article explaining how simple it is to turn poppy pods into a mild narcotic tea (simply crush and soak them in hot water) or laudanum (soak them in vodka instead).

However, if your sole purpose is to admire the ephemeral tissue-thin blossoms or the stately seed pods, you should have nothing to worry about. Though you might want to dispose of this article before any visits from the police.

The status of San Pedro is slightly different: it is legal to grow these handsome, columnar cacti until the moment you begin cutting up and cooking a chunk of the cactus (by slowly simmering a stock from its flesh and drinking a cup or two of that, or so I've been told). Then you're guilty of manufacturing mescaline, a felony carrying a prison

sentence of five to 20 years in the US. Peyote, the other mescaline-producing cactus, is straight-out illegal to grow or possess here, as are psilocybin mushrooms, except in a handful of jurisdictions—including Oakland, Santa Cruz, Denver, Oregon and Washington, DC—that have recently decriminalized "plant medicines." I look forward to the day when my city of Berkeley follows suit. Until then, it's already legal to grow small quantities of cannabis in California (as it is in 18 other states), and although I have yet to see cannabis seedlings for sale in the nurseries I frequent, you can find them in some licensed pot dispensaries.

This spring I bought a single clone of a hybrid called "Brr Berry" for $30, its buds resembling small turds glazed with psychoactive hoar frost. The catalog description of this cultivar had a slightly different flavor from what gardeners are accustomed to: "This lady is icier than an electrified ice-cream cone, cooler than a polar bear's toenails and frostier than a snowman's snowballs. Brrr! With such a frosty exterior, it's hard to believe that she has such a sweet center, but if you get close to her you will notice that her core is nothing but bubblegum, sweet berries and acetone; a strangely intoxicating combination that is sure to excite your senses and put a little tingle in your jingle."

Though mine hasn't yet thrown any buds, I must say it is a handsome and hard-to-miss character in the garden, its seven-fingered pattern of deeply serrated leaves by now as iconic as any leaf on earth. I have not met another plant that grows so lustily or is quite so avid for sunlight and water.

The one coming closest is the tobacco plant, a powerful psychoactive that we westerners unjustly demonize. Long before European colonists transformed this New World native into a lethal addiction, tobacco was revered by indigenous peoples as a sacred medicine with the power to purge ill health and evil spirits. Tobacco's double identity—as medicine and poison, depending on context— goes to the heart of the story that the psychoactive garden tells.

Plants produce all manner of poisons, but as Paracelsus, the Swiss Renaissance medical pioneer, famously observed, "the dose makes the poison." Many of the dangerous alkaloids plants manufacture to defend themselves do other, more interesting things at low doses,

including changing the texture of animal consciousness. How much cleverer to invent molecules that merely mess with the minds of animals, disorienting or distracting them or ruining their appetites, perhaps because plants have learnt over the course of their evolution that simply killing your pests outright is not necessarily the best strategy. This is precisely what a great many plant alkaloids—including caffeine, mescaline, morphine and nicotine—reliably do.

We humans have been the greatest beneficiary of

it's hard to look at a cannabis plant in full flower without feeling the stir of something psychoactive. One doesn't necessarily have to ingest these plants in order to register their power. Imagine what could become of our gardens if we won the right not only to grow but to prepare and take these psychoactive plants into our bodies, so they might change our minds every now and again. I can attest that plants appear different when under the influence—in my experience, their agency and subjectivity become blazingly apparent.

"It's an eerily familiar story: a credulous animal drugged by a plant's clever neurochemistry to act against its interests."

this sophisticated chemical warfare—and I say that fully aware that the use of psychoactive plants can end badly. But there is something in us that isn't satisfied with everyday normal consciousness and seeks to change or even transcend it, despite the risks.

Merely to gaze at a poppy is to feel dreamy, to judge by Impressionist paintings, and

To me, the very idea of a criminal plant seems wrong. Using plants to alter the textures of consciousness is a practice as old as our species, an essential part of our relationship to the natural world. What better, safer or more interesting place to explore the possibilities of that relationship than in our gardens?

August

THE 8TH MONTH | 31 DAYS

Sturgeon Moon

Named for the time of year when sturgeons are most abundant in lakes.

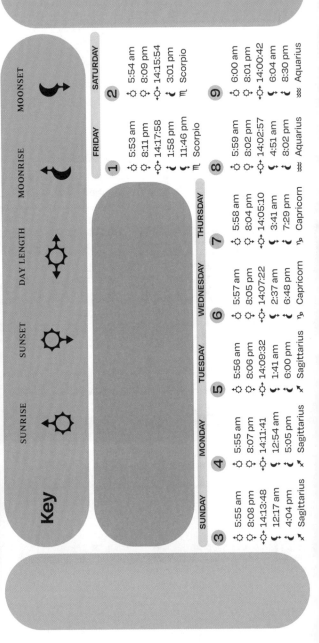

Key

| SUNRISE | SUNSET | DAY LENGTH | MOONRISE | MOONSET |

SUNDAY	MONDAY	TUESDAY	WEDNESDAY	THURSDAY	FRIDAY	SATURDAY
					1	**2**
					☼ 5:53 am	☼ 5:54 am
					☼ 8:11 pm	☼ 8:09 pm
					☼ 14:17:58	☼ 14:15:54
					☾ 1:58 pm	☾ 3:01 pm
					☾ 11:46 pm	♏ Scorpio
					♏ Scorpio	
3	**4**	**5**	**6**	**7**	**8**	**9**
☼ 5:55 am	☼ 5:55 am	☼ 5:56 am	☼ 5:57 am	☼ 5:58 am	☼ 5:59 am	☼ 6:00 am
☼ 8:08 pm	☼ 8:07 pm	☼ 8:06 pm	☼ 8:05 pm	☼ 8:04 pm	☼ 8:02 pm	☼ 8:01 pm
☼ 14:13:48	☼ 14:11:41	☼ 14:09:32	☼ 14:07:22	☼ 14:05:10	☼ 14:02:57	☼ 14:00:42
☾ 12:17 pm	☾ 12:54 am	☾ 1:41 am	☾ 2:37 am	☾ 3:41 am	☾ 4:51 am	☾ 6:04 am
☾ 4:04 pm	☾ 5:05 pm	☾ 6:00 pm	☾ 6:48 pm	☾ 7:29 pm	☾ 8:02 pm	☾ 8:30 pm
♐ Sagittarius	♐ Sagittarius	♐ Sagittarius	♑ Capricorn	♑ Capricorn	♒ Aquarius	♒ Aquarius

National Brownies at Brunch Month

Day	☀ Rise	☀ Set	☀ Transit	☾ Rise	☾ Set	Sign
10	6:01 am	8:00 pm	13:58:26	7:16 am	8:55 pm	♓ Pisces
11	6:02 am	7:58 pm	13:56:08	8:29 am	9:18 pm	♓ Pisces
12	6:03 am	7:57 pm	13:53:50	9:41 am	9:41 pm	♈ Aries
13	6:04 am	7:56 pm	13:51:30	10:54 am	10:06 pm	♈ Aries
14	6:05 am	7:54 pm	13:49:09	12:09 pm	10:33 pm	♈ Aries
15	6:06 am	7:53 pm	13:46:47	1:26 pm	11:07 pm	♉ Taurus
16	6:07 am	7:52 pm	13:44:24	2:43 pm	11:48 pm	♉ Taurus
17	6:08 am	7:50 pm	13:41:59	3:56 pm		♊ Gemini
18	6:09 am	7:49 pm	13:39:34	12:40 am	5:01 pm	♊ Gemini
19	6:10 am	7:47 pm	13:37:08	1:43 am	5:55 pm	♋ Cancer
20	6:11 am	7:46 pm	13:34:41	2:53 am	6:38 pm	♋ Cancer
21	6:12 am	7:44 pm	13:32:13	4:06 am	7:12 pm	♌ Leo
22	6:13 am	7:43 pm	13:29:44	5:18 am	7:39 pm	♌ Leo
23	6:14 am	7:41 pm	13:27:14	6:28 am	8:02 pm	♍ Virgo
24	6:15 am	7:40 pm	13:24:44	7:34 am	8:22 pm	♍ Virgo
25	6:16 am	7:38 pm	13:22:13	8:38 am	8:42 pm	♍ Virgo
26	6:17 am	7:37 pm	13:19:41	9:40 am	9:02 pm	♎ Libra
27	6:18 am	7:35 pm	13:17:09	10:42 am	9:23 pm	♎ Libra
28	6:19 am	7:34 pm	13:14:36	11:45 am	9:47 pm	♏ Scorpio
29	6:20 am	7:32 pm	13:12:02	12:48 pm	10:15 pm	♏ Scorpio
30	6:21 am	7:30 pm	13:09:28	1:51 pm	10:49 pm	♏ Scorpio
31	6:22 am	7:29 pm	13:06:53	2:52 pm	11:32 pm	♐ Sagittarius

August

Phenology Calendar

Late summer brings tomatoes, ripe corn, and an impossible-to-ignore uptick in police presence. Fire hydrants are on, clothes are stored in the freezer, the city is sweaty and horny and excited. People are losing their minds. Brooklyn Heights Promenade is full of Begonias.

Herbal Tips

Did you know Aloe Vera gel is 98% water, and has at least 20 medicinal functions? It has become a front and center ally to help soothe sunburns and electrolytes. This is just one of many excellent herbal allies that can greatly help with mineralization and water absorption. Tap into Nature's medicine cabinet to stay cool and ready for any summertime adventure with these botanical essentials:

ALOE VERA

Known for its high water content + soothing properties; hydrates from within + cools sunburned skin

MARSHMALLOW ROOT

Contains mucilage to form a protective moisture layer, soothing + hydrating tissues

LINDEN

Calms + hydrates; perfect as a tea to keep your body hydrated + reduce anxiety

Herbal Tips

CHAMOMILE

Gentle + soothing for digestion + relaxation with mild hydrating benefits

SLIPPERY ELM

Coats + soothes, aiding in hydration + healing

LICORICE ROOT

Moisturizes, soothes irritated tissues + promotes hydration

HIBISCUS

Rich in antioxidants + vitamin C for added immune support

OAT STRAW

Packed with vitamins + minerals, also supporting overall health

CUCUMBER

Composed mostly of water, perfect for hydration + skin health

CHIA SEEDS

Absorb water, forming a gel that provides prolonged hydration

SEA MOSS

Contains 92 of the 102 essential minerals, forming a gel-like consistency to hydrate tissues

Astrology

Whether celebrating with family and friends or cherishing the final pool days before school starts, August's astrological weather encourages you to resist isolation and reconnect with community. If you are looking for an ideal date to link up with your network or launch a new social campaign, the collaborative Aquarius full moon on Aug. 9 is an excellent time for that. To help your voice be heard, Mercury will station direct in Leo on Aug. 11, signaling a shift toward clarity and forward momentum. If your creativity tank has been on E, maybe it's time to get back in the studio, collaborate with other creators, or explore a new passion project altogether. With the planet of thought and communication no longer retrograde, you may experience a heightened sense of self-expression and confidence in your communication this Leo season. What ideas have you been sitting on that you're ready to test? Saturn's sextile to Uranus in Gemini on Aug. 11 offers the chance to break free from limiting structures and beliefs and find more personalized solutions to old problems. The key to this transit is trusting yourself. Do your best to silence outside opinions. You'll be grateful for the extra boost in self-confidence once Virgo season officially begins on Aug. 22, shifting your focus from leisure and self-expression to productivity and wellness. Take ownership of your health.

The New Green Revolution

WINONA LADUKE

It's said that around 100 years ago, we had a choice between a carbohydrate economy, making industrial materials with clean, renewable plant matter, or a hydrocarbon economy that would lay waste to our planet. We made the wrong choice.

In 1890, on the banks of Wounded Knee Creek, a dream died amid the brutal Wounded Knee Massacre. A 100 years later, another dream—of cannabis, of the hemp economy—was born. That work began with the family of Alex White Plume, traditional leader and former tribal president of the Oglala Lakota, who hoped growing industrial-grade hemp might pull his people out of poverty and heal Mother Earth. For this dream, they saw a frenzy of federal agents descend upon them, seizing their crops and slamming them with federal charges. The feds tried to kill their dream, but the White Plumes persevered. Today, their hemp field is still here. It's a sign of things to come.

Cannabis can transform our material economy, create sustainable housing, provide health and well-being, while returning carbon to the soil and creating a pathway to restorative

justice.
We call it the
New Green Revolution,
a nod to Norman Borlaug,
the so-called "Father of the Green Revolution"
who brought us seeds, food, and chemicals
from the University of Minnesota. Today's
New Green Revolution is a story about that
potential, and how Indigenous nations
embrace this new economy.

BUILDING COOPERATIVES

Inspired by the White Plumes
and the recently deceased Dakota
poet and philosopher John Trudell, I started
growing industrial hemp under state and
federal permits in 2015, the first year it was
legal in Minnesota. Through this, I founded
Winona's Hemp—I've farmed for 40-plus
years and this was a crop of epic promise.

The tribal nonprofit research project
Anishinaabe Agriculture Institute, which
I founded with a group of other farmers
on the White Earth Reservation in
northwestern Minnesota, took up hemp
research the following year, in 2016. While
this started as a local project, less than a
decade later our hemp was decorticated
in North Carolina, degummed in Virginia,
spun in Mexico, woven in Washington
state, and cut and sewn in California. It
eventually became a Patagonia workbag,
but little credit was given to the original
farmers. Supply chains are now longer and
more complex than ever, accumulating large
carbon footprints and decimating local farm
communities. We need to change the way
we operate in order to survive.

Minnesota used to have eleven hemp mills
mostly located in the south of the state.
The hemp industry was a scaled version
of hundreds of years of hemp processing
technology, which then added mechanization
and paired hemp with other local textile
plants like flax, from which linen is made.
The strongest rope in the world, so-called
"hanging rope," were all made of hemp. The
last place hemp ropes were made was at
Stillwater Prison, in Minnesota. I figure one
of my relatives made hemp rope.

My grandmother was a union member of
the International Ladies Garment Workers
Union. In the push for corporate profits, the
American
textile industry
was offshored during the later part of the
20th century. From 1994 to 2005, the United
States lost more than 900,000 textile and
apparel jobs. Now, most textiles are no longer
natural materials—they're fossil fuels adding
a huge carbon footprint to our world.

We must rebuild the North American textile
economy with natural fibers like hemp and
linen. That's the work of the Indigenous
Hemp and Cannabis Cooperative, a group
of Native farmers from the northern plains.
Together we're working to support farmers
across the Dakotas and Southwest preparing
for the hemp renaissance, helping them find
and purchase hemp processing equipment
themselves, producing canvas at a cost-
effective scale. In doing so, the farmers will
own the value of their labor. The textile
industry is just reemerging after a 70-year
hiatus, and with proper planning, this time it
will be equitable and sustainable.

DAKOTA "HEMPCRETE" HOUSING

The Dakota communities who have
remained in their Mns Sota homeland are
survivors. Indeed, Minnesota did all it
could to destroy the people in the genocidal
policies and wars of the late 1800s. But we
are still here, and we need houses. With
tribal housing demand far outstripping
supply nationally, it's estimated that a third
of our members lack adequate shelter.

But in the summer of 2023, the Dakota built
their first hempcrete house, putting together
a 1500 square foot ranch-like structure.
They worked with Cameron MacIntosh of
Americhanvre and his system of EZ Reaser,
filling 2 X 12 framed walls with a hemp slurry.
Two weeks later, they had a house. The pilot
project garnered much attention, and now

the tribe is looking to build a processing facility.

Concrete is the most widely used man-made material in the world and is the source of about 8% of the world's carbon dioxide (CO_2) emissions. If the cement industry were a country, it would be the third largest emitter in the world — behind China and the US.

Unlike concrete, which is made with smokestacks and mining, hempcrete is derived from plants which draw in huge amounts of carbon dioxide when grown. While politicians and scientists look to "carbon sequestration facilities", hemp is a living carbon sequestration program. Hemp housing sequesters carbon, and this world needs that. Hemp in the green building industry can spare a lot of trees from the chainsaw—saving lives.

HEALING THE EARTH

The accumulation of anthropogenic heavy metals in soil is a major form of pollution. Many of these are persistent pollutants, and they are toxic. To put it frankly, we've made quite a mess. Hemp can help heal that.

In the 1990s, a team of scientists worked with hemp at Chernobyl, the site of the world's worst nuclear accident. The term "phytoremediation" was coined by the scientist Ilya Raskin, a member of a team that tested hemp's ability to accumulate heavy metals. According to another team member, Vyacheslav Dushenkov, the experiment was a success. "For the specific contaminants that we tested, hemp demonstrated very good phytoremediation properties," says Dushenkov.

Hemp has roots that quickly grow more than 3 feet deep and its high tolerance to different metals make it effective at accumulating toxic metals in soil. As such, people like Richard Silliboy, Vice Chief of the Aroostook Band of the Mi'kmaq Nation, have seen hemp as key to cleaning up after the many old US military bases adjoining Native lands. The US military is the single largest polluter in the world. With the help of Chelli Stanley, Richard started Upland Grassroots, a nonprofit using hemp to help heal the land. They began in 2019 at Loring Air Force Base, a Superfund site the Mi'kmaq tribe now owns that is considered a high priority for federal cleanup.

The soil was full of PFAS, cancer-causing "forever chemical" compounds difficult to break down. Even the water is contaminated. Chellis and Richard had to wear hazmat suits, but their work is paying off. By 2020, researchers discovered their hemp plants were successfully sucking PFAS out of the contaminated soil. While the land hasn't recovered 100%, it's a start—and that's what we need.

JOIN THE REVOLUTION

Cannabis and hemp are a solution to many challenges in industrial society. Native nations in the Northern Plains are moving towards hemp with the intention of sequestering carbon, saving forests, protecting groundwater, and creating a carbohydrate-based materials economy. This spring, the White Earth Anishinaabe will plant 60 acres of hemp on a field they bought back from a big potato farmer. That's fiber hemp, the stuff from which you make clothes, cars, rebar, housing, and more. This is the ninth year tribal farmers on the White Earth reservation have been planting fiber hemp, and this is their biggest crop. These farmers are on the front lines of what is going to be the New Green Revolution.

"When you go out there in the early spring, you hear those birds and then you get to till up your spot there and make it look like art out there—that's good. It's good to be proud of what you can grow out there, and learn from the older farmers and your ancestors" Jerry Chilton, AAI's Executive Director, told me. "Growing hemp is the future, and we are proud to be part of it."

It's a lot of work to bring life back to the soil, but these farmers are doing it. Fields of dreams, indeed.

If you want to help, sign up here:

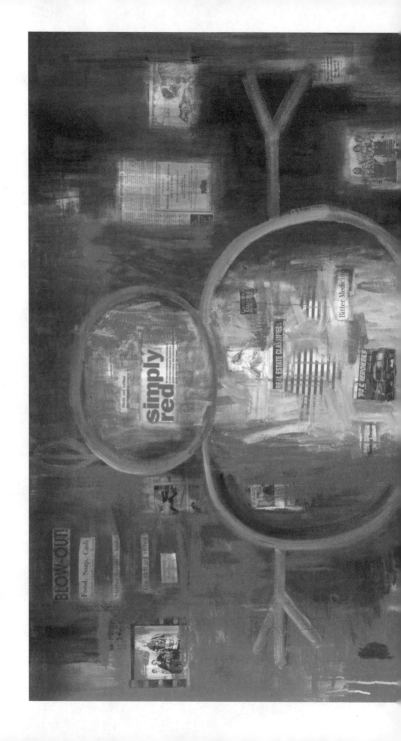

I See Red: Snowman

JAUNE QUICK-TO-SEE SMITH

140

September

THE 9TH MONTH | 30 DAYS

Harvest Moon

Named for the light that comes from the closeness of the setting sun and rising moon which allows farmers to harvest later into the evening.

Key

☀ SUNRISE

☀ SUNSET

	SUNDAY	MONDAY	TUESDAY	WEDNESDAY	THURSDAY	FRIDAY	SATURDAY
		1	**2**	**3**	**4**	**5**	**6**
Sunrise		6:23 am	6:24 am	6:25 am	6:26 am	6:27 am	6:28 am
Sunset		7:27 pm	7:26 pm	7:24 pm	7:22 pm	7:21 pm	7:19 pm
		13:04:18	13:01:42	12:59:06	12:56:30	12:53:53	12:51:16
Moonrise		3:50 pm	12:23 am	1:23 am	2:31 am	3:42 am	4:55 am
Moonset			4:40 pm	5:24 pm	6:00 pm	6:30 pm	6:56 pm
		♐ Sagittarius	♑ Capricorn	♑ Capricorn	≈ Aquarius	≈ Aquarius	≈ Aquarius
	7	**8**	**9**	**10**	**11**	**12**	**13**
Sunrise	6:29 am	6:30 am	6:31 am	6:32 am	6:33 am	6:34 am	6:35 am
Sunset	7:17 pm	7:16 pm	7:14 pm	7:12 pm	7:11 pm	7:09 pm	7:07 pm
	12:48:38	12:46:00	12:43:22	12:40:43	12:38:04	12:35:25	12:32:46
Moonrise	6:09 am	7:23 am	8:38 am	9:54 am	11:13 am	12:32 pm	1:48 pm
Moonset	7:20 pm	7:44 pm	8:08 pm	8:35 pm	9:08 pm	9:47 pm	10:36 pm
	♓ Pisces	♓ Pisces	♈ Aries	♈ Aries	♉ Taurus	♉ Taurus	♊ Gemini

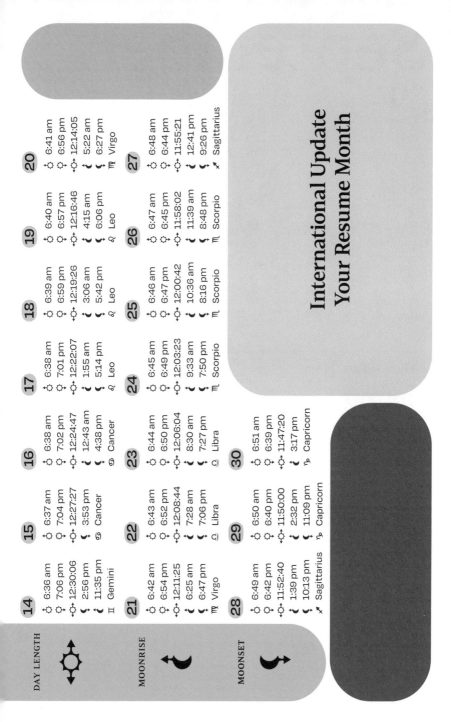

International Update Your Resume Month

	DAY LENGTH ☼			MOONRISE ☽	MOONSET ☽	Zodiac
14	6:36 am	7:06 pm	12:30:06	2:56 pm	11:35 pm	♊ Gemini
15	6:37 am	7:04 pm	12:27:27	3:53 pm		♋ Cancer
16	6:38 am	7:02 pm	12:24:47	12:43 am	4:38 pm	♋ Cancer
17	6:38 am	7:01 pm	12:22:07	1:55 am	5:14 pm	♌ Leo
18	6:39 am	6:59 pm	12:19:26	3:06 am	5:42 pm	♌ Leo
19	6:40 am	6:57 pm	12:16:46	4:15 am	6:06 pm	♌ Leo
20	6:41 am	6:56 pm	12:14:05	5:22 am	6:27 pm	♍ Virgo
21	6:42 am	6:54 pm	12:11:25	6:25 am	6:47 pm	♍ Virgo
22	6:43 am	6:52 pm	12:08:44	7:28 am	7:06 pm	♎ Libra
23	6:44 am	6:50 pm	12:06:04	8:30 am	7:27 pm	♎ Libra
24	6:45 am	6:49 pm	12:03:23	9:33 am	7:50 pm	♏ Scorpio
25	6:46 am	6:47 pm	12:00:42	10:36 am	8:16 pm	♏ Scorpio
26	6:47 am	6:45 pm	11:58:02	11:39 am	8:48 pm	♏ Scorpio
27	6:48 am	6:44 pm	11:55:21	12:41 pm	9:26 pm	♐ Sagittarius
28	6:49 am	6:42 pm	11:52:40	1:39 pm	10:13 pm	♐ Sagittarius
29	6:50 am	6:40 pm	11:50:00	2:32 pm	11:09 pm	♑ Capricorn
30	6:51 am	6:39 pm	11:47:20	3:17 pm		♑ Capricorn

September
FALL

Herbal Tips

It is of VITAL importance that we keep our connection to wild and medicinal foods alive. By foraging sustainably and mindfully, we preserve the allies in our ecosystem that have nourished our ancestors for millennia. Wild foods and herbs hold some of the most nutrient-dense profiles known.

Think beyond what's readily available at your supermarket and learn about your local allies so you can deeply nourish your biome. What's growing around you is in perfect symbiosis with the mystery of cycles. Turn to nature's seasonal offerings for some of the most powerful gut-nervous system healing.

Goldenrod stands tall, ready to lend its diuretic and anti-inflammatory prowess to those in need of urinary and respiratory support.

Black Walnut hull has antibacterial and antifungal properties. It's also high in alpha-linoleic acid (an important omega-3!).

Hawthorn berries are a cardiovascular tonic, supporting and protecting blood, heart, and blood vessels.

Rose Hips are laden with vitamin C and antioxidants.

Sumac berries grow in clusters and persist well into the Fall.

Pine needles are high in vitamins, rich in antioxidants, supporting immune health and soothing respiratory ailments.

Elderberries are powerful antioxidants that have been used as immune boosters for centuries.

Dandelion roots are bitter digestive aids which support the liver and blood.

Burdock root offers itself as a powerful detoxifier and purifier.

Phenology Calendar

September brings the onset of autumnal coloring—leaves start to turn and fall, empty storefronts and shuttered businesses transform into Spirit Halloweens. Early blooming bulbs are planted and, like so many bare legs and short sleeves, won't be seen again until spring. College students make their yearly migration, crestfallen parents in tow hoisting mini-fridges or wrestling with shoe racks. Campus curbs are littered with empty moving boxes.

Seasonal Birding

Fall is your other opportunity to see migratory birds traveling the Atlantic Flyways to their winter homes, which may be in the Southern United States and Mexico, the Caribbean and Central America, or South America. The Black-billed Cuckoo, a long-distance migrant, can be quite elusive and is mostly found in the woods, but I was able to spot one in the Fall at BBG. This bird, with a rusty brown tint to its wings and a long tail with white tips, remained perched for a while, low to the ground, which gave me ample time to identify it. I also regularly see yellow-rumped warblers and palm warblers at BBG this time of year.

Bird species are often named for the male's plumage in the Spring, during mating season. This can make identifying birds in the fall more difficult, when there are many young birds migrating in juvenile plumage. At Prospect Park I, along with many other birders, was able to see a Purple Gallinule, though this one was not purple. It was a mute, brownish color, but its yellowish long legs and long spread out toes were undeniable markers of the Gallinule. Because this may be some birds' first time migrating, you may see some that overshot their landing or haven't perfected their route. If you're reluctant to be outdoors birding during the winter, you'll be able to spot some species that winter in NYC arriving during the more temperate fall weather.

Astrology

As September unfolds and the earth transitions from summer to fall, find comfort in the organization and studiousness this month brings. With the sun resting in intentional Virgo until Sep. 21, the first few weeks of the month are ideal for organizing your affairs to end the year strong rather than starting a new project or venture. In fact, with the onset of eclipse season, a time of introspection and aligning oneself with personal growth and evolution, try to avoid overloading your to-do list and schedule. If your friends complain about you canceling your plans during this time, you can direct them to this chart. Keep things simple during the Pisces total lunar eclipse on Sep. 7 and the Virgo partial solar eclipse on Sep. 21. With this eclipse series occurring on the Virgo - Pisces axis; it marks a time for streamlining, health improvements, and redefining how we want to serve others. Consider exploring your inner world more during tense moments and consciously release stagnant emotional patterns. On a lighter note, the sun will enter Libra on Sep. 21, bringing harmony and beauty to your relationships and self-care habits. Use this Venus-ruled energy to pamper yourself after a tough month. You deserve it!

Salted Herbs

PASCAL BAUDAR

Salted herbs are a traditional way to preserve fresh herbs and enhance the flavors in cooking. This technique is especially popular in French-Canadian cuisine, where a mixture of fresh herbs is salted to keep them throughout the year.

Equipment

· Clean jar with a tight-fitting lid

Ingredients

· 4 cups of mixed fresh herbs (such as parsley, chives, tarragon, thyme, sage, and basil). If you are a forager, you can use chickweed, miner's lettuce, wild chervil and other savory herbs.

· 1 cup coarse sea salt (or kosher salt)

Instructions

1. **Prepare the Herbs**

· Wash your chosen herbs thoroughly to remove any dirt or debris. It's important to ensure that the herbs are completely dry before proceeding, as excess moisture can lead to spoilage. You can air dry them or use a salad spinner followed by patting them down with a clean kitchen towel.

2. **Chop the Herbs**

· Finely chop the herbs. You can mix the herbs as you like, depending on the flavors you prefer. Some herbs like rosemary or sage can overpower others, so use them sparingly unless they are your preferred flavors.

3. **Layer Herbs and Salt**

· In your clean jar, begin by placing a layer of salt at the bottom. Add a layer of chopped herbs, then cover with another layer of salt. Repeat this process until all the herbs are used up, making sure to finish with a layer of salt on top.

4. **Seal and Store**

· Seal the jar tightly and store it in a cool, dark place. The salt will draw moisture from the herbs, intensifying their flavors and preserving them.

5. **Wait Before Using**

· Let the jar sit for at least two weeks before starting to use the salted herbs. This waiting period allows the flavors to meld and the salt to fully preserve the herbs.

6. **Usage**

· Use the salted herbs in cooking as you would use fresh herbs. They are excellent for adding to soups, stews, marinades, and other dishes. Remember that the herbs are already salted, so adjust the amount of additional salt in your recipes accordingly.

Tips:

· Storage: Stored in a cool, dry place, your salted herbs can last for several months up to a year. Make sure to keep the jar tightly closed to prevent any moisture from entering.

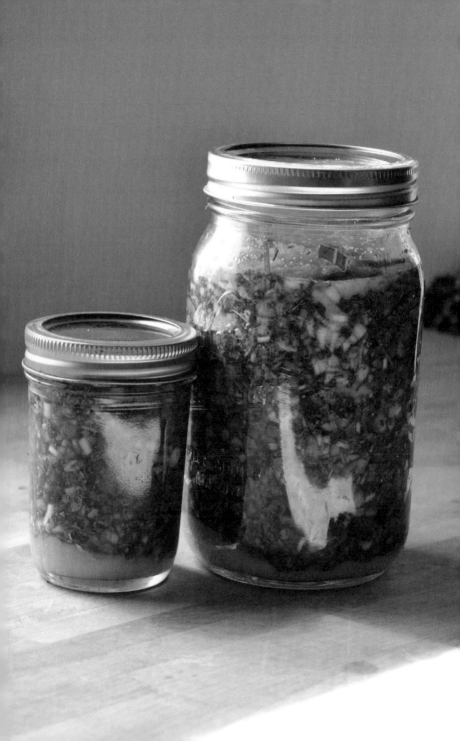

An Introduction to The Bill Pickett Invitational Rodeo

SAM RUSSEK

A promotional poster from 1985.

It's not exactly by accident that when people think of cowboys, they tend to imagine the John Wayne type, white and grizzled and out on his own, laying claim to the vast, arid vistas of the wild west. This image is as much a product of Hollywood as it was the state department, back when President James K. Polk annexed Texas and went to war with Mexico in the name of so-called manifest destiny. The truth of the matter is that white cowboys were but a fraction of the profession. While the term "cowboy" was inspired by Spanish vaquero, by the late 19th century, the zenith of the industry, historians estimate that around one-third of cowboys were Mexican, and one-fourth were Black. As such, a solid majority of cowboys were not white.

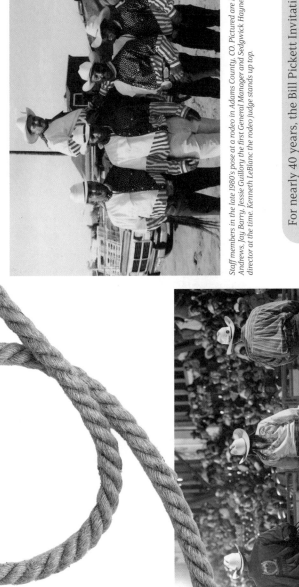

Staff members in the late 1980's pose at a rodeo in Adams County, CO. Pictured are Phillip Andrews, Jay Barry, Jessie Guillory the first General Manager and Sedgwick Haynes the arena director at the time. Kenneth LeBlanc the rodeo judge stands up top.

For nearly 40 years, the Bill Pickett Invitational Rodeo (BPIR) has traveled the country hosting cultural events that celebrate and honor Black cowboys and cowgirls and the stories behind a subculture still strong today.

Danell Tipton, Denise Tyus and the "stock guy" (the person who provides the animals for the rodeo), watch the show at the Fort Worth Cowtown Coliseum.

An unknown bull rider in 1985 or 1986. The bulls ridden weigh nearly a ton and the rider must stay on for 8 seconds while holding on with just one hand.

Bill Pickett (1870-1932)—the man for which the group is named—was a ranch hand in Texas responsible for catching longhorn steers. He's also the most famous Black rodeo performer of all time, and the first black cowboy movie star. BPIR still honors his legacy through "bulldogging", a rodeo event he popularized, in which a rider on horseback grabs a steer by its horns and uses their weight to tip the steer on its side. Rodeos grew out of the cowboy profession, a way of showcasing one's skills herding, taming, riding, and roping cattle.

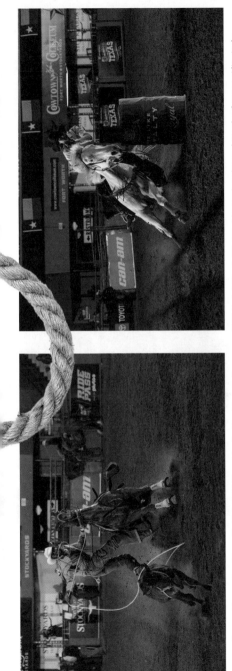

Justin Moffett, a calf roper from Huntsville, TX in 2022. The origin of calf roping came from working cowboys who needed to catch calves for branding and medical treatments. This skill was later turned into contests to see which cowboys could do it the most quickly and easily.

2022, Paris Wilburd of Austin, Arkansas barrel races during her first year riding in the BPIR. Barrel racing tests both the agility of the horse and the horsemanship of the rider. Contestants compete for the fastest time to complete loops around the barrels.

Today, rodeo is a televised phenomenon popular across the American west, but BPIR fills an important void by bringing Black history to the forefront. BPIR's mission is to educate and uplift new generations of Black cowboys and cowgirls. The BPIR rodeo is the brainchild of the late Lu Vason, an entertainment industry veteran who got the idea for an all-Black rodeo as he attended Cheyenne Frontier Days, the world's largest outdoor rodeo—shocked as he was at the lack of Black riders and viewers.

Michael Timmons, a young cowboy at a rodeo in Oakland, CA in the early 1990's. He barrel raced at a young age and his mother worked for the rodeo in Oakland as a rodeo timer.

Lu Vason in the late 1980's with the saddle bags that he always wore over his shoulders. The cowboys use to laugh at him since they thought of him as a newcomer trying to be western.

The images collected here are an expansion from the John Wayne type: A more honest history of the west is not solely or even majority white. "I love seeing our young kids get into rodeo," said Valeria Howard-Cunningham, BPIR's current president and Vason's wife before his death. "I can see the excitement in their faces when they compete—and the friendships they're making with other cowboys and cowgirls. Our rodeo is about developing that next generation."

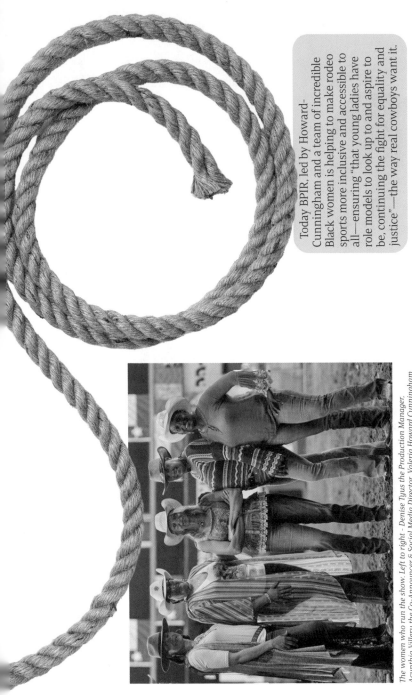

Today BPIR, led by Howard-Cunningham and a team of incredible Black women is helping to make rodeo sports more inclusive and accessible to all—ensuring "that young ladies have role models to look up to and aspire to be, continuing the fight for equality and justice"—the way real cowboys want it.

The women who run the show. Left to right - Denise Tyus the Production Manager; Acynthia Villery the Co-Announcer & Social Media Director, Valeria Howard Cunningham the current Owner & President, Margo Wade LaDrew the National Partnership & Marketing Director and Stephanie Haynes the Executive Rodeo Assistant.

October

THE 10TH MONTH | 31 DAYS

Squirrel Awareness Month

Blood Moon

Named for the time of year that hunters kill and process animals to eat during winter.

SUNDAY	MONDAY	TUESDAY	WEDNESDAY	THURSDAY	FRIDAY	SATURDAY
			1 ☿ 6:52 am ☿ 6:37 pm ☍◇ 11:44:39 ☽ 12:12 am ☾ 3:56 pm ♑ Capricorn	**2** ☿ 6:53 am ☿ 6:35 pm ☍◇ 11:41:59 ☽ 1:20 am ☾ 4:28 pm ♒ Aquarius	**3** ☿ 6:54 am ☿ 6:34 pm ☍◇ 11:39:20 ☽ 2:31 am ☾ 4:55 pm ♒ Aquarius	**4** ☿ 6:55 am ☿ 6:32 pm ☍◇ 11:36:40 ☽ 3:44 am ☾ 5:20 pm ♓ Pisces
5 ☿ 6:57 am ☿ 6:31 pm ☍◇ 11:34:00 ☽ 4:57 am ☾ 5:44 pm ♓ Pisces	**6** ☿ 6:58 am ☿ 6:29 pm ☍◇ 11:31:21 ☽ 6:12 am ☾ 6:08 pm ♈ Aries	**7** ☿ 6:59 am ☿ 6:27 pm ☍◇ 11:28:42 ☽ 7:29 am ☾ 6:35 pm ♈ Aries	**8** ☿ 7:00 am ☿ 6:26 pm ☍◇ 11:26:03 ☽ 8:49 am ☾ 7:05 pm ♉ Taurus	**9** ☿ 7:01 am ☿ 6:24 pm ☍◇ 11:23:25 ☽ 10:11 am ☾ 7:43 pm ♉ Taurus	**10** ☿ 7:02 am ☿ 6:23 pm ☍◇ 11:20:47 ☽ 11:32 am ☾ 8:30 pm ♊ Gemini	**11** ☿ 7:03 am ☿ 6:21 pm ☍◇ 11:18:09 ☽ 12:46 pm ☾ 9:28 pm ♊ Gemini

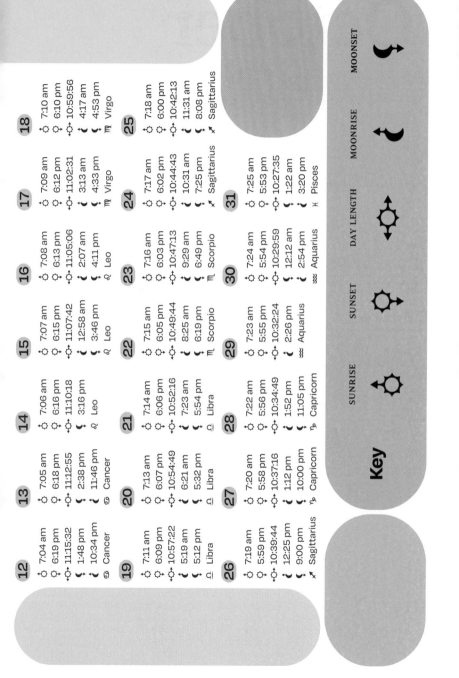

12
- ☼ 7:04 am
- ☾ 6:19 pm
- ☼↔☼ 11:15:32
- ☽ 1:48 pm
- ☽ 10:34 pm
- ♋ Cancer

13
- ☼ 7:05 am
- ☾ 6:18 pm
- ☼↔☼ 11:12:55
- ☽ 2:38 pm
- ☽ 11:46 pm
- ♋ Cancer

14
- ☼ 7:06 am
- ☾ 6:16 pm
- ☼↔☼ 11:10:18
- ☽ 3:16 pm
- ♌ Leo

15
- ☼ 7:07 am
- ☾ 6:15 pm
- ☼↔☼ 11:07:42
- ☽ 12:58 am
- ☽ 3:46 pm
- ♌ Leo

16
- ☼ 7:08 am
- ☾ 6:13 pm
- ☼↔☼ 11:05:06
- ☽ 2:07 am
- ☽ 4:11 pm
- ♌ Leo

17
- ☼ 7:09 am
- ☾ 6:12 pm
- ☼↔☼ 11:02:31
- ☽ 3:13 am
- ☽ 4:33 pm
- ♍ Virgo

18
- ☼ 7:10 am
- ☾ 6:10 pm
- ☼↔☼ 10:59:56
- ☽ 4:17 am
- ☽ 4:53 pm
- ♍ Virgo

19
- ☼ 7:11 am
- ☾ 6:09 pm
- ☼↔☼ 10:57:22
- ☽ 5:19 am
- ☽ 5:12 pm
- ♎ Libra

20
- ☼ 7:13 am
- ☾ 6:07 pm
- ☼↔☼ 10:54:49
- ☽ 6:21 am
- ☽ 5:32 pm
- ♎ Libra

21
- ☼ 7:14 am
- ☾ 6:06 pm
- ☼↔☼ 10:52:16
- ☽ 7:23 am
- ☽ 5:54 pm
- ♎ Libra

22
- ☼ 7:15 am
- ☾ 6:05 pm
- ☼↔☼ 10:49:44
- ☽ 8:25 am
- ☽ 6:19 pm
- ♏ Scorpio

23
- ☼ 7:16 am
- ☾ 6:03 pm
- ☼↔☼ 10:47:13
- ☽ 9:29 am
- ☽ 6:49 pm
- ♏ Scorpio

24
- ☼ 7:17 am
- ☾ 6:02 pm
- ☼↔☼ 10:44:43
- ☽ 10:31 am
- ☽ 7:25 pm
- ♐ Sagittarius

25
- ☼ 7:18 am
- ☾ 6:00 pm
- ☼↔☼ 10:42:13
- ☽ 11:31 am
- ☽ 8:08 pm
- ♐ Sagittarius

26
- ☼ 7:19 am
- ☾ 5:59 pm
- ☼↔☼ 10:39:44
- ☽ 12:25 pm
- ☽ 9:00 pm
- ♐ Sagittarius

27
- ☼ 7:20 am
- ☾ 5:58 pm
- ☼↔☼ 10:37:16
- ☽ 1:12 pm
- ☽ 10:00 pm
- ♑ Capricorn

28
- ☼ 7:22 am
- ☾ 5:56 pm
- ☼↔☼ 10:34:49
- ☽ 1:52 pm
- ☽ 11:05 pm
- ♑ Capricorn

29
- ☼ 7:23 am
- ☾ 5:55 pm
- ☼↔☼ 10:32:24
- ☽ 2:26 pm
- ♒ Aquarius

30
- ☼ 7:24 am
- ☾ 5:54 pm
- ☼↔☼ 10:29:59
- ☽ 12:12 am
- ☽ 2:54 pm
- ♒ Aquarius

31
- ☼ 7:25 am
- ☾ 5:53 pm
- ☼↔☼ 10:27:35
- ☽ 1:22 am
- ☽ 3:20 pm
- ♓ Pisces

Key

SUNRISE	SUNSET	DAY LENGTH	MOONRISE	MOONSET
☼	☼	☼	☾	☽

October

Astrology

Welcome to October, a month infused with mystery, magic, and manifestation. In addition to all the spooky celebrations and fall festivities this month generally brings, it also offers an opportunity to enter a new era of independence, authority, and self-validation. This is because, on Oct. 6, a radiant Aries full moon will illuminate the sky, empowering you to take bold action and confront any challenges with courage and confidence. In addition to the fierce Aries full moon, transformative Pluto—the planet of power and persuasion—will turn direct in rebellious Aquarius on Oct. 13, signaling a roaring shift in how we utilize and value technology, social activism, and community. What have you learned about the role technology, social justice, and networking community play in your life? How will you implement your learning for the greater good? To sweeten this month's introspective vibes, the Libra new moon on Oct. 21 promises to inject more romance and intentionality into your partnerships. If ready to take things to another level, you'll get the green light to dig deeper with your partner once the sun enters Scorpio on Oct. 22. Let the love pour in!

Phenology Calendar

October signals the end of goldenrod blooming. Ginkgo trees drop their fruit, which lie rotting on the sidewalk. Unable to decompose into soil, they fill the air with their strangely comforting, absolutely foul dog shit smell.

Herbal Tips

BLUE LOTUS

With the passing of the Fall Equinox, October marks the beginning of the dark time, when the nights become longer than the day. In many cultures worldwide, this time of the year is thought to be a portal into the liminal realm: a time for honoring our ancestors and tapping into our subconscious.

The Blue Lotus flower is traditionally known to be a gateway to the divine. For centuries, Blue Lotus has been respected as an ancestral visionary flower known to induce deep meditative energy, enhance third eye function and motivate lucid dreaming. The effects of the Blue Lotus, or Blue Waterlily, can be euphoric, while helping to decompress the nervous system and relax the whole body and mind.

Unending metamorphosis

On shape-shifting caterpillars, moth-like men, and the healing that comes with transformation.

WILLA KÖERNER

Last April, on a warm spring day, I went hiking at a defunct woodland quarry with a couple of friends. As we began our climb from the parking area into the forest, all was still— except for, well, *something.*

Pausing to listen, we heard an intermittent crackling, sort of like the pitter-patter of rain landing on dry leaves. It was odd, but we didn't think much of it. Later, upon entering the deeper woods, the sound got louder and more perturbing. That's when we finally noticed them: *The caterpillars.* They were everywhere— hanging on silken threads, dangling from chewed-up leaves, crawling across the trail, clustering on lichen-covered tree trunks, and inching along every. single. branch.

In that moment, it was like the forest suddenly shape-shifted from a soothing

While my research exposed spongy moths to be just as terrible as I feared, it also revealed one thing that comforted me: **Their unending metamorphosis.** As caterpillars, spongy moths wreak havoc starting in early spring. But come summer, they always transform into moths and fly away. This inevitable transformation brings relief to infested forests. And usually, the defoliated trees will have enough time left in the season to capture the carbohydrates necessary to regrow their leaves, and to heal.

We humans have much to learn about the regenerative possibilities inherent in personal and planetary transformation. As true agents of metamorphosis, moths (and spongy moths in particular) offer a particularly grounding glimpse into

cosmic illustrations captivated viewers with their delicately rendered depictions of sumptuous galaxies, patterned planets, and solar and lunar phenomena. His images were so stunning, in fact, that he was asked to join the staff at Harvard's observatory. Some of his pastel works were exhibited at the first World's Fair in Philadelphia alongside Alexander Graham Bell's telephone and the torch-bearing arm of the Statue of Liberty. Later, he even had a lunar crater named in his honor.

I'm not sure whether Trouvelot himself would have considered his vocational pivot a kind of "metamorphosis," or if he even understood the gravity of the harm he unleashed on North America prior to his career as an artist. But viewed through an historical lens, it's interesting to hold two truths about Trouvelot: He did an awful thing, but he was not an awful man.

greenlit canopy into an ominous mass of fuzzy, black-and-brown caterpillars. To my horror, I realized we were caught in a full-blown infestation of larval spongy moths. The strange sound was a combination of the caterpillars chewing leaves, shedding skin, and dropping their poop from the trees.

While I've certainly seen individual trees infested with caterpillars, I'd never seen anything like this, where the entire forest was simply overrun. It was shocking and frightening, and compelled me to research the situation.

As I feared, populations of invasive spongy moths have been absolutely ballooning in the Northeast over the past few years. And, as many people witnessed in their own backyards this spring, the destruction they cause can be downright distressing. They feed on almost any kind of tree, and when their populations explode, they can leave an entire forest's canopy looking like Swiss cheese in just a few weeks. In the eastern U.S. alone, it's estimated that spongy moths defoliate an average of 700,000 acres each year. In 2023—when the infestation wasn't even as bad as this past year—the caterpillars defoliated 441,000 acres in Pennsylvania alone. That's half a year's worth of defoliation coming from *just one state*. But during a truly bad year, as we experienced in 2024, they can do far more damage.

the cyclical processes of harm and healing. And, strangely, the story of the species' introduction to North America opens a portal into an even deeper exploration.

In 1869, the French artist and amateur entomologist Étienne Léopold Trouvelot unwisely introduced the first spongy moths to North America by bringing their eggs from Europe to the far-away Boston suburb where he lived. Trouvelot wanted to try breeding them with North American moths as a way to potentially create cold-hardy silkworms. His plan went haywire when some of them "escaped" out of his open window and began to breed in the woods beyond his house. Now, over 150 years later, the caterpillars have spread across more than half of this country and can be found in at least 27 states.

After committing such a heedless act, it'd be easy to think of Trouvelot as a villain. But, just as nocturnal moths use the moon and stars to navigate, Trouvelot was guided by the cosmos towards a personal transformation. Shortly after the escaped-larvae incident, he pivoted his vocational focus away from entrepreneurial bug-breeding, and ended up finding a tremendous amount of success as an astronomical artist.

At a time when the wonders of astrophotography had yet to permeate the public sphere, Trouvelot's

Interestingly, Trouvelot was working on his astronomical drawings at the same time that another moth-like artist, Eadweard Muybridge, was wrapped up in his own metamorphosis. But while Trouvelot worked to illustrate images of the heavens, Muybridge was more interested in capturing Earthly phenomena—most especially the real-time transformation of bodies in motion.

Born in England as "Edward Muggeridge," he left home at the age of 20 to seek his fortune in America, setting up shop as a bookseller in San Francisco during the gold rush. A few years later, he took a cross-country stagecoach trip and ended up in a violent crash that killed his driver and left him with a traumatic head injury. While Muybridge eventually recovered, the crash severely altered his character. Upon his return to California a decade and a half later, friends stated that he had completely changed from a "smart and pleasant businessman" into an "eccentric, erratic, and unstable artist."

Muybridge soon adopted the pseudonym "Helios," which means "Titan of the sun," and became utterly obsessed with pursuing new ways of capturing the world around him. In his transformed state, he pioneered multiple forms of photography—from stop-motion to 360-degree panoramas to zoopraxiscope

THE NOVEMBER METEORS.

cycles. As I've continued to research spongy moths, I've been relieved to learn that infestations of the caterpillars are, or at least have been, cyclically self-regulating. Their population growth follows a boom-and-bust pattern thanks to two ailments (a virus and fungus, which threaten to either liquify or dehydrate their bodies, respectively) that seem to infect them like clockwork. After about a decade of rapid proliferation, the vast quantities of caterpillars become unsustainable and the infections tend to spread. From there, as if the laws of nature ruled them out of hand, their populations collapse.

Just prior to publishing this essay, someone I trust to know about this stuff told me this year's spongy moth population is already in the process of collapsing. She said she saw their dead, virus-infected corpses raining down from the trees.

Perhaps to shapeshift is to survive, but also to die. While metamorphosis brings relief, it can also kill us—but in our place, something else can heal, or be born. Both Trouvelot and Muybridge experienced intense personal metamorphoses. They were both, at times, awful men. But their lives and work also captured motion, and duality, and the magic of unending transformation. Above, Trouvelot's illustration of a meteor shower shows multiple shooting stars superimposed together in the night sky, like a timelapse photograph—a new concept for his time. He called this way of rendering the meteors "an ideal view," as it captured the sky in motion.

To the right, Muybridge's series, Animal Locomotion, documents movement in a way that was entirely groundbreaking. For the first time, we could see the fractional

displays, a predecessor of modern film—which brought our species entirely new ways of seeing and understanding the world.

But at the age of 41, just as his career was truly on the rise, Muybridge shot and killed his 21-year-old wife's lover in cold blood. When put on trial for murder, his attorney pleaded insanity on his behalf, and Muybridge was acquitted. Later, he sent his only son—who he suspected to have been fathered by the man he killed—to an orphanage.

It would seem that in each life, there are unsettling pieces that feel incongruous to the broader story. In ecosystems, too, the gruesome act of transformation creates a constant oscillation between good and bad, life and death—for better and worse.

While there is nothing stable about transformation, at least we can depend on the forward momentum of life's unending

moments that carry animals—including us—through space and time, from the past into the future.

As humans, we have an innate tendency to think linearly, and to view each other, and our world, two-dimensionally. We see villains or heroes instead of complicated human creatures. We decry the caterpillars' devastation instead of celebrating the tremendous ability of the trees to heal— instead of trusting that nature will find its own way to reestablish equilibrium. We're often unable to hold the vast nuance of our planet, and of our lives, in a way that enables us to see both beauty and brutality coexisting. But life is a strange, infinite circuitry as terrible as it is awe-inspiring.

It makes me hopeful to think that, right now, our species is in caterpillar mode. As we voraciously hurtle forward, overconsumption is our priority— but metamorphosis is inevitable. In the wake of our devastation, transformation will bring relief. And just as the forests still have time to heal, so do we.

Where Moonlight Meets the Ground.

DEBARATI SARKAR

164

November

THE 11TH MONTH | 30 DAYS

NOVEMBER 1ST
Fall back 1 hour.

 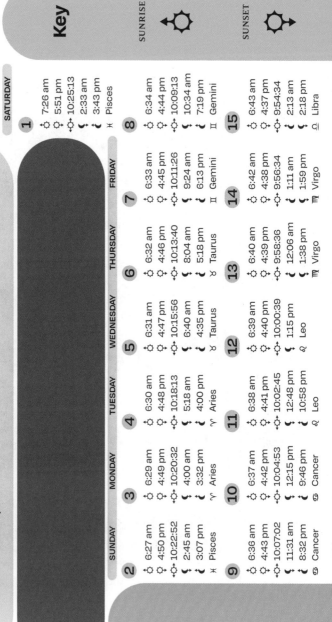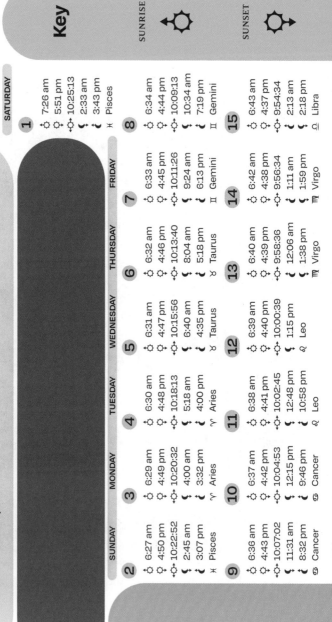
	SUNDAY	MONDAY	TUESDAY	WEDNESDAY	THURSDAY	FRIDAY	SATURDAY
							1 ☼ 7:26 am ☼ 5:51 pm ☼ 10:25:13 ☽ 2:33 am ☾ 3:43 pm ♓ Pisces
2	☼ 6:27 am ☼ 4:50 pm ☼ 10:22:52 ☽ 2:45 am ☾ 3:07 pm ♓ Pisces	**3** ☼ 6:29 am ☼ 4:49 pm ☼ 10:20:32 ☽ 4:00 am ☾ 3:32 pm ♈ Aries	**4** ☼ 6:30 am ☼ 4:48 pm ☼ 10:18:13 ☽ 5:18 pm ☾ 4:00 pm ♈ Aries	**5** ☼ 6:31 am ☼ 4:47 pm ☼ 10:15:56 ☽ 6:40 am ☾ 4:35 pm ♉ Taurus	**6** ☼ 6:32 am ☼ 4:46 pm ☼ 10:13:40 ☽ 8:04 am ☾ 5:18 pm ♉ Taurus	**7** ☼ 6:33 am ☼ 4:45 pm ☼ 10:11:26 ☽ 9:24 am ☾ 6:13 pm Ⅱ Gemini	**8** ☼ 6:34 am ☼ 4:44 pm ☼ 10:09:13 ☽ 10:34 am ☾ 7:19 pm Ⅱ Gemini
9	☼ 6:36 am ☼ 4:43 pm ☼ 10:07:02 ☽ 11:31 am ☾ 8:32 pm ♋ Cancer	**10** ☼ 6:37 am ☼ 4:42 pm ☼ 10:04:53 ☽ 12:15 pm ☾ 9:46 pm ♋ Cancer	**11** ☼ 6:38 am ☼ 4:41 pm ☼ 10:02:45 ☽ 12:48 pm ☾ 10:58 pm ♌ Leo	**12** ☼ 6:39 am ☼ 4:40 pm ☼ 10:00:39 ☽ 1:15 pm ♌ Leo	**13** ☼ 6:40 am ☼ 4:39 pm ☼ 9:58:36 ☽ 12:06 am ☾ 1:38 pm ♍ Virgo	**14** ☼ 6:42 am ☼ 4:38 pm ☼ 9:56:34 ☽ 1:11 am ☾ 1:59 pm ♍ Virgo	**15** ☼ 6:43 am ☼ 4:37 pm ☼ 9:54:34 ☽ 2:13 am ☾ 2:18 pm ♎ Libra

| | DAY LENGTH | MOONRISE | MOONSET |

16
- ☼ 6:44 am
- ☼ 4:36 pm
- ◇ 9:52:36
- ☾ 3:14 am
- ☾ 2:38 pm
- ♎ Libra

17
- ☼ 6:45 am
- ☼ 4:36 pm
- ◇ 9:50:40
- ☾ 4:15 am
- ☾ 2:59 pm
- ♎ Libra

18
- ☼ 6:46 am
- ☼ 4:35 pm
- ◇ 9:48:47
- ☾ 5:17 am
- ☾ 3:23 pm
- ♏ Scorpio

19
- ☼ 6:47 am
- ☼ 4:34 pm
- ◇ 9:46:56
- ☾ 6:20 am
- ☾ 3:51 pm
- ♏ Scorpio

20
- ☼ 6:49 am
- ☼ 4:34 pm
- ◇ 9:45:07
- ☾ 7:23 am
- ☾ 4:25 pm
- ♐ Sagittarius

21
- ☼ 6:50 am
- ☼ 4:33 pm
- ◇ 9:43:21
- ☾ 8:24 am
- ☾ 5:07 pm
- ♐ Sagittarius

22
- ☼ 6:51 am
- ☼ 4:32 pm
- ◇ 9:41:38
- ☾ 9:20 am
- ☾ 5:56 pm
- ♐ Sagittarius

23
- ☼ 6:52 am
- ☼ 4:32 pm
- ◇ 9:39:57
- ☾ 10:09 am
- ☾ 6:53 pm
- ♑ Capricorn

24
- ☼ 6:53 am
- ☼ 4:31 pm
- ◇ 9:38:19
- ☾ 10:51 am
- ☾ 7:56 pm
- ♑ Capricorn

25
- ☼ 6:54 am
- ☼ 4:31 pm
- ◇ 9:36:43
- ☾ 11:26 am
- ☾ 9:02 pm
- ♒ Aquarius

26
- ☼ 6:55 am
- ☼ 4:30 pm
- ◇ 9:35:11
- ☾ 11:56 am
- ☾ 10:09 pm
- ♒ Aquarius

27
- ☼ 6:56 am
- ☼ 4:30 pm
- ◇ 9:33:41
- ☾ 12:21 pm
- ☾ 11:17 pm
- ♒ Aquarius

28
- ☼ 6:57 am
- ☼ 4:30 pm
- ◇ 9:32:15
- ☾ 12:44 pm
- ♓ Pisces

29
- ☼ 6:58 am
- ☼ 4:29 pm
- ◇ 9:30:51
- ☾ 12:25 am
- ☾ 1:07 pm
- ♓ Pisces

30
- ☼ 6:59 am
- ☼ 4:29 pm
- ◇ 9:29:31
- ☾ 1:36 am
- ☾ 1:30 pm
- ♈ Aries

Adopt a Senior Pet Month

Beaver Moon
Named for the beavers who get very busy preparing for the colder months.

November

Herbal Tips

SCORPIO: PASSION, ENERGY, PURIFICATION

Scorpio is ruled by the planets Mars and Pluto, which govern our sexual and reproductive organs; the urinary tract and bladder; the mouth; as well as sensuality and intimacy.

The Herbs of Scorpio:

Devil's Club is said to ward off negative energies and add a protective shield. It helps balance hormones and aids the reproductive system.

Hibiscus is often associated with passion, love and sensuality. Its lush appearance mirrors Scorpio's ability to dive into the depths of their emotions.

Pau D'Arco bark is associated with renewal and resiliency. It protects the body from viruses, bacteria and other harm.

Dragon's Blood resin is associated with Scorpio traits such as protection + strength, transformation + renewal, intuition + personal power.

Nettle root is linked with strength and vitality. Scorpio's, who often display tremendous strength and resilience in facing challenges, might connect with this herb's ability to boost endurance during intense moments.

Damiana is well known for its aphrodisiac properties and ability to enhance passion and sensuality.

Bloodroot is associated with protection and strength, and its healing properties can be connected to Scorpio's transformative nature: symbolizing the ability to heal and regenerate.

Astrology

November signifies a period of introspection and appreciation for the abundance in our lives. It encourages us to reflect on our journey, express gratitude for our blessings, and begin thinking about intentional goals for the upcoming year. This is also reflected in November's astrology as it starts with Mercury —the planet of thought and transportation— stationing retrograde in generous Sagittarius on Nov. 9. When Mercury goes retrograde in Sagittarius, it prompts us to review our beliefs, philosophies, and how we communicate our truths. Another critical moment occurs on Nov. 11 when Jupiter stations retrograde in Cancer, inviting us to delve into our emotions, family dynamics, and sense of security. If you haven't visited distant relatives in a while, the sun's entrance into Sagittarius on Nov. 21 is an excellent time to invite them over or plan a visit for December. The month ends with Saturn turning direct in Pisces on Nov. 27 and Mercury turning direct in Scorpio on Nov. 29. This direct motion prompts us to apply the wisdom gained from introspection and spiritual exploration, allowing us to manifest our visions with discipline and practicality.

Phenology Calendar

In November, Rockefeller Center ice rink opens, that gigantic tree goes up, and tourists clog every artery of the city. Whooping cranes, swans, hawks, Canada geese, and every wealthy occupant who can afford to do so, head south for the winter.

Venom is a Protein

YASAMAN SHERI

I had just landed at LAX from Berlin when my lover picked me up from the airport, two boards, let's go. We were on our way to Seal Beach to surf. It was hot, as Los Angeles tends to be in November, a week or two after my birthday. We arrived at sunset, the Pacific Ocean drenched in crimson sun. They say when you surf, you leave your thoughts at the beach, and that's exactly what I do—not only my thoughts, but also my phone. Only me and my board in the water; no scrolling, no thinking. That's why I like surfing, my mind in a trance state, a corporeal feeling. My gestures become slower, more sensual and choreographed. I move through water with my arms: an oceanic dance.

We jump in and paddle out with our boards. To catch a wave, you have to paddle faster and faster to reach the same speed as the water moving towards the shore. When we—the wave and I—are the same speed, I hop on and let it push me into a balance. Every wave is different, just as is every time of day, month, and year is different.

I was tired from the travel and jet lagged. Nothing beats a 14 hour flight, sitting without limb movement in an enclosed air vehicle, like jumping in cold saltwater, surrounded by Californian marine flora and fauna. The water was not as cold or velvety as I'd fantasized. It was windy, the waves were chaotic, and the tide was low. Frustrated and exhausted after barely catching any waves, I decided to go to shore. But with the waves hitting me in every direction, I could barely stand up straight. It was not an elegant choreography: I had no control over my movements, the ocean pushed me in every possible direction as if it didn't care about me, was maybe even upset with

me. It can be beautiful to see wilderness as a reminder that you have to relinquish control and let water move you in ways you can't fully anticipate.

But this time, ungraceful, my body was being smacked down, and as I struggled to get to the shore, I suddenly felt a sharp pain, as though something had bitten my foot. Chills rushed over my body, not only was I suddenly very cold, I panicked. Did I get bit by a shark? Within seconds, I felt the heaviest pain that sucked my breath. I screamed uncontrollably, but my voice was lost in the orchestra of crashing waves and wind. Fear grasped any remaining power I had over my body. Strings of crimson coursed from below the surface to the water around me. I limped as fast as I could to the beach, pushing against what felt like walls of heavy concrete, waves battering me in every direction. As I neared the shore, I screamed for help. I was terrified to look at my foot. My lover was nowhere to be found.

Life guards dragged me out of the water and told me: I had been stung by a very large stingray directly in my big toe, split open. The pain escalated to the point where the only sound coming from me was painfully uncomfortable to hear. Was I possessed by an ocean demon? This was a new state of trance, a new bodily choreography: the dance of venomous pain. As the venom entered my bloodstream, shooting up to my heart, my entire leg became numb. In my ovaries and pelvis sharp pains pulsated. I'm going to die, I thought. As if the stingray was trying to knock out my reproductive organs.

The three lifeguards, with their tan, toned bodies, knew the drill: Soak the

foot in scalding hot water—*Venom is a protein, and hot water breaks it down.* Are lifeguards nurses of the oceanic wilderness? When you are in a state of excruciating pain, the mind finds the fastest grasps at care. Three lifeguards holding my leg and telling me I'm going to live; three attractive, knowledgeable men giving me undivided attention and respect, felt like a temporary anti-venom. The pain of the venom subsided within 2-3 hours and my toe took many months to heal. I still have PTSD and replay the incident in my mind. I even have dreams about it. I felt both afraid of the stingray and enamored by the animal's power. I want to like it so I don't have to be afraid of it. I want to replace my fear with kinship.

Seal Beach is home to some of the largest habitats of stingrays. When the water gets warm, the stingrays migrate, especially in low tide. California has tried many ways to discourage their population growth or to find ways of removal, but instead of finding ways of displacing or destroying these species, humans are now taught to coexist with stingrays but doing the "shuffle," whereby one slowly shakes the foot before putting down each step. It is a choreography of communion, expression of proximity.

In western cultures, venomous animals are often considered as villains or scary. We can see this in movies, cartoons, caricatures, and even graphic novels and comics. Snakes, Stingrays, Spiders, Scorpions. This fear and sense of danger has created a way of looking, a perception compounded by the stories we tell without ever encountering them. Yet in cultures that have had a closer relationship with wilderness, the peoples of those lands have a closer understanding of and empathy for the diversity of species, with methods of respectful coexistence. In some indigenous Brazilian cultures, for instance, it's a sign of luck if a stingray attacks you. The more painful the sting, the luckier the sign.

The relationship to human power over other species is a profound one. While stories of kinship around mushrooms, mycelium, pets, and flowers are starting points of interspecies communion, it's easy to forget our relationship to power and

control. Venomous animals and insects remind us to consider different forms of coexistence and ecological empathy. By changing the stories and relationships to the animals around us we can also begin to move beyond the binary of good and bad, villain and hero, evil and not.

What is danger? Dangerous to whom? Why? The environment is meant for many. How might we co-exist? Danger is a matter of perspective: who's home might we be entering when we swim in the ocean? Venom serves as a defense mechanism—to immobilize, to kill prey for consumption, or to deter a predator from stepping on one's home. While most venoms are much more complex than simply a protein, containing various toxins and enzymes that affect the nervous system, it's interesting to consider the material relationship to one another: Bodily fluids mixing with the human bloodstream. The stingray not only hurt me; it also engaged in a very intimate and physical molecular conversation with me. Maybe even a part of it is inside me.

There is something profound about the ocean, that vast mass of water. It reminds us about our relationship to nature in ways that cities simply can't. Water has ways of transforming, it's not static, and we can't master it by exerting control, no matter how hard we try. The dance is to learn to move with it, lean into the way it pushes and pulls you, embody it as an extra force to propel or, as surfers say, become one with it and ride it. The moon's gravitational pull causes tides to change. To be a surfer is to embrace change: celestial bodies are changing, waves are changing, the tide is changing, the ocean is changing—and it is much larger than any human body. It requires far less force for us to change too.

Since my injury, my body has developed a new relationship with the ocean, one of coexistence not only with water but with many species, especially those with the power—and willingness—to protect their living space. I am a guest in their home, a visitor in their gorgeous, velvety life.

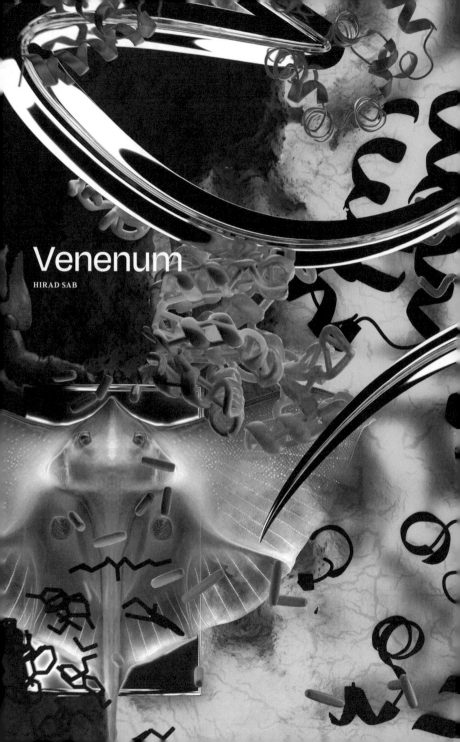

Venenum

HIRAD SAB

December

THE 12TH MONTH | 31 DAYS

Cold Moon
Named for the start of winter.

National Tie Month

SUNDAY	MONDAY	TUESDAY	WEDNESDAY	THURSDAY	FRIDAY	SATURDAY
	1 ☿ 7:00 am ♀ 4:29 pm ☿ 9:28:14 ☽ 2:50 am ☽ 1:56 pm ♈ Aries	**2** ☿ 7:01 am ♀ 4:29 pm ☿ 9:27:00 ☽ 4:07 pm ☽ 2:26 pm ♉ Taurus	**3** ☿ 7:02 am ♀ 4:28 pm ☿ 9:25:50 ☽ 5:29 am ☽ 3:04 pm ♉ Taurus	**4** ☿ 7:03 am ♀ 4:28 pm ☿ 9:24:43 ☽ 6:52 am ☽ 3:54 pm ♊ Gemini	**5** ☿ 7:04 am ♀ 4:28 pm ☿ 9:23:39 ☽ 8:09 am ☽ 4:55 pm ♊ Gemini	**6** ☿ 7:05 am ♀ 4:28 pm ☿ 9:22:39 ☽ 9:15 am ☽ 6:08 pm ♋ Cancer
7 ☿ 7:06 am ♀ 4:28 pm ☿ 9:21:43 ☽ 10:06 am ☽ 7:25 pm ♋ Cancer	**8** ☿ 7:07 am ♀ 4:28 pm ☿ 9:20:50 ☽ 10:45 am ☽ 8:41 pm ♌ Leo	**9** ☿ 7:08 am ♀ 4:28 pm ☿ 9:20:01 ☽ 11:16 am ☽ 9:53 pm ♌ Leo	**10** ☿ 7:09 am ♀ 4:28 pm ☿ 9:19:16 ☽ 11:41 am ☽ 11:00 pm ♍ Virgo	**11** ☿ 7:10 am ♀ 4:28 pm ☿ 9:18:34 ☽ 12:03 pm ♍ Virgo	**12** ☿ 7:10 am ♀ 4:28 pm ☿ 9:17:57 ☽ 12:05 am ☽ 12:23 pm ♍ Virgo	**13** ☿ 7:11 am ♀ 4:29 pm ☿ 9:17:23 ☽ 1:07 am ☽ 12:42 pm ♎ Libra

Day	Sunrise	Sunset	Day Length	Moonrise	Moonset	Zodiac
14	7:12 am	4:29 pm	9:16:53	2:08 am	1:03 pm	♎ Libra
15	7:13 am	4:29 pm	9:16:27	3:10 am	1:26 pm	♏ Scorpio
16	7:13 am	4:29 pm	9:16:05	4:12 am	1:53 pm	♏ Scorpio
17	7:14 am	4:30 pm	9:15:48	5:15 am	2:25 pm	♏ Scorpio
18	7:15 am	4:30 pm	9:15:34	6:16 am	3:04 pm	♐ Sagittarius
19	7:15 am	4:31 pm	9:15:24	7:14 am	3:52 pm	♐ Sagittarius
20	7:16 am	4:31 pm	9:15:18	8:06 am	4:47 pm	♑ Capricorn
21	7:16 am	4:31 pm	9:15:16	8:51 am	5:49 pm	♑ Capricorn
22	7:17 am	4:32 pm	9:15:19	9:28 am	6:55 pm	♑ Capricorn
23	7:17 am	4:33 pm	9:15:25	9:59 am	8:02 pm	♒ Aquarius
24	7:18 am	4:33 pm	9:15:36	10:25 am	9:09 pm	♒ Aquarius
25	7:18 am	4:34 pm	9:15:50	10:48 am	10:15 pm	♓ Pisces
26	7:18 am	4:34 pm	9:16:09	11:10 am	11:23 pm	♓ Pisces
27	7:19 am	4:35 pm	9:16:32	11:32 am		♈ Aries
28	7:19 am	4:36 pm	9:16:58	12:33 am	11:56 am	♈ Aries
29	7:19 am	4:37 pm	9:17:29	1:46 am	12:23 pm	♉ Taurus
30	7:19 am	4:37 pm	9:18:03	3:03 am	12:56 pm	♉ Taurus
31	7:19 am	4:38 pm	9:18:42	4:23 am	1:38 pm	♉ Taurus

Key

SUNRISE SUNSET DAY LENGTH MOONRISE MOONSET

December

Phenology Calendar

December brings the first snowfall and the shortest day of the year. New York City is at its most cinematic.

Herbal Tips

RECIPE: IMMUNE BOOSTING MOON PIE

Celebrate the Winter Solstice with this exquisite Immune Boosting Moon Pie! Recipe by Silvia Bifaro for Anima Mundi Herbals.

INGREDIENTS

JAM FILLING

· 1 jar blackcurrant jam
· 1 punnet forest berries of your choice
· 1 Tbsp Euphoria Powder
· 3 Tbsp Black Elderberry Syrup
· 2 tsp cornstarch or arrowroot powder

CRUST

· 2 + 1/4 C all-purpose flour
· 3 Tbsp raw sugar
· 1/4 tsp sea salt
· 9 3/4 C cold vegan butter
· 3 Tbsp ice-cold water

INSTRUCTIONS

JAM FILLING

Mix all the filling ingredients with cornstarch or arrowroot to absorb the moisture. Slightly cook if still too runny and add 1 Tbsp flour. Set aside.

CRUST

Mix flour, sugar, and salt together in a bowl. Cube the butter into small pieces. Add the diced butter to the dry ingredients, and using your fingertips or the dough machine, work until the dough is crumbly. Drizzle with ice water, 1 Tbsp at a time, and mix gently with a fork. Press until dough comes together, but do not knead it. Press the dough into a smooth ball. Flatten into a disc, wrap in plastic, and place in the fridge for at least one hour. Remove the dough from the fridge and let it rest for a few minutes at room temperature. Roll out half the dough into a large circle about 4 mm thick, on a lightly floured surface.

ASSEMBLE

Place into a pie dish and cut the excess (save for designs!). Fill in with the jam mixture. Roll the other half and cut a half-circle big enough to cover half the pie dish. Cut out 3 circles and 2 half circles following the image and use the cut-out pieces to create the moons on the jam. Cut stars from the leftover dough. Decorate and freeze for 15-20 minutes. Turn on the oven to 375°F. Take the pie straight from the freezer and bake on a medium lower rack for about 30 minutes or until the crust is golden. Serve warm or room temperature. Enjoy!

Astrology

Embrace the spirit of festivity as December's horoscope sets the stage for meaningful connections and spiritual evolution. The month begins with Neptune ending its retrograde in Pisces on Dec. 10. Neptune—the planet of spirituality, dreams, and intuition—moving direct in its home sign of Pisces, can bring about a sense of clarity and spiritual renewal. This is especially important for those looking to take a calculated risk during the liberating Sagittarius new moon on Dec. 19. The final new moon of the year invites you to embrace a spirit of open-mindedness, pursue new experiences, and broaden your horizons. To help keep you grounded, the sun will zoom into conservative Capricorn on Dec. 21, also known as the winter solstice. As Capricorn embodies qualities of ambition, responsibility, and long-term planning, the winter solstice and the onset of Capricorn season are ideal for setting practical goals, working diligently, and embracing a heightened sense of determination and resilience. Additionally, the entry of Venus into Capricorn on Dec. 24 and Juno—the asteroid of marriage and unity—into Capricorn on Dec. 29 emphasizes themes of commitment, stability, and the importance of building enduring relationships. End the year celebrating love.

Live From Gaza

VIVIEN SANSOUR

Cats nibbling slowly on your flesh

There is all of you to eat and all the time
they need

20 hours I am watching you bleeding and
then stop breathing

and in this moment eaten too

by wild stray cats

Your brother's body next to me shivering
of cold

Losing blood

Father call 101

Father get an ambulance

Officer I beg you I am watching my second
son die and you can let the ambulance in

"Rady 3ani yaba"

You ask me: are you pleased with me
father?

I want to die knowing that you are
pleased with me

That the days I made you mad have not
stayed with you

That my playfulness never hurt you

That I am in the grace of God a son whose
father is pleased with

Forgive me my sons, I screamed, I called
all news agencies, my voice was even
broadcasted on live television pleading for
the soldiers to let the medics in

I even plead that they would let me try
to walk

I would have carried you on my back

The distance between your life and your
death was only one kilometer

But the distance between my begging and
the soldier's heart was infinite

And I heard you my father, all the way from Saudi Arabia I saw you and Ibrahim and my other brother Qassim, I saw you father you were pleading

You were scrapping the gravel with your skin

You were on your knees

Your voice was loud and clear through the waves

Live from Gaza:

"My eldest son just died in front of me, my other son is bleeding to death, the ambulance is here, call on Israeli soldiers to let them in, the hospital is near let me at least walk!"

I heard you father, you were loud and clear

Sitting in my living room

I watched you on live feed

I was one of the millions in their living room watching the live report from the ground in Gaza

The only difference I knew your face

My brothers faces

I recognized my brother's left toes as they were photographed like petrified wood in a forest

I recognized his mole that no one noticed

Live from Gaza father, I saw you between two dead bodies and a military commander

Collapsing into tears

Forgive me father I was in my living room

Forgive me father they would not have let me through

Forgive me father I was over a 1000 miles away

And again the hospital was less than one kilometer away

And I heard you too father

When the phone rang all the way from Saudi Arabia to Washington, DC

My brother told me

Our brothers are dead

Our father is in hospital

And we are not allowed back in

Live from Gaza

Live from Gaza

Father I am here in the heart of the American Capital

Lobbying senators

Calling human rights organizations

Speaking on radio shows

Sobbing as I speak

Can I bring Ibrahim back?

Can I bring Qassam back?

Can I even be let in to give you a hug from one of your remaining sons?

Security reasons

Security reasons

Security reasons say you and I are a security threat

The farm you raised me on is a security threat

My brother's feet are a security threat

The songs we sing, the cloths we wear, the food we eat and even our kisses are security threats

Father what do I do here

From the heart of DC

I cannot even swim from this shore to the Mediterranean Sea

I am a security threat father

My loss could make me angry

My loss could make me mad

My loss father could make me crazy

My loss father could make me into a terrorist

I throw my diplomas and certificates away

I lay them old paper to compost on this soil

Father I never belonged here

And when the good people of this land come to hold me they say

"I am so sorry about your loss"

What do I say father

Which loss

My brothers, your tears, or the heart that has been carved into pieces

Father: I answer them. I say, "I know you are good people"

Father I want to stay faithful to what I was taught

Treat people with respect

But father I am a security threat

My respect

My lack of respect

The mere fact that I am from Gaza father

Negates that I am the son of a farmer

The son of a fisherman

The humble man of the sea

My identity father is a Gazan and when people look at me

They judge me with the lies they know

Palestine does not exist
Palestine is not a country
And your people are angry people
Why do you hate us so much?

Father I will not conclude this message to
you

This is not a story that ends with the tragic
death of my brothers

I will not accept that

Father our story is not over yet and for
those tanks and soldiers that rolled into our
neighborhood and for those governments
that orchestrate our demise, and for all the
fat cats in suits on capital hill

I say

Your bombs have only fueled our anger and
our anger has just fueled our desire to live
and live and live until our justice is served

Live From Gaza

Nothing has changed

I have been released from the hospital but
my two sons are dead and the other two
are in exile.

Al-Atlal (The Ruins)

JORDAN NASSAR

Community Gardens of New York

Below are listed just a few of the many community gardens in New York State. For complete maps and lists visit:

For New York City community gardens

For New York State community gardens

Albany County

Livingston Avenue Community Garden

419 Livingston Avenue
Albany, NY

Edward Street Community Garden

7 Edward Street
Cohoes, NY

Rensselaer Family Garden

1510 5th Street
Rensselaer, NY

Broome County

Gregory Lane Community Garden

9 Gregory Lane
Binghamton, NY

Liberty Street Community Garden

79 Liberty Street
Binghamton, NY

Bronx County

Belmont Little Farmers

2485 Belmont Avenue
Bronx, NY

Dred Scott Bird Sanctuary Garden

1304 Grant Avenue
Bronx, NY

Chautauqua County

Washington Street Community Garden

Washington Street
Jamestown, NY

Allen Street Community Garden

Allen Street
Jamestown, NY

Cayuga County

Case Mansion Community Garden

180 South Street
Auburn, NY

St. Francis Park

25 Underwood Street
Auburn, NY

Chemung County

Tanglewoods Nature Rangers

215 Partridge Street
Elmira, NY

Clinton County

Plattsburgh Community Garden

4817 South Catherine Street
Plattsburgh, NY

Columbia County

Crellin Park Community Garden

Crellin Park
Chatham, NY

Salaam BIPOC Community Garden

20 School Teacher Road
Hudson, New York

Cortland County

Youth Community Garden

3 South Avenue
Cortland, NY

Delaware County

Farm Catskills

87 Sal Bren Road
Delhi, NY

Dutchess County

Red Hook Community Garden

7282-7296 South Broadway
Red Hook, NY

Fall Kill Partnership Garden

29 North Hamilton Street
Poughkeepsie, NY

Erie County

Fruitbelt Coalition

37 Mulberry Street
Buffalo, NY

Lugar Hermoso de Pedro Community Garden

Corner of Hudson Street &
West Avenue
Buffalo, NY

Essex County

Schroon Lake Community Garden

Main Street
Schroon Lake, NY

Florence Hathaway Park Community Garden

Florence Hathaway Park
Essex Road
Willsboro, NY

Franklin County

Tupper Lake Community Garden

120 Demars Boulevard
Tupper Lake, NY

Common Ground Garden

254 Old Lake Colby Road
Saranac Lake, NY

Bloomingdale Elementary School Garden

79 Canaras Avenue
Saranac Lake, NY

Fulton County

Fremont Neighborhood Garden

Fremont Street & Forest
Street
Gloversville, NY

Jefferson County

Zenda Community Garden

38973 Zenda Farm Road
Clayton, NY

Kings County

Bedford Stuyvesant Community Garden (Lola Bryant Community Garden)

95 Malcolm X Boulevard
Brooklyn, NY

El Puente: Espiritu Tierra Community Garden - Earth Spirit

203-207 South 2nd Street
Brooklyn, NY

Monroe County

In the City Off the Grid

55 Plover Street
Rochester, NY

Neighbors Together

Garson Street &
Chamberlain Street
Rochester, NY

Nassau County

Seed to Table Community Garden

171 Lakeview Avenue
Freeport, NY

Sherman Brown Community Garden

Riverside Boulevard & East
Pine Street
Long Beach, NY

New York County

133rd Swing Street Garden

155 West 133rd Street

Campos Community Garden

640-644 East 12th Street

Niagara County

Ontario Street Community Garden

Ontario Street & Hawley Street
Lockport, NY

Highland Community Vegetable Garden

1800 Beech Avenue
Niagara Falls, NY

Oneida County

Somali Bantu Community Gardens & Education Project

Vega/Martinez Community Center
1736 Armory Drive
Utica, NY

Housing Visions' Garden

40 Grant Street
Utica, NY

Ontario County

Canandaigua Churches in Action

5188 Bristol Road
Canandaigua, NY

Naples, NY Community Gardens

North End of Main Street
Naples, NY

Onondaga County

NOPL Cicero Library Farm

8699 Knowledge Lane
Cicero, NY

Rahma Clinic Edible Forest Snack Garden

3100 South Salina Street
Syracuse, NY

Otsego County

City of Oneonta Community Gardens

Wilcox Avenue
Oneonta, NY

Orange County

Newburgh Armory Community Garden

321-355 South William Street
Newburgh, NY

Port Jervis Community Garden

Intersection of North Street & Main Street
Port Jervis, NY

Orleans County

Community Action Garden

409 East State Street
Albion, NY

Oswego County

Oswego Community Garden

70 East Schuyler Street
Oswego, NY

Putnam County

Tilly Foster Community Garden

Prospect Hill Road, across from Tilly Farm Entrance
Brewster, NY

Queens County

Curtis "50 Cent" Jackson Community Garden

117-09 165th Street
Queens, NY

Rockaway Roots Urban Farm

308 Beach 58th Street
Queens, NY

Rensselaer County

The Preserve Community Garden

76 Wynantskill Way
Troy, NY

Vanderhyden & Fifth Community Garden

2541 5th Avenue
Troy, NY

Richmond County

Roots of Peace Community Garden

390 Targee Street
Staten Island, NY

Westervelt Community & Family Garden

143 Westervelt Avenue
Staten Island, NY

Rockland County

Haverstraw Community Garden

50 Broad Street
Haverstraw, NY

Nyack Community Garden

80 Depew Road
Nyack, NY

Saint Lawrence County

Ogdensburg Community Garden

Route 68 Arterial Highway
Ogdensburg, NY

Saratoga County

Saratoga Springs Community Garden

81 Lincoln Avenue
Saratoga Springs, NY

Halfmoon Heights Community Garden

24 Saratoga Drive
Halfmoon, NY

Schenectady County

Steinmetz Park Community Garden

2151 Lenox Road
Schenectady, NY

Craig & Wyllie Community Garden

981 Craig Street
Schenectady, NY

Suffolk County

YES Community Garden

555 Clayton Avenue
Central Islip, NY

Garden of Feedin'

233 North Country Road
Mt. Sinai, NY

Tompkins County

Project Growing Hope Ithaca Community Garden

Route 13 at Third Street
Ithaca, NY

The Jane Minor BIPOC Community Medicine Garden

40 Burns Road
Brooktondale, NY 14817

Ulster County

YMCA Children and Community Garden

Susan Street
Kingston, NY

New Paltz Gardens for Nutrition

51 Huguenot Street
New Paltz, NY

Wayne County

Newark Rotary Club/ Catholic Family Center of Wayne County

439 West Maple Ave
Newark, NY

Warren County

Sagamore Street Playground

Corner of Sagamore Street &
Hunter Street
Glens Falls, NY

Village Green Community Garden

South Delaware Avenue
Glens Falls, NY

Washington County

Fort Edward Community Garden

Corner of Canal Street &
East Street
Fort Edward, NY

Cambridge Community Garden

Washington Street
Cambridge, NY

Westchester County

Marsh Sanctuary Community Garden/ Intergenerate

114 South Bedford Road
Mt. Kisco, NY

Peekskill Community Garden

Route 6
Peekskill, NY

Community Fridges

A community fridge is a refrigerator stocked with free food. They are located in public spaces and enable food to be shared among members of a neighborhood. Some have attached pantries for non-perishable foods. Food can be added or taken by anyone.

International

NYC

Mutual Aid Groups of NY

Below are listed just a few of the many mutual aid groups in New York State. For more complete maps and lists visit:

Bronx

The Pillars

The PILLARS is a holistic recovery community outreach and resource center. Their comprehensive network of partnerships ensures all who are in recovery and those loving someone in active addiction can receive the support they need.

PILLARSNYC.ORG

NYC Common Pantry

NYC Common Pantry is working toward reducing hunger and food insecurities through many programs that establish long term sustainability. They distribute food that is fresh and balanced for people in need.

NYCOMMONPANTRY.ORG

Brooklyn

Environmental Action Lab

Environmental Action Lab is an environmental nonprofit that wants to help bring food justice to NYC. They offer a free urban farming mentorship program aimed towards high school students.

ENVIROACTIONLAB.COM

Bushwick Ayuda Mutua

Bushwick Ayuda Mutua is a collective group of Bushwick residents, long-term residents, and recent arrivals, rooted in the mission of creating a local network for neighbors to support neighbors.

BUSHWICKAYUDAMUTUA.COM

Manhattan

Canal Cafeteria

Canal Cafeteria is a mutual aid group aimed at creating a more equitable food landscape by distributing fresh groceries to working class families and individuals in the Lower East Side of Manhattan.

CANALCAFETERIA.COM

Clio

Formerly known as Washington Heights SeniorLink, Clio provides phone/mail social support, needs assessments, informational resources, and care packages to older adults in the Washington Heights area.

CLIOCONNECT.ORG

Queens

Chhaya CDC

Chhaya CDC was founded in 2000 to advocate for the housing needs of New York City's South Asian community. Their mission is to work with New Yorkers of South Asian origin to advocate for and build economically stable, sustainable, and thriving communities.

CHHAYACDC.ORG

South East Queens United Professionals Front

WSEQUPF invests in the well-being of neighbors and their community by pooling their resources and time to promote locally-sourced goods and services, strengthen social cohesion,

and power equitable ventures that enrich the quality of life in Southeast Queens.

FACEBOOK.COM/
GROUPS/305614520239799/
ABOUT

Rockaway Mutual Aid and Support Network

This group is intended to be a space to provide resources, assistance, and connections between members of our community who may be suffering or unable to provide for their basic needs in the midst of the COVID-19 epidemic. The values of solidarity, mutual care, and direct action underlie our actions as a group.

Staten Island

The Moving Support Project

The Moving Support Project helps formerly unhoused people secure furniture to make their space into a real home. The furniture they secure can be anything from couches and beds to wall art. They search for free or cheap furniture online and coordinate with people who are willing to donate their items.

OPENCOLLECTIVE.COM/THEMOV-
INGSUPPORTPROJECT

New York City Wide

The Bowery Mission

The Bowery Mission serves homeless and hungry New Yorkers by providing services that meet their immediate needs and transform their lives from poverty and hopelessness to hope.

BOWERY.ORG

Domestic Workers United

Advocating for fair labor standards for nannies, house cleaners, and elder caregivers in NYC.

DWUNEWYORK@GMAIL.COM

Apothecaries / Botanicas / Wellness Centers

From the Database of Black healers and herbalists

Full database

The Herbal Scoop

Narrowsburg, NY

@the.herbal.scoop

THEHERBALSCOOP.COM

Sacred Vibes Apothecary

Brooklyn, NY

@sacredvibesapothecary

SACREDVIBESHEALING.COM

HealHaus

Brooklyn, NY

@healhaus

HEALHAUS.COM

Rootwork Herbals

Ithaca, NY

@rootworkherbals

ROOTWORKHERBALS.COM

MINKA brooklyn

Brooklyn, NY

@minkabrooklyn

MINKABROOKLYN.COM

Image Index

Meet Oko Farms
Photo by Suki Zoe

Meet Merry
Photo by Oliver Leone

Jose Sanabria Aka Who Tattoo
Images courtesy of the artist

Pascal Baudar
Photos by Pascal Bauder

Jeffrey Gibson
I NEED TO BE IN YOUR ARMS, 2023. Acrylic paint on canvas, acrylic velvet, acrylic felt, glass beads, druzy crystal, pin back buttons, artificial sinew, nylon thread, cotton canvas and cotton rope inset in a custom frame, 62.5" x 50.5". Copyright Jeffrey Gibson. Courtesy the artist and Stephen Friedman Gallery, London and New York. Photo by Max Yawney.

Sky Hopinka
These are dense countries and empty cities, 2019. Inkjet print, etching, 13" x 13". Edition of 3. Photo credit: John Riepenhoff.

Tauba Auerbach
Spilhaus XIX, 2020. Acrylic on canvas, with metal grommets and binder's tape, Painting: 44" x 65", Overall: 63" x 84" Photo by Vegard Kleven courtesy of Standard (Oslo)

Or Zubalsky
Images courtesy of the artist

Qais Assali
IMG_4678 CROP, 2015-05-29 07:10:33. (From "I Only Read About Myself on Bathroon Walls") iPhone 5c photo. Courtesy of the Artist.

This photographic series documents queer time and dialogues and proposes bathroom walls as meeting spaces between bodies and temporalities. Part autoethnography, part autobiography, and part visual historiography, these images tell stories of a queer Palestinian diasporic experience and its parlance with wider cultural, political, and social meanings and understandings.

VIDEO STILL, 2019-07-2 10:55:48. iPhone 7 photo. Courtesy of the Artist.

A sequence of 49 still images in a grid from a video taken by the artist. Almost all the images of a right arm and torso against a corner wall with different light shades. The images show slight movements between the right arm and torso, suspiciously creating different shapes of the map of Palestine.

Baseera Khan
Made in India, Found in Egypt, Black from Law of Antiquities, 2023. Archival inkjet print, artist's custom frame. Image courtesy of the artist and Simone Subal Gallery, New York. Photo: Daniel Terna. Produced in collaboration with the Brooklyn Museum.

Khan's Law of Antiquities photographs chart the artist's collaboration with museum curators and conservators to establish new dialogues with objects from the Arts of the Islamic World collection at the Brooklyn Museum. Many foreign holdings in museum collections were acquired under questionable circumstances, and Khan symbolically reclaims access to their cultural lineages by staging performative interventions with the fragile objects. Without the ability to handle these historic objects directly, Khan instead engaged with the collection through photography and used the resulting printed images as studio props in and of themselves. Khan appears in editorialized photographs and digital collages that attempt to compress both the physical and historical distance between themself and these symbolic artifacts. Here and there, a nitrile-gloved hand of a conservator peeks into view, commingling with Khan's elaborately manicured nails. In Made in India, Found in Egypt, Black, from Law of Antiquities, Khan holds a cotton textile fragment from the 12th - 15th century found in Egypt, but thought to have been produced in India, which is now in the Brooklyn Museum collection.

Courtesy of Simone Subal Gallery, New York.

Jia Sung
Scab Harvest, 56" x 46", acrylic and embroidery thread and beads on linen.

Roberto Lugo
Put Yourself in the Picture at Grounds for Sculpture in Hamilton, NJ. Photo by Ken Ek. Courtesy of Grounds for Sculpture.

Day Brièrre
Untitled 2024. Courtesy of the artist.

Paula Querido
É Tão Triste Cair

Photo by Alberto Bravini, courtesy of Ronchini Gallery

Jaune Quick-to-See Smith
I See Red: Snowman. Courtesy of the artist and Garth Greenan Gallery, New York.

The Bill Pickett Invitational Rodeo
All photos courtesy of The Bill Pickett Invitational Rodeo.

Debarati Sarkar
Where Moonlight Meets the Ground.
2021, wax pastels on paper, 5.5" x 8".

Hirad Sab
Venenum 84" x 62", Mixed Media.

Jordan Nassar
Al-Atlal (The Ruins). 2024, Glass Tile and
Cement Grout on Foam Board, ca. 5' x 8'

Courtesy the Artist, James Cohan, New
York, Anat Ebgi, Los Angeles & The Third
Line, Dubai

Contributor Bios

Adriana Ayales was born and raised in Costa
Rica and has extensively studied several
healing traditions, alongside master herbalists
and shamans for 13+ years. She started Anima
Mundi in Brooklyn NY as a means to bridging
ancient remedies to the modern world, sourcing
materials from honest farmers, wildcrafters,
and from indigenous peoples when possible,
to alchemize and create truly high vibrational
medicines for the mind, body and soul. Ayales
believes that by preserving ancient forms of
indigenous botany, we keep alive a very sacred
aspect to our source.

Anne Kadet is the creator of CAFÉ ANNE, a
weekly newsletter with a focus on New York
City that takes a fresh look at the everyday,
delights in the absurd, and profiles unusual
folks who do things their way.

Baseera Khan is a multi-disciplinary
installation artist born in Texas of Indo-Muslim
heritage. Khan is interested in the play of color,
but only with the knowledge that color exists
through the use of language, not solely affect.
Placing focus on the relationship between
what is created and what is experienced,
Khan uses soft and hard organic materials,
textiles, upholstery, and the transformation of
utilitarian objects into larger statements about
the self. Khan exposes how resources and
technologies are not apolitical, but catalysts of
global migration, power, and empire.

Baseera Khan's work was recently exhibited
in their solo show at Brooklyn Museum of Art
as well as Art Basel Statements 2023 and at
Contemporary Arts Center Cincinnati.

The Bill Pickett Invitational Rodeo celebrates
and honors Black Cowboys and Cowgirls and
their contributions to building the west. They
highlight the irrefutable global appeal of
Black Cowboys and Cowgirls and the stories
behind a subculture that is still strong today.
BPIR also serves as a cultural event and
opportunity for families to enjoy

and embrace cowboy culture,
while being educated and entertained
with reenactments, history highlights, and
western adventure.

Cy X is an erotic writer, performance artist,
and somatic practitioner sometimes based in
Brooklyn, NY. They are the founder of Pleasure
Ceremony, an apothecary and eco-erotic care
practice.

Day Brièrre is a Haitian-born illustrator and
ceramics artist based in Brooklyn, NY. Her
visual palette derives inspiration from Afro-
indigenous myths and folklore. She earned
a BA in ceramics from Florida International
University in 2018. Day has participated in
residencies at BKLYN CLAY and Clayworks
in New York City. She was awarded a Leroy
Neiman fellowship at Oxbow School of Art. Her
illustrations have been featured in publications
such as the New York Times and Elle magazine.

Debarati Sarkar is an artist and art historian
making and thinking about things in Brooklyn.
She is currently making ceramics and small-
scale tapestries.

Hirad Sab is an Iranian-American artist
exploring the margins of digital aesthetics,
internet culture, and technology. His amalgams
occupy a precarious intersection of culture
and the democratic nature of image circulation,
an aesthetic trend that expands and mutates
rapidly.

Indigo Goodson-Fields is a writer, poet, and
birder from Hayward, California, and based
in Brooklyn. She received her BA in Black/
Africana studies from San Francisco State
University and her MA in International/African
Studies from Ohio University.

Jaune Quick-to-See Smith was born in 1940
at the St. Ignatius Indian Mission on her
reservation, and is an enrolled Salish member
of the Confederated Salish and Kootenai Nation,
Montana. Smith received an MA in Visual Arts
from the University of New Mexico in 1980.
Smith has been creating complex abstract
paintings and prints since the 1970s. Combining
appropriated imagery from commercial
slogans and signage, art history and personal
narratives, she forges an intimate visual
language to convey her insistent socio-political
commentary with astounding clout.

Jeffrey Gibson (American, born 1972) is the
United States Representative to the 60th
International Art Exhibition in Venice. A
member of the Mississippi Band of Choctaw
Indians and of Cherokee descent, Gibson's
artistic practice combines Native art traditions
with the visual languages of modernism
to explore the confluence of personal

identity, popular culture, queer theory, and international social narratives. Across sculpture, painting, and collage, Gibson's multi-disciplinary work embraces ideas of hybridity and reveals intersections between contemporary issues and past histories.

Jia Sung is an artist, educator, and author born in Minnesota, bred in Singapore, and now based in Brooklyn. Her practice spans painting, artist books, textiles, printmaking, murals, writing, and translation. She draws on motifs from Chinese mythology, Buddhist iconography, and the familiar visual language of folklore to examine and subvert the archive through a queer feminist lens. She is the author of Trickster's Journey, a Chinese mythological tarot deck and guidebook, published with Running Press in 2023.

Jordan Nassar's (b.1985, New York, NY) art practice engages the material variety of craft to execute ideas centered on heritage and homeland. He examines identity and diaspora through traditional Palestinian hand-embroidery, wood inlay, mosaics, glasswork, and expansive installations. His work has been featured at the Institute of Contemporary Art/Boston and the Whitney Museum of American Art, New York, among many others.

Jose Sanabria Aka Who Tattoo is a Puertorrican queer tattoo artist working in California, specializing in illustration and bold colorful tattoos.

Julie Rossman is the Data Visualizations Designer at the National Audubon Society, where she is passionate about crafting infographics and data visuals that explain the science of the natural world. Her work has been published by Time, Slate, NASA, Science Friday, How Stuff Works, Buzzfeed, Huffington Post, Scholastic, and The Week, among others. She lives in Brooklyn with her cats, Tomato and Ethel.

Kay Kasparhauser is a New York City based research-artist.

Meredith Celeste Lawder is a writer, editor, and filmmaker from New York.

Merry lives in New York City. Her dream is to have her own garden. In the meantime, she helps others weed, plant, and maintain their gardens. From time to time, she'll plant seeds or flowers along the West Side Highway. She is always anxious to bring some beauty to the concrete jungle.

Michael Pollan is a writer, teacher, and activist. His most recent book, This is Your Mind on Plants, was published in 2021. He is the author of eight previous books, all

of which were New York Times Bestsellers. Pollan teaches writing in the English department at Harvard and for many years served as the Knight Professor of Journalism at UC Berkeley's Graduate School of Journalism. Several of his books have been adapted for television. In 2010 Time Magazine named Pollan one of the 100 most influential people in the world. In 2022-23, Pollan was a Guggenheim Fellow. Pollan lives in Berkeley with his wife, the painter Judith Belzer.

Morgan Lett is an Atlanta-based writer, business manager, and astrologer. Her work has been published by PS, The Every Girl, Refinery29, and Popular Astrology. Find more of her work on social media @morganlettinsights or morganlettinsights.com.

Naomi Klein is an award-winning journalist, columnist, and the international bestselling author of nine books published in over 35 languages including Doppelganger: A Trip into the Mirror World. She is an Associate Professor in Geography at University of British Columbia and is the founding co-director of UBC's Centre for Climate Justice.

Nora N. Khan is an independent critic, essayist, curator, editor, and educator. She is internationally recognized for her essays and short books, marked by a hybrid, genre-defiant prose style. Formally, this work attempts to both theorize the limits of algorithmic knowledge and outline the future of creative production in a technocratic age. For 15 years, her writing has focused on artists' most trenchant ideas, models of experimentation across creative fields, and critique of technological design. In particular, her work on philosophy of AI/ML, with a focus on 'incomputable' knowledge and the relationship of language to computation, is referenced heavily by writers, theorists, artists, and practitioners across fields.

Or Zubalsky is an artist, educator, and parent based in Lenapehoking (Brooklyn).

Orfeo Tagiuri (b. 1991, Brookline, MA, USA) lives and works in London. Orfeo's practice spans from painting and drawing to performance, film, woodcarving, animation, and music. Orfeo has both exhibited and performed internationally, including at the Palais de Tokyo, Paris (2018), at Fiorucci Art Trust's Volcano Extravaganza (2016) and the ICA, London (2015). Orfeo is a graduate (MFA Painting, 2019) of the Slade School of Fine Art, and previously attended Stanford University

Pascal Baudar is a wild food expert, forager, and author who has influenced the way we think about natural foods and culinary innovation. Known for his deep

connection to the landscape and a creative approach to using wild plants and ingredients, Baudar has authored several books where he explores the fusion of traditional foraging techniques with modern culinary practices. Through his work, Baudar invites us to look at the natural world not just as a place to explore, but as a bountiful source of food and inspiration.

Paula Querido is a painter from Rio de Janeiro, Brazil, currently based in New York.

Qais Assali (they/them) is an interdisciplinary artist/designer born in Palestine in 1987 and raised in the UAE before returning to Palestine in 2000. Assali taught in Visual Communication at Al-Ummah University College, Jerusalem, the School of the Museum of Fine Arts' at Tufts University, MA, Michigan State University, MI, and Vanderbilt University, TN.

Roberto Lugo is an American potter, social activist, spoken word poet, and educator. Lugo's work as a social activist is represented in his artworks, where he draws together hip-hop, history, politics and his cultural background into formal ceramics and 2D works

Sally DeWind is a teacher and writer from Brooklyn, New York. She is a graduate of the Brooklyn College MFA program where she received the Lainoff Prize for fiction. Her work has been published in Bennington Review.

Sky Hopinka is a filmmaker and artist living in Brooklyn, New York.

Sonya Renee Taylor is one of many hands currently called to midwife the new world. She is a guide, poet, storyteller, vision holder, intuitive astrologer, and evangelist of radical love. She is the author of seven books including the New York Times bestseller The Body Is Not an Apology: The Power of Radical Self Love (2021) and her most recent offering for young readers The Book of Radical Answers (2023).

Spencer Tilger lives in Brooklyn, which is part of an island with many names (Paumanok, Sewanhacky, Lenapehoking, Long Island, home). He works at a refugee rights nonprofit and writes when inspired.

Tauba Auerbach's work (b. 1981, San Francisco, CA) contemplates structure and connectivity on the microscopic to the universal scale. Building on crafts in many disciplines, Auerbach often invents tools and techniques for inducing material behaviors. In 2013, Auerbach founded Diagonal Press to formalize their ongoing typography and book-design practice. Auerbach's work is included in the collections of The Museum of Modern Art, the Whitney Museum of American Art, The Astrup Fearnley Museum of Modern

Art, and the Centre Pompidou, among others. In 2021, the San Francisco Museum of Modern Art presented S v Z — a 17 year survey of Auerbach's work.

Vivien Sansour is an artist, researcher, and writer. Vivien is the current Executive Director and founder (2014) of the Palestine Heirloom Seed Library, where she works with farmers in Palestine and around the world to preserve ancestral seeds and biocultural knowledge. Her work as an artist, scholar, and writer has been showcased internationally. Vivien was most recently the Distinguished Artistic Fellow in Experimental Humanities at Bard College.

Tony Caridea is an airbrush artist specializing in pet and animal memorial art. He is well known for his ability to depict the complex emotions and inner worlds of the creatures he paints. He pulls inspiration from compiling and blending the art of the many images he sees and analyzes across the internet.

Willa Köerner writes Dark Properties, a newsletter connecting personal and planetary ecologies. She is a co-editor of two books, and has worked with an array of technology-and-culture-focused organizations including the New York Times R&D, Are.na, NEW INC, Feral File, and SFMOMA.

Winona LaDuke (Anishinaabe White Earth reservation) is a farmer and writer who works for Anishinaabe Agriculture, a nonprofit focused on Indigenous seeds, foods, and hemp.

Yasaman Sheri is a professor, designer and writer and investigates contemporary critical inquiry into life sciences. She is Principal Investigator of Serpentine Galleries Synthetic Ecologies Lab.

Yemi Amu is the Founder and Director of Oko Urban Farms, Inc. and one of NYC's leading aquaponics experts. In 2013, she established NYC's first and only publicly accessible outdoor aquaponics farm - The Oko Farms Aquaponics Farm and Education Center. She directs all of Oko Farms' programs including education, design/build projects, and community related activities. Yemi has a M.A. in Health and Nutrition Education from Teachers College, Columbia University.

Notes / Sketches